FRENCH MASTER DRAWINGS

The exhibition and accompanying catalogue
have been made possible by
J. P. Morgan & Co. Incorporated

JPMorgan

FRENCH MASTER DRAWINGS

From The Pierpont Morgan Library

Cara Dufour Denison

THE PIERPONT MORGAN LIBRARY

Exhibition dates

Musée du Louvre, Paris
1 June 1993–30 August 1993

The Pierpont Morgan Library, New York
15 September 1993–2 January 1994

Cover:
Jean Antoine Watteau, *Two Studies of the Head
and Shoulders of a Little Girl* (cat. no. 39)

All photography for The Pierpont Morgan Library
is by David A. Loggie

Photographic credits: Lauros-Giraudon/Art Resources,
New York, pp. 44, 154, 208, 218, 228, 242; Gilbert Mangin,
Nancy, p. 38 (left); Service photographique de la Réunion
des musées nationaux, Paris, pp. 47 (top), 152, 202, 268.

Publication coordination by Kathleen Luhrs

Published in the United States of America in 1993
by The Pierpont Morgan Library

French edition available from
Editions de la Réunion des musées nationaux
49, rue Etienne-Marcel 75001 Paris

Library of Congress Card Number 93-084266

ISBN 0-87598-096-1

Contents

Acknowledgments

THE MORGAN LIBRARY is grateful to Arlette Sérullaz, conservateur général au département des Arts graphiques du musée du Louvre for her assistance throughout the planning of this exhibition. Peter Dreyer, Stephanie Wiles, and Evelyn Phimister of the Library's Department of Drawings and Prints, along with Felice Stampfle and Ruth S. Kraemer, have been very generous with their time and expertise. Other colleagues, including John H. Plummer and William M. Voelkle, of the Department of Medieval and Renaissance Manuscripts, and H. George Fletcher and Anna Lou Ashby of the Department of Printed Books and Bindings, have also given freely of their time. D. W. Wright, registrar and archivist, has provided much information about the early collecting activities of Pierpont Morgan. He has also been greatly involved with the official organization of the exhibition and arrangements for insurance and transportation.

Elizabeth Horwitz, an intern in the Department of Drawings and Prints, ably assisted in putting the catalogue together, assembling and checking the bibliography and exhibition histories of each drawing and coordinating work on the project with the Publications and Photographic departments of the Library. Asher Miller, Kathleen Stuart, and Michael Addiego, all of whom were Rudin summer interns, were of great assistance. Two other interns, Charlotte Hayman and Peter Wojcik, also helped with bibliographic questions. Elizabeth O'Keefe and her colleagues in the Reference Cataloguing Department, have willingly answered numerous reference questions. Mrs. Patricia Reyes and Timothy Herstein of the Conservation Department have prepared the drawings for exhibition and resolved many of the technical problems. The excellent work of the Library's photographer, David A. Loggie, is much in evidence, and he and his staff have been very cooperative in connection with the project.

Kathleen Luhrs, with great forbearance, has seen the catalogue through the press. Mimi Hollanda and Elizabeth Gemming assisted in the editing and proofreading. The catalogue was designed by Klaus Gemming to whom we are particularly grateful for his organization of the two-language editions. He and the printer, Martino Mardersteig, worked under great pressure to produce both catalogues for this exhibition. Bérengère de Guernon and Hélène Joly, working together, the first as translator and the second as French editor, worked in close collaboration with the author and each other and were a pleasure to work with. They were ably supported by our colleagues in Paris, Laurence Posselle at the Réunion des musées Nationaux and Lucilia Jeangeot who assisted in proofreading the text.

Curators at the Louvre, especially Françoise Viatte, Jean-François Méjanès, Catherine Monbeig-Goguel, and Pierre Rosenberg, have been generous with their opinions and support. Carlos van Hasselt and Marianne Roland Michel have also been consulted to advantage as have Dr. Myra Nan Rosenfeld and Dr. David Thomson. François Borne and Edward Lewine, experts at Christie's, have supplied valuable sale catalogue information. In the United States, Joseph Baillio, the late Jacob Bean, Victor Carlson, Helen B. Mules, William W. Robinson, Roberta Waddell, Jacques Olivier Bouffier, and Margot Gordon have been helpful in various ways.

Sponsor's Foreword

SINCE 1868, J. P. Morgan has conducted business continuously in Paris. During these 125 years, our firm has always been close to the economic and financial life of France. Beyond the lasting business links we have established, many unshakable personal ties have also been formed over half-a-dozen generations, so that it is no exaggeration to say that, to the House of Morgan, Paris is as much home as New York.

J. Pierpont Morgan, who founded our firm in the last century and later conceived the idea for the Library which his son gave to the public in 1924, would no doubt approve of this exhibition. He was inordinately fond of French art in all its myriad forms and spent many enjoyable months traveling in France.

For these reasons, it is probably not just coincidence that the Pierpont Morgan Library should house one of the world's leading collections of French drawings. Our anniversary in France accordingly provides a fitting occasion for a selection of these great drawings, now seen together for the first time outside of New York, to appear at the Louvre.

As a firm, J. P. Morgan has spent many productive years in France. We proudly and confidently look forward to what the next 125 years may bring.

Dennis Weatherstone
Chairman of the Board
J. P. Morgan & Co. Incorporated

Louvre Foreword

For all lovers of drawings – and they have become more and more numerous and fervent, the Paris showing of these remarkable works from the Pierpont Morgan Library is an event.

After the exhibition of the "Dessins français du Metropolitan Museum de New York (de David á Picasso)," which was held at the Louvre from October 1973 to January 1974, and that of the "Dessins français de l'Art Institute of Chicago (De Watteau à Picasso)," shown in the same space three years later, this is a grouping of 125 French drawings that our friends at the Pierpont Morgan Library have chosen from their admirable holdings to be presented at the Pavillon de Flore.

The interest in French drawings that the United States has shown since the end of the nineteenth century is here illustrated in the most brilliant fashion.

Not content with acquiring already distinguished sheets by the great masters, American collectors and curators have also broadened their search and have discovered, often well before others, the value of less well-known artists, today widely appreciated by all.

It is this double requirement, this curiosity, this quest for the rarest and the best that explains the importance of the collection of manuscripts, illustrated books, and of drawings assembled by Mr. Pierpont Morgan, worthy of the richest princely collection rooms of Europe. When his collection became accessible to researchers and visitors, it formed the foundation for an institution whose reputation rapidly became international. The Pierpont Morgan Library established itself as a point of reference not only for the exceptional quality of its collections, but also for the professional quality which has always pervaded its exhibitions and the editing of its catalogues. Under the leadership of Belle da Costa Greene, Frederick B. Adams, Jr., Charles A. Ryskamp, and today Charles E. Pierce, Jr., the Morgan Library has been considerably enriched, principally in the field of drawings, thanks to the opportune acquisitions and generous donations for which Felice Stampfle, responsible for the collection from 1945 to 1984, and now Peter Dreyer and Cara Dufour Denison, have taken the initiative.

The works being shown at the Louvre, in the rooms of the département des Arts graphiques, are among the jewels of the Morgan Library collection. They were chosen with taste and discernment to illustrate as it were a history of French drawing from Jacquemart de Hesdin to Gauguin, or rather one of the possible histories; for it should be well understood that all spirit of didacticism or weightiness has been carefully eschewed.

Our gratitude goes to Charles E. Pierce, Jr., director of the Pierpont Morgan

Library, Cara Dufour Denison, curator of drawings and prints, and also to all those from the library on 36th Street who assisted in the preparation of this exhibition. Françoise Viatte, conservateur général in charge of the département des Arts graphiques du Louvre, and Arlette Sérullaz, conservateur général of this department, as well as curator in charge of this exhibition, have been especially happy to work with them.

We also owe grateful recognition to Dennis Weatherstone, chairman of J. P. Morgan & Co. Incorporated, and Frederick H. S. Allen, vice president for corporate sponsorships, for their constant support during this project.

In this spring of 1993, it is truly a pleasure to tell you how much the Musée du Louvre is honored and proud to gather on its walls, on the occasion of the 125th anniversary of the opening of the Paris branch of the Morgan Bank, this unique collection. For this we thank our New York friends. For several months they offer to the visitors to the Musée du Louvre, the most delectable of gifts.

Michel Laclotte
Président-Directeur
Musée du Louvre

Morgan Library Foreword

THIS EXHIBITION is a celebration of many things. First, and most obviously, it is a celebration of the art of drawing in France—specifically, as represented in the collections of the Morgan Library. The group of 125 drawings presented here extends from highly refined metalpoint drawings of the late medieval period to the wonderfully spontaneous and vibrant achievements of the eighteenth century and to the evocative drawings of nineteenth-century artists, such as Degas and Redon. The range of periods, media, and styles, while not encyclopedic, is broad and representative of the special strengths of the holdings.

This exhibition has been organized to coincide with the 125th anniversary of the creation of the Paris office of the exhibition's corporate sponsor, J. P. Morgan & Co. Incorporated. It was the Morgan Library's founder, J. Pierpont Morgan (1837-1913), who consolidated and expanded the great international banking firm which still bears his name today. Not only do the Library and J. P. Morgan & Co. have this historical link, in the past decade they have also collaborated on a number of important projects. The most recent of these was the Library's exhibition of Mozart manuscripts, which was seen both in New York and at the British Library in London. Now, once again, J. P. Morgan has come forward to lend its support to an exhibition of international scope and significance. We are grateful for their generous and enthusiastic support.

This year also marks the bicentennial of the creation of the Louvre as France's national museum. It was two hundred years ago that this royal palace became a public museum and one of the greatest institutions of its kind in the world. To have been invited to be a part of their anniversary celebrations is a source of great pride for all of us associated with the Morgan Library and this exhibition. The Library is, of course, a much younger institution, having been incorporated as a public museum and research library in 1924. It began life, however, several decades earlier, as the private library of Pierpont Morgan, a remarkable man whose preeminence in the world of banking and finance was equaled if not surpassed by his activities as a bibliophile and collector. The elegant Renaissance-style library he built in 1906 for his burgeoning collections of illuminated manuscripts, rare books, fine bindings, and autograph manuscripts has since become a familiar landmark in New York. It was only toward the end of his life, in 1910, that he became a serious collector of old master drawings, when he purchased the extraordinary group of fifteen hundred drawings assembled by the English connoisseur Charles Fairfax Murray. Prior to this there existed in this country no collection of old master drawings comparable in scope or quality. Thence forward, the United States has witnessed a steady rise in the

serious study and collecting of fine drawings both in the public and private sectors.

The Morgan Library has been privileged to play a central role in this development. Of all the Library's collections, that of drawings has shown the most dramatic growth since Morgan's day. Each year, a steady stream of scholars, both from the United States and abroad, conduct research in the Library's print room. In addition to an active loan program, the Library regularly presents major exhibitions of its own drawings, as well as those of important institutional and private collections from around the world. The list of exhibition catalogues and other publications devoted to aspects of the Morgan's drawings collections is a lengthy and impressive one. We are now proud to add the present volume, the first major, fully illustrated catalogue devoted to our superb examples of French draughtsmanship. We are very pleased to have this opportunity to share these works with the ever-increasing numbers of persons on both sides of the Atlantic who derive pleasure and enlightenment from great drawing.

This exhibition owes its existence to the cooperation, time, and expertise of a great many people. Cara Denison, curator of drawings and prints, selected the works and wrote the accompanying catalogue entries. In addition, she has written the introduction that discusses the scope and formation of the Library's collection of French drawings. I am also grateful to the many other members of the Library's curatorial, administrative, and technical staffs who have helped in numerous ways with the exhibition and catalogue.

From the very beginning, Michel Laclotte, président-directeur du Musée du Louvre, has given this project his enthusiastic support and careful attention. We have also benefited greatly from the assistance and guidance of Arlette Sérullaz, conservateur général au département des Arts graphiques. They and their colleagues at the Louvre have at every turn smoothed the way with their graciousness and collaborative spirit. Irène Bizot, administrateur général de la Réunion des musées Nationaux and her staff have also played a central role, facilitating all aspects of the Louvre showing of this exhibition and of the French edition of the catalogue.

On behalf of the Morgan Library, its staff and Trustees, I should also like to express my special thanks to Dennis Weatherstone, chairman of J. P. Morgan & Co. Incorporated, and Frederick H. S. Allen, the firm's vice president for corporate sponsorships, for the high level of commitment and interest that they have brought to this project. A more complete list of people who have contributed to the success of this exhibition is found on the Acknowledgments page. To each of them, I offer my deepest thanks for their invaluable assistance.

Charles E. Pierce, Jr.
Director
The Pierpont Morgan Library

Introduction

By European standards, the drawings collection of the Morgan Library is relatively new, but in America it stands as one of the oldest established collections of old master drawings. Its beginnings go back to 1910 when the financier and collector Pierpont Morgan acquired and brought to New York the noted collection belonging to the indefatigable English *marchand-amateur* Charles Fairfax Murray. For the first time, this country was in possession of a large, comprehensive collection of old master drawings from all the schools of Europe and ranging in date from the late fourteenth through the eighteenth centuries. The principal strengths of the Fairfax Murray collection were Italian and northern European. French drawings—although less broadly represented—were, however, present in works of the highest artistic merit. These included landscapes by Claude Lorrain, a few works by Claude's fellow expatriate, Nicholas Poussin, as well as examples by Jean Honoré Fragonard and Hubert Robert.

This was the foundation of the Morgan Library's collection of French drawings. Although many of them have been lent to other exhibitions, they have never before been shown abroad as a collection. An exhibition of the best Morgan drawings of all schools went to Stockholm in 1970, and in 1978 and 1979 a large selection of the Dutch and Flemish drawings was exhibited at the Institut Néerlandais, Paris, the Musée des Beaux-Arts, Antwerp, and at the British Museum in London.

The Library surveyed its French holdings in an exhibition in 1984, but this effort was accompanied only by a brief illustrated checklist and was not shown elsewhere. While that exhibition included drawings made by artists before 1825, the present exhibition includes a number of later nineteenth-century works. Neither in the earlier exhibition nor here has it been the aim to make a methodical survey of each century, but rather to show the particular strengths of the collection. For this reason, the exhibition includes two or more examples of several artists. Since a number of items were acquired quite recently, this exhibition necessarily has a somewhat different and broader aspect than the earlier show. A number of drawings that might have been included in this selection are exhibited in *Exploring Rome: Piranesi and His Contemporaries*, which is to be shown at the Canadian Centre for Architecture in Montreal in the summer of 1993. Notably, these include a group of drawings by Hubert Robert, along with the Roman sketchbook, his only sketchbook that survives intact.

Less than a quarter of the exhibition is associated with Fairfax Murray or Pierpont Morgan. It has been remarked that Pierpont Morgan was influential in

the heightening of American taste for French art that occurred at the turn of the century, having, among many other things, purchased Fragonard's *Progress of Love* series in 1899, which is now in the Frick Collection, New York. While Ambroise Dubois's *Toilet of Venus and Psyche* and Jean de Gourmont's *Flagellation* came from Fairfax Murray, Pierpont Morgan also bought drawings of the greatest rarity and quality elsewhere. These include the boxwood sketchbook, the Boucher *Four Heads of Cherubim*, the Portail *Lady Sketching at a Table*, the Watteau drawings of the *Seated Young Woman* (which was engraved by Boucher), and the *Two Studies of the Head and Shoulders of a Little Girl*, all of which he purchased independently in the early 1900s. Also in the exhibition are Edme Bouchardon's Roman sketchbooks, including a *Self-portrait of the Artist* from his *Vade Mecum*, and the important series of portraits of the participants at the Congress of Vienna taken in 1815 by Jean-Baptiste Isabey, which Pierpont Morgan bought in 1907 and 1908, respectively. After his death in 1913, the Library did not actively collect drawings for nearly four decades.

More than seventy drawings in the exhibition were acquired after 1952. This reflects the renewed interest in collecting that began with the formation of the Association of Fellows (an informed support group that donates art and funds for new acquisitions) as well as the arrival of Felice Stampfle as curator of the Department of Drawings and Prints in 1945. Many of the drawings included in the exhibition came to the Library because of her scholarship and enthusiasm for French art.

Almost twenty drawings in the present exhibition entered the collection during the 1950s and 60s. Several rare early drawings were acquired, including another drawing by Jean de Gourmont, *The Holy Family;* the *Seated Figure of Faith,* executed by one of the artists closely connected with Francesco Primaticcio when he worked at Fontainebleau; *The Water Festival at Bayonne, June 24, 1565,* one of Antoine Caron's six large designs for a tapestry; and *St. Luke Seated on His Ox, Painting at an Easel* by Jean Cousin the Elder. The early seventeenth-century red chalk study of a woman's head, personifying the sense of taste, was acquired as Jacques Bellange but has recently been reattributed (along with a large group of similar drawings) to an important but little-studied artist from Rouen, Jean de Saint-Igny. Like the Saint-Igny, the fantastic *Mounted Amazon with a Spear* by Claude Deruet, who studied with Bellange and later succeeded him as court painter to the duchy of Lorraine, was traditionally believed to be by Bellange as well. Despite these acquisitions, however, the most significant growth in these decades was in the area of eighteenth-century French drawings. Gifts and purchases in those years included important examples by Boucher, Natoire, Saint-Aubin, a major drawing by Fragonard, an unusual watercolor by Fragonard's close contemporary Hubert Robert, the almost life-sized portrait by Greuze of Denis Diderot, and Prud'hon's study for *Le Cruel rit des pleurs qu'il*

fait verser. Henry S. and Junius S. Morgan donated the set of five volumes from the collection of their mother, Mrs. J. P. Morgan (d. 1925), containing the *Plan des Maisons royales.* These volumes were bound for Mme Pompadour's brother, the marquis de Marigny, as he took up the important post of *surintendant des bâtiments du roi* in the middle of the eighteenth century.

In the 1970s, the Library acquired *Procris and Cephalus* by the elusive sixteenth-century artist known as the Maître de Flore, along with a major drawing by Jacques Callot, *The Miracle of St. Mansuetus,* from the collection of Germain Seligman. *The Hunter Orion Carrying Diana on His Shoulders,* the exceptional mannerist drawing by Jacques Bellange, along with the fine example of Israel Silvestre's topographical drawing *A Panoramic View of Loreto,* complemented the seventeenth-century holdings. Several important drawings by Vouet, Prud'hon, and Ingres were bequeathed to the Library in 1977 by Mrs. Herbert N. Straus.

It was also in this decade that Mr. and Mrs. Eugene Victor Thaw promised their extraordinary collection of drawings to the Library and gave the beautiful Prud'hon drawing of a *Female Nude,* a gift in 1974 that was followed the next year by Cézanne's *The Card Player.* Both of these drawings are in the present exhibition along with a selection of twenty-three promised drawings that include examples by Claude, Watteau, Fragonard, and Robert as well as drawings by Géricault, Delacroix, Daumier, Redon, and Gauguin. Many of these artists have not been represented in the Library. The importance of this collection cannot be overestimated since ultimately it will substantially augment our existing holdings and strengthen the collection through the nineteenth- and into the twentieth-century periods.

Also in the 1970s, Mr. and Mrs. Claus von Bulow began to give funds for the purchase of eighteenth-century French drawings. The first acquisitions, which were made in 1977, included Boilly's study for *Les Déménagements* and Ingres's *Portrait of Charles Désiré Norry.* To date some thirty-seven drawings have entered the collection as purchases on the von Bulow Fund, of which thirteen are shown in the exhibition.

An unusually large number of the drawings exhibited (twenty-seven) were acquired in the 1980s, both by gift and purchase, including the gifts of two trustees of the Library. One trustee, who preferred anonymity, presented drawings by Poussin and Dumont. Another trustee, Miss Alice Tully, presented the remarkable view of *La Salle des Machines* by Chalgrin in 1986. Other donors include Mrs. Anne Bigelow Stern, who made it possible to purchase the Gillot and one of the Prud'hon drawings. The Lois Duffie Baker and Edwin H. Herzog Funds provided funding for drawings by Carmontelle, Dorigny, and the Boucher *Design for Frontispiece to "Tombeau du comte Sidney Godolphin."* The well-known Lancret drawing for *Le Déjeuner au Jambon* was acquired in 1985 on funds derived from the bequest of Mrs. Herbert N. Straus. Mrs. Charles

Wrightsman made it possible for the Library to obtain the newly discovered LeBrun drawing for the Richelieu thesis, while a number of exceptional drawings were purchased on the von Bulow Fund such as the Watteau *Temple of Diana,* the Quentin de La Tour portrait, the Moreau gouache landscape, and another drawing by Gabriel de Saint-Aubin. In 1985 the Library received a bequest from John S. Thacher, a scholar and art collector, of an important group of drawings including eight by Degas (four are included here) and four by Delacroix, including the famous copy of Rubens's *Coup de Lance* and a watercolor view of the *Harbor at Dieppe.*

Except for the Isabey *View of Etretat,* all of the seven drawings in the exhibition that were acquired in the 1990s were purchased on the von Bulow Fund. This group includes a fashion study by Trinquesse, an artist not previously represented in the collection; one of Oudry's views of the park at Arcueil; Saint-Aubin's *The Lesson of the Chemist Sage at the Hôtel des Monnaies;* Hüet's curiously modern watercolor study of corn and wheat; Boucher's study for a painted overdoor, *Arion and the Dolphin;* and, most recently, an Italianate gouache by Hoüel.

Three directors of the Library, Frederick B. Adams, Jr., who retired in 1969, Charles Ryskamp, until 1987, and presently Charles E. Pierce, Jr., have pursued an active drawings acquisition program with great success, making it possible to build the French collection to its present-day size and strength.

All the catalogue entries bear the donor's name or fund's designation where applicable. Drawings acquired after 1950 carry accession numbers by year, while earlier acquisitions follow the numbering system established in the Fairfax Murray catalogue. The entries have benefited greatly from Felice Stampfle's scholarship, especially with respect to drawings acquired in the 1950s through the early 1980s. A number of entries are compiled from her essays in the *Reports to the Fellows:* Cat. nos. 6, 9, 11, 27, 46, 47, 52, 59-62, 67, 71, 77, 82, 90, and 91. Ruth S. Kraemer has written several entries for this catalogue including Cat. nos. 5, 59, 89, 100, 101.

<div align="right">Cara Dufour Denison</div>

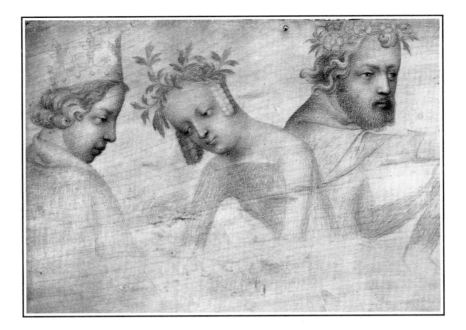

Fourteenth Century

Circle of Jacquemart de Hesdin

CA. 1400

1 Sketchbook

THE BOXWOOD SKETCHBOOK has been known since 1840, when it was in the collection of Baron Camuccini of Rome and was published as Giotto by Rosini in his history of Italian painting. By the early 1900s it had turned up in Paris, firmly assigned to the Franco-Flemish School of the late fourteenth century. The English connoisseur and art critic Roger Fry published it shortly after Mr. Morgan's acquisition in 1906 and made a careful appraisal, connecting it with the French illuminator André Beauneveu on the basis of comparison with manuscript illuminations. In 1930 Pierre Lavallée reattributed the sketchbook to Jacquemart de Hesdin. Although the stylistic canon of most of the drawings remains closest to that of Jacquemart, especially in the *Virgin and Child* shown here, the overall quality of the book is not consistent, and scholars now believe it may be the work of more than one artist in Jacquemart's circle. The book may have served as a pattern or model book for illuminators. There is a marked relationship between the *Virgin and Child* of the boxwood sketchbook and the Virgin and Child in two contemporary manuscripts, one in St. Gall (repr. Scheller 1963, fig. 56) and the other at one time in S. María del Mar, Barcelona (repr. Meiss 1967, fig. 280). Both are compositionally close to the boxwood *Virgin and Child* but are inferior to it in quality, which suggests either

Six boxwood leaves. Metalpoint on boxwood washed with white gesso

5⅛ x 2¾ inches (70 x 30 mm)

Provenance: Baron Camuccini, Rome; private collection, Rome; G. Brauer, Paris; J. Pierpont Morgan (no mark; see Lugt 1509).

Bibliography: Rosini 1840, pp. 196f.; Fry 1906, pp. 31ff., repr.; Fry 1910, p. 51; Lavallée 1930, pp. 12ff., 61f., pl. VIII; Dimier 1932, pp. 12ff. (as nineteenth-century forgery); Habelberg 1936, pp. 15 n. 15, 16, 21, 32, 66, 53, 29, 71ff.; Parker 1938, I, under no. 271; Parkhurst 1941, pp. 300ff.; Ring 1949, p. 197; Boon 1950, p. 267; Squilbeck 1950, pp. 127ff.; Porcher 1953, p. 123 n.5; Pächt 1956, pp. 156, 159; Scheller 1963, pp. 104ff., repr.; Kreuter-Eggermann 1964, p. 28, figs. 44, 45; Troescher 1966, pp. 156, 158, 162f., 222ff., 232, 243, 277, 293, 299, figs. 352-60; Meiss 1967, pp. 206f., 267, 278f., 330, figs. 279, 281-86; Châtelet 1972, pp. 16ff., fully repr. in color; Jenni 1976, pp. 13, 27, 36, 40, 80, figs. 17, 106; Jenni 1978, III, pp. 139, 142, repr.; Voelkle 1981, pp. 243ff., repr.

Exhibitions: London 1909, p. 21, pls. XXXVII-XXXVIII; New York PML 1939, no. 99; New York PML 1981, no. 3, repr.

M.346

1 Jousting Scene, *f. 5*

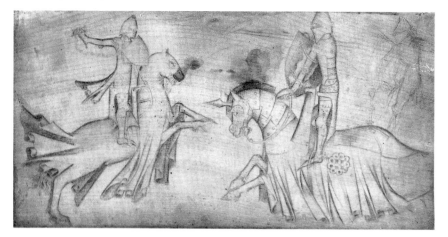

1 Virgin and Child, *f. 1v*

that they depend on the Morgan sketchbook or that all three derive from a common, perhaps lost, prototype.

Even the lesser leaves in the boxwood sketchbook show distinction. As Roger Fry once remarked, the ensemble "is carried out with a minuteness and perfection which could not be surpassed in the miniatures for which they might serve as studies." This is most evident in the *Virgin and Child*. Here the artist has scraped away the white gesso wash around the figures, casting the curvilinear silhouette of the Virgin and Child into relief against the light brown surface of the boxwood and working with varying pressure in metalpoint to achieve subtle distinctions and delicacy in the modeling.

Nearly all of the other leaves of the sketchbook illustrate secular subjects, including crowned and wreathed courtiers. One leaf depicts two wild men shown with three courtiers. This has led several scholars to connect the sketchbook with the masked ball of 1392, described by the chronicler Froissart, at which several courtiers did costume themselves as wild men. A few drawings that have been erased can be distinguished under ultraviolet examination, indicating that the boxwood leaves had been used before; this economical use of material was commonly practiced in the late medieval period.

William Voelkle, curator of the Department of Medieval and Renaissance Manuscripts of the Morgan Library, has connected a separate boxwood leaf with the sketchbook; this drawing, *Virgin and Child Enthroned,* also in metalpoint, was acquired by Mr. Morgan in 1911 (M. 346A; see Voelkle 1981, 243ff.). Despite evident similarities in technique, date, and style, the relationship between the two drawings had never been sufficiently explored until Mr. Voelkle verified the connection by matching the measurements and certain physical irregularities peculiar to both.

1 Five Figures; Two Are Wild Men, *f. 3v*

1 Four Heads. *f. 2*

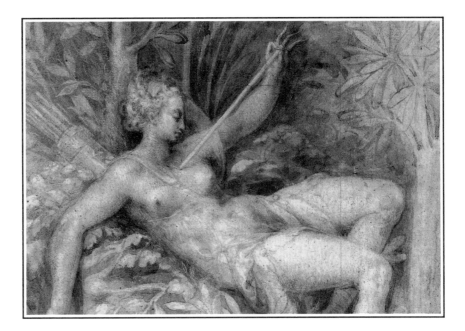

Sixteenth Century

Jean Cousin, the Elder

SOUCY, NEAR SENS CA. 1490 — CA. 1560 PARIS

2 St. Luke Seated on His Ox, Painting at an Easel

THIS EXCEEDINGLY RARE DRAWING by Cousin resembles one in the British Museum. Both of them carry contemporary inscriptions. The drawing in London represents Jupiter and Semele and is inscribed, presumably by the artist, *IO CVSINVS SENON. INVENTOR*. Stylistically, the two drawings have much in common. St. Luke and Jupiter have similar profiles and the figure style is similar. Even the handling of the black chalk and the delicacy of the penwork are comparable, as is the texture of the papers. While the London sheet is assigned to Jean Cousin the Younger, the attribution of the Morgan drawing to the elder Cousin was suggested by Felice Stampfle and supported by Anthony Blunt, who had the opportunity to examine the drawing at the Library in 1958.

Little else can be connected with the elder Cousin: possibly a painting, *Eva Prima Pandora* in the Louvre, *Le Livre de Perspective,* published in 1560, and some designs for the St. Mammès tapestries, commissioned in 1543, two of which are still in the Cathedral of Langres.

Felice Stampfle surmised (PML/*FR*, IX, 1959, p. 92) that the inscription on the verso of the Morgan drawing is a receipt for a payment of fifteen *sols,* or *sous,* to Jean de Caysse, to be paid by Cousin. Since, however, there is an old vertical fold parallel to the inscription, it is possible that the piece of paper on which Cousin drew may have started out as a letter addressed to him, which would account for the inscription.

Black chalk, and pen and brown ink

6¹/₁₆ x 6⁷⁄₈ inches (154 x 175 mm)

Watermark: one-handled pot (cf. Briquet 12732-33)

Inscribed in a sixteenth-century hand on the verso, in red ink, *Jehan Cousin XV S/De Caysse* and in black chalk, *Cousin*

Provenance: Victor Spark, New York.

Bibliography: PML/*FR*, IX, 1959, pp. 91-92.

Exhibitions: New York PML 1984, no. 1.

Purchased as the gift of Mrs. W. Murray Crane

1957.13

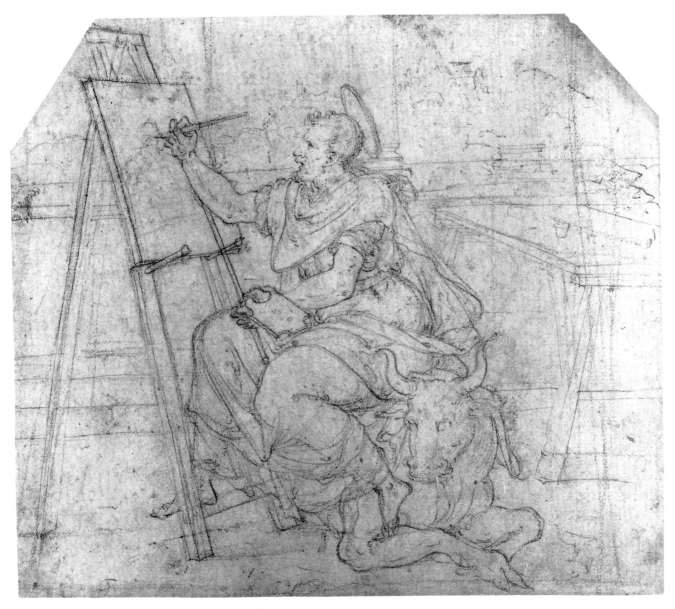

2 St. Luke Seated on His Ox, Painting at an Easel

Jean de Gourmont

PARIS (?) 1506 – 1551

3 The Flagellation

THE SHEET, catalogued by Fairfax Murray as French School, sixteenth century, was first attributed to Jean de Gourmont by J. P. Heseltine in a letter to J. Pierpont Morgan in 1910. In a subsequent letter, Heseltine stated that he had discovered an apparently unique impression of Gourmont's print of this subject in the British Museum (Inv. No. 1845-8-9-1567) and suggested that Mr. Morgan present the drawing to the British Museum. The print is in reverse, signed with Gourmont's distinctive monogram, and dated 1526. It is identical to the Morgan drawing, although the artist has left the architectural elements at the upper right unfinished, an area where the drawing is carefully incised. In size, technique, and subject matter, the drawing is related to one by Gourmont in the Cabinet des Estampes in the Bibliothèque Nationale, Paris, which has not been incised for transfer.

Gourmont's works demonstrate his interest in architecture, which is often shown in his portrayal of ruins and the attention he paid to problems of perspective. The broken columns seen in the foreground of the Morgan drawing

The Flagellation. British Museum

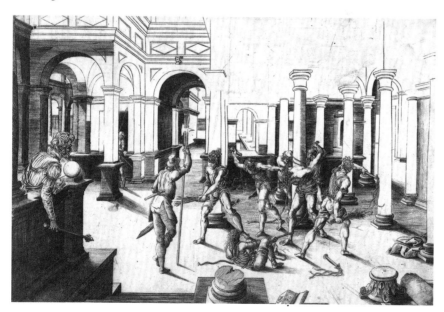

Pen and brown ink, and brown wash; traced with a stylus

8⁹⁄₁₆ x 12¹¹⁄₁₆ inches (218 x 323 mm)

Watermark: none visible through lining

Provenance: J. C. Robinson (Lugt 1433); Charles Fairfax Murray; J. Pierpont Morgan (no mark; see Lugt 1509).

Bibliography: Fairfax Murray 1905-12 III, no. 66, repr. (as French School, 16th century); Thieme-Becker XIV, p. 445 (in reference to no. 180 in the 1904 exhibition in Paris); Lavallée 1930, under no. 59 (incorrectly cited as being in the Metropolitan Museum of Art); Colombier 1945, fig. 113, repr.; Brion 1948, fig. 24; Shoolman and Slatkin 1950, p. 10, pl. 5; Ragghianti 1972, under note 23.

Exhibitions: Paris 1904, no. 180 (listed as *Combat de gladiateurs dans un temple*); Rotterdam and elsewhere 1958-59, no. 8, pl. 6; Fort Worth and Austin 1965, p. 36, repr.; New York PML 1984, no. 2.

III, 66

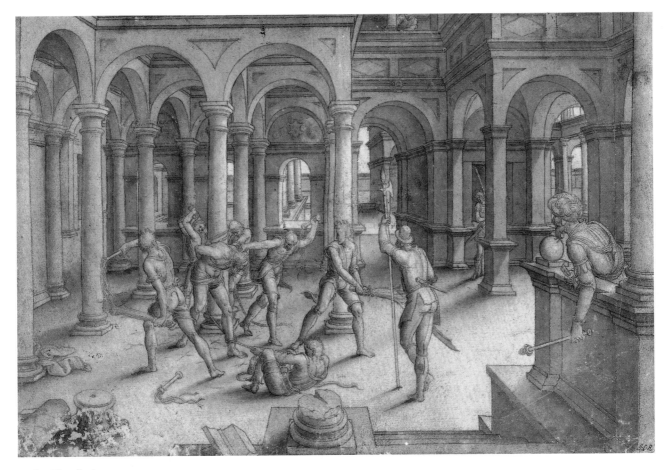

3 The Flagellation

are quite typical and appear to a greater or lesser extent in most of the works attributed to Gourmont. A drawing in the British Museum (Inv. no. 1860-16-53; pen and brown ink, brown wash) depicting a mythological subject is similar in several aspects to the Morgan sheet. The architectural decoration—such as the diamond-shaped decoration of the vault shaded to create a contrast with the architecture itself—compares well with the Morgan drawing. The figures in the British Museum drawing are more tightly executed, but the curious way the artist depicts the figures' hair is quite similar to that of the figures in the Morgan drawing.

11

Jean de Gourmont

PARIS (?) 1506 – 1551

4 The Holy Family

ALTHOUGH THIS DRAWING cannot be connected with any of Gourmont's extant prints, the arrangement of small figures in a complex setting of French Renaissance architecture is very typical of the French printer and engraver. As Felice Stampfle observed (PML/*FR*, III, 1952, p. 63), the emphasis on Joseph as a carpenter reflects the then current cult of the Virgin's husband, which had been initiated a hundred years earlier by Jean Gerson, chancellor of the University of Paris. The Library's drawing is undoubtedly a prefiguration of the Bearing of the Cross, as the Child leans out toward Joseph, who is carrying a long timber suggestive of the upright part of the cross. The elaborate architectural background is developed with an almost dream-like fantasy, which is paralleled in the *Vues d'optique* (1551) of the architect Jacques Androuet Du Cerceau, where similar long perspectives of colonnades and spiral staircases may be found.

Pen and brown ink, brown wash

6 x 8⁷⁄₁₆ inches (153 x 214 mm)

Watermark: none visible through lining

Provenance: André de Hevesy; H. M. Calmann, London.

Bibliography: Lavallée 1930, p. 91; PML/*FR*, III, 1952, pp. 63-64.

Exhibitions: Los Angeles 1976, no. 133, repr.; New York PML 1984, no. 3, repr.

Purchased as the gift of Walter C. Baker 1952.1

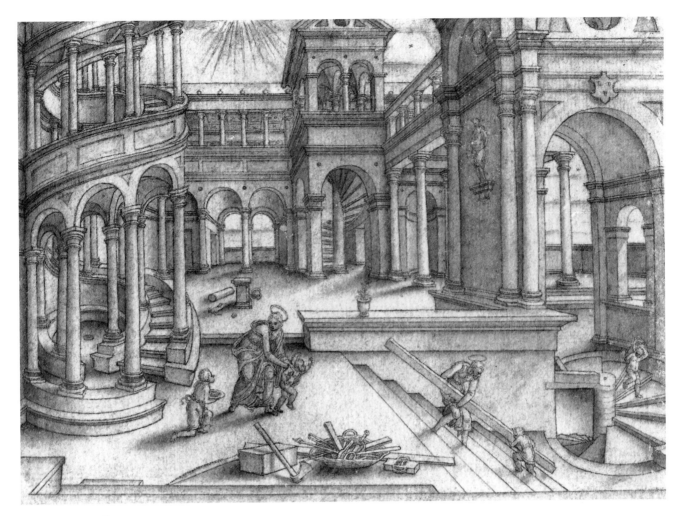

4 The Holy Family

Attributed to Jacques Androuet Du Cerceau, the Elder

CA. 1515 – 1585

5 Album of Architectural and Other Designs

JACQUES ANDROUET DU CERCEAU, THE ELDER, the only son of a Paris wine merchant, was the first of a dynasty of architects. He published a book of decorative designs in 1545, and in July 1551 he was entrusted with preparations for Henry II's triumphal entry into Orléans. Du Cerceau, a Protestant, had to seek refuge with Renée de France, duchess of Ferrara, at Montargis during the religious war about 1560. His two most important publications, *Les Plus Excellents Bastiments de France,* which was issued in 1576 and 1579, and *Les Trois Livres d'Architecture,* which appeared in 1559, 1561, and 1582 respectively, popularized his designs and influenced the taste in architecture and decoration of his contemporaries as well as those of succeeding generations.

Perfectly preserved, the album features eleven double-leaved designs for façades, fifteen for arches, gateways, and doorways, twelve drawings for mantelpieces, and nine for fountains. Most of the drawings are executed with a fine pen, in black ink and gray wash (some folios, e.g. 58r, 64v, 66r, 67v, 68r, 70r, are in pen and brown ink and wash; red ink was used to indicate the brick on folio 17v). Some drawings, especially the plans for buildings, show preparatory lines in metalpoint and graphite as well as tiny holes left by the point of a compass. There are fourteen blank pages, two of which show vertical and horizontal preparatory lines in graphite. The album leaves are for the most part single-folio gatherings. In some cases—all double-leaved designs—two folios have been hinged together and sewn through the hinge, with one thread passing up and down between the gatherings.

The varied nature of the designs causes some confusion about attribution. While Dr. David Thomson considers the drawings wholly autograph, executed about 1555 to 1575, Dr. Myra Nan Rosenfeld distinguishes at least five hands. The album may represent examples from several members of this renowned family of architects, perhaps compiled after Du Cerceau's death, as its original seventeenth-century binding suggests. Yet it is this diversity that epitomizes the inventive genius of Jacques Androuet and his family (two of his sons, Baptiste and Jacques II, as well as his grandson, Salomon de Brosse, were architects). The book includes drawings for fountains (folios 110r-118r), such as the drawing after the famous *Fontaine de Diane* at Anet (folio 115v), which has been traditionally attributed to Jean Goujon and is now in the Louvre. As a monument to Diane de Poitiers, mistress of Henri II of France, the fountain was widely copied by

Ninety-eight pen and wash drawings, chiefly in pen and black ink and gray wash, with some in pen and brown ink and brown wash, one with some red ink, on vellum (120 folios)

Red morocco binding, tooled in gold, probably Paris, last quarter of the seventeenth century

Watermarks on fly leaves: Letter *L* with crown and cartouche with heart motif (cf. Heawood 3009 and 3011, Paris 1681-82 and 1684)

Binding: 13 x 8¾ inches (340 x 220 mm)
Leaves: 12¾ x 8 inches (325 x 205 mm)

Provenance: William Scott Advocate (his bookplate on inside of cover); sale, Sotheby's, London, 14 June 1926, lot 63 (the property of a nobleman); Quaritch (for 450 pounds); his sale, London, July 1926, no. 3587; J. P. Morgan.

Bibliography: PML 1930, p. 42; de Ricci 1937, II, p. 1491, no. 733; Miller 1962-64, pp. 33-41; Coope 1972, appendix *et passim*; Paris and Ottawa 1972-73, I, nos. 109, 113, 114, 115, II, pp. 46-47; MacMillan 1982, I, p. 605; (for the most recent discussion of Du Cerceau and his publication, *Les Plus Excellents Bastiments de France,* see Thomson 1988).

Exhibition: New York PML 1984, no. 106.

M. 733 (formerly)

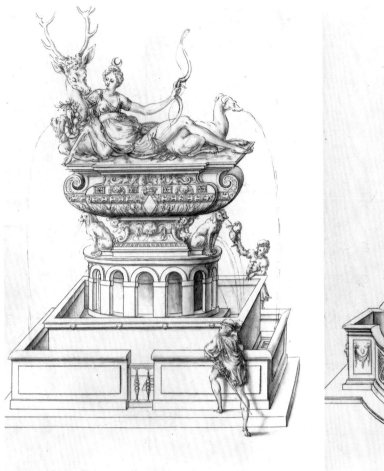

5 Fountain of Diana at Anet, *f. 115v*

5 Drawing of a Fountain, *f. 116*

15

Du Cerceau and others (one drawing is at the British Museum, another at the Cabinet des Dessins of the Louvre).

Only a few drawings can be connected with existing buildings. Most of the castles associated with Du Cerceau, such as Verneuil and Charleval, have been destroyed or are in ruins, for example, the Château de Maulnes-en-Tonnerois. Its pentagonal plan appears on folios 93v-94r and may have been inspired by the Villa Farnese at Caprarola. A further proof of Italian influence on Du Cerceau and his circle are the drawings of Palladian villas on folios 103v, 104r, 105v, and 106r, which were probably copied from the second book of that famous Italian architect's *Quattro Libri dell' Architettura,* published in 1570. Two drawings for gates, enlivened with figures, on folios 3v and 4r, were linked with the main gate at the castle of Blérancourt as well as with the gatehouses and the so-called Porte Henri IV at Verneuil (the latter two destroyed during World War II).

Among the surviving albums of architectural drawings that have been associated with Jacques Androuet Du Cerceau and his workshop, the Morgan manuscript is one of the most sumptuous and attractive. This beauty certainly heightened the appeal of the album, made to provide models for patrons and inspiration for architects and master masons. The impression of a great treasure is created by the execution on vellum and the penmanship, very fine down to the minutest detail, especially in the drawings of façades of buildings and mantelpieces. It is also possible that this assemblage of drawings was gathered for a very demanding and knowledgeable patron, such as a king or nobleman.

Dr. Ruth S. Kraemer is preparing a more extensive discussion of the album for the catalogue raisonné of the Library's French drawings.

Antoine Caron

BEAUVAIS 1521 – 1599 BEAUVAIS

6 The Water Festival at Bayonne, June 24, 1565

A SUITE OF SIX DRAWINGS by Antoine Caron recording some of the major Valois court festivals between 1562 and 1575 came to light in the 1950s when five of the six drawings, including the present sheet, appeared on the London art market. While the Library acquired *The Water Festival at Bayonne*, two drawings, *Running at the Quintain* and *The Tournament at Bayonne between the Knights of Great Britain and Ireland*, were purchased for the Courtauld Institute; the American collector Winslow Ames bought *The Festival for the Polish Ambassadors*, a drawing which he subsequently presented to the Fogg Art Museum, Harvard University, and the fifth in the series, *A Hunting Scene at the Château d'Anet*, was purchased for the Louvre. The sixth drawing, *The Water Festival at Fontainebleau*, had been previously recorded in the collection of the National Gallery of Scotland at Edinburgh (the six drawings repr. Yates 1959, pls. IX-XI). All six designs depict the sort of well-documented political "magnificences" much loved by the refined Valois court as directed by Catherine de' Medici. All were used as the models for the famous set of Valois tapestries now in the Uffizi, Florence. (One of Catherine de' Medici's granddaughters, Christine de Lorraine, married the grand duke of Tuscany in 1589, about six or seven years after the tapestries were woven, and they most probably went to Italy at that time.) There are, however, eight tapestries (repr. Yates 1959, pls. I-VIII), suggesting that Caron may have made two more drawings for the series. While Caron's designs served as the inspiration for the tapestries, the textile artist transformed them into large-scale, detailed accounts of those elaborate ceremonial occasions.

Caron's early training at Beauvais was as a cartoon designer for stained glass. Around 1540 he went to Fontainebleau, where, under the influence of Primaticcio and above all Niccolò dell'Abate, he acquired his basically Italianate style. He became painter to Catherine de' Medici—her favorite, it is said—making something of a specialty of painting and planning royal festivals.

The contemporary taste for water spectacles is reflected in two of Caron's drawings, including the Morgan sheet. The water festival at Fontainebleau was not as elaborate as the one enacted at Bayonne a year later. That one was designed to underscore the historic meeting of the French and Spanish courts. France had just signed the Treaty of Amboise concluding the first of the religious wars between Protestants and Catholics. In a misguided effort to stress peace and plenty in the realm and play down the discord and depletion, Catherine

embarked in 1564 with her son Charles IX on a *grand voyage du court,* accented with elaborate feasts and culminating in the entertainments at Bayonne. Where Catherine de' Medici's policy toward the Protestants was moderate—she had offered them the Edict of Toleration—that of her powerful son-in-law, Philip II of Spain, was not in the least conciliatory. Philip himself did not go to Bayonne. Instead he sent his wife and the duke of Alba with specific directions to offer the French court only an alliance to stamp out heresy. This frustration of the political goals, however, does not seem to have diminished the splendor of the Bayonne festivities according to contemporary accounts.

At the end of several days of festivities the water spectacle was presented as the *pièce d'occasion.* The Library's drawing summarizes what one account tells us: the notables of both courts boarded a magnificent boat in the shape of a castle and sailed through various canals to an island in the river, witnessing spectacles along the way. The first tableau was a mock whale hunt, which lasted half an hour; then the spectators saw six tritons, dressed in cloth of gold, playing trumpets on the back of a huge sea turtle. Next came Neptune in a great chariot pulled by sea horses, followed by Arion on a dolphin's back and three sirens who sang songs celebrating Charles IX's meeting with his sister, Elisabeth de Valois, the queen of Spain. After this they landed on the island, where shepherds and shepherdesses served a banquet, which was followed by a ballet danced by nine nymphs to the accompaniment of six violins; then the royal party returned as they had come.

Black chalk, pen and brown ink, and some black ink, gray-brown wash, heightened with white

13 x 19⅜ inches (348 x 492 mm)

Watermark: none visible through lining

Provenance: P. & D. Colnaghi and Co., London.

Bibliography: Ehrmann 1956a, p. 10; Ehrmann 1956b, pp. 118f.; Ehrmann 1956c, p. 98, fig. 2; PML/*FR,* VII, 1957, pp. 65ff., repr.; Ehrmann 1958, pp. 54, 57, fig. 7; Yates 1959, pp. 3-4, 15, 54, 56-57, 131 n. 2, pl. Xa; PML 1969, p. 136; Morel 1973, no. 51, repr.; Strong 1973, pp. 137-38, fig. 104; Yates 1975, same as 1959 ed.; Graham and Johnson 1979, pp. 59-60, 63-64, fig. 24; Strong 1984, pp. 100-101, 107-8, fig. 74; Ehrmann 1986, p. 193, figs. 168, 211.

Exhibitions: New York PML 1981, no. 28, repr.; New York PML 1984, no. 4, repr.

Purchased as the gift of the Fellows

1955.7

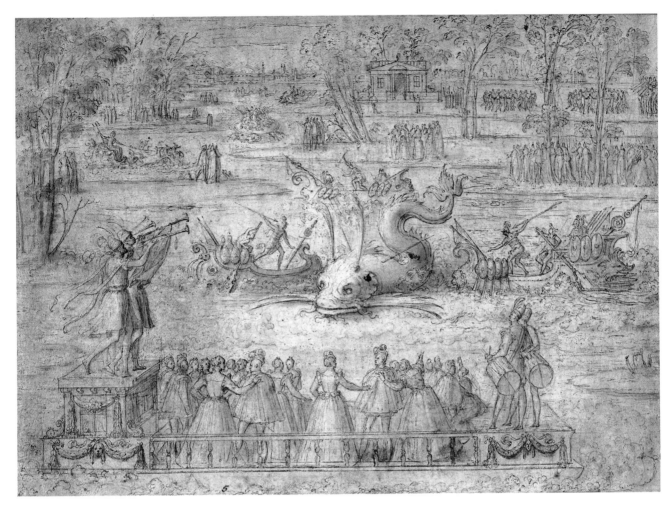

6 The Water Festival at Bayonne, June 24, 1565

School of Fontainebleau

MID-SIXTEENTH CENTURY

7 Seated Figure of Faith

WHILE THE UNDENIABLY Bolognese character of this beautiful drawing has resulted in its attribution to three draughtsmen of Bolognese origin or inspiration, definitive identification of the draughtsman still remains open. The drawing entered the collection in 1961 as by Primaticcio, an identification which at the time was supported by notable specialists including Philip Pouncey, who saw the drawing when he visited New York in 1965, and Sylvie Béguin (Paris and Ottawa 1972-73). As Felice Stampfle noted (PML/FR, XI, 1961), the figure represents Faith, one of the theological virtues; her attribute of the chalice, while only lightly outlined, is clearly visible. Primaticcio is known to have designed several series of the virtues during his long career in France. Most significant for our drawing is a gallery at the Hôtel de Montmorency, rue Sainte-Avoie, Paris, painted by Niccolò dell' Abate after the designs of Primaticcio, which included representations of the virtues (now known only through the prints of René de Guerineau). Niccolò is first mentioned as being in France in 1552, and the Morgan drawing might have served as one of the models for the decoration of the Hôtel de Montmorency.

Later, in an article in the Emilian catalogue (Bologna and elsewhere 1986-87), Mme Béguin reattributed the drawing to Ruggiero de' Ruggieri, Primaticcio's close follower, a hypothesis supported by the old inscription on the drawing, *Rugiero del' Abati*. Most recently, in 1985, Dominique Cordellier in his exhaustive article on Toussaint Dubreuil has attributed the Morgan drawing to that artist. While Cordellier's attribution is plausible, it is made in the context of a thorough reappraisal of Dubreuil, and our drawing is grouped with many drawings that Cordellier reassigns to the artist; he does not deal with the attributions to Primaticcio and Ruggiero. Certain aspects of the draughtsman's technique suggest that Niccolò dell' Abate might also qualify as a candidate. For these and many reasons, the drawing is exhibited here under the classification School of Fontainebleau in the hope that something definitive may come to light over the course of the exhibition.

It is interesting that the artist changed the figure's head by pasting a second version over the first. Felice Stampfle speculated that the paper for the second version of the head might have come from one of the upper corners of the sheet, thus accounting for the tapered shape of the drawing.

Black chalk, heightened with brushed white, on light gray-brown paper. The artist has made a change in the head by pasting a second version over the first.

12 x 7 inches (304 x 177 mm)

Inscribed at lower left in pen and brown ink over an earlier inscription in chalk: *Giovanni Battista da Bologna;* in pencil and ink at lower right: *Rugiero del'Abati*

Provenance: Sir Peter Lely (Lugt 2092); sale, London, Sotheby's, 22 February 1961, lot 33 (one of four drawings); H. M. Calmann, London.

Bibliography: PML/FR, XI, 1961, pp. 75-78, repr.; PML 1969, p. 162; Cordellier 1985, nos. 9, 10, fig. 5, p. 28 n. 21; Béguin in Emiliani 1982, pp. 53-54; Bologna and elsewhere 1986-87, p. 28; Cleveland and elsewhere 1989, under no. 3, fig. 3a (as Toussaint Dubreuil [?]).

Exhibitions: New York 1965-66 I, no. 96 (as Primaticcio), repr.; Paris and Ottawa 1972-73, no. 186 (as Primaticcio), repr.

Purchased as the gift of the Fellows

1961.15

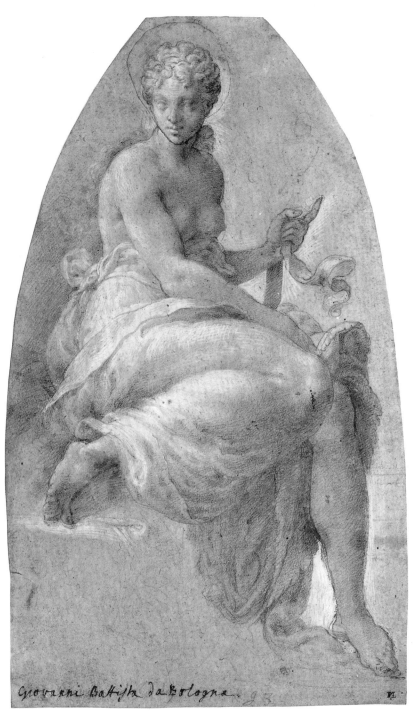

7 Seated Figure of Faith

Maître de Flore

WORKING AT FONTAINEBLEAU,
SECOND HALF OF THE SIXTEENTH CENTURY

8 Procris and Cephalus

PROCRIS AND CEPHALUS, the subject of this drawing, is taken from Ovid's *Metamorphoses* and exemplifies the preference for mythological subjects and mannerist style of the School of Fontainebleau. Charles Sterling recognized that the drawing (Morgan 1959) was by the anonymous master known as the Maître de Flore, whose small oeuvre includes at least two paintings with the goddess Flora as subject. One, *The Triumph of Flora*, is in the collection of Count Canera di Salasco, Vicenza, while the other, the present location of which is unknown, depicts *Flora and Zephyr*. The same master also painted *The Birth of Cupid* now in the Metropolitan Museum of Art, New York, *Venus and Cupid* in the Fine Arts Museums of San Francisco, and *The Concert* in the Louvre. This drawing is a copy of a painting from the ballroom at Fontainebleau.

Here, the artist has illustrated Ovid's tale of the doomed young couple whose marriage ended tragically (*Metamorphoses*, 7: 795-866). The Amazon Procris gave her husband, the hunter Cephalus, a magic spear which never missed its mark. In the drawing, Cephalus has just unknowingly hurled the spear at his wife Procris and killed her. Procris, who had concealed herself in the forest to spy on Cephalus, attempts to remove the spear from her breast. Cephalus, unaware of what has happened and still armed with a bow and quiver, is seen in the forest background, his hunting dog at his side.

It is not known whether the drawing was made in connection with a painting or a tapestry. The figure of Procris is more finished in contrast to the diffuse painterly background of the forest and shrubbery against which the scene is set. While the unknown artist has absorbed the Bolognese manner brought to Fontainebleau by Primaticcio and (as seems especially evident in this case) Niccolò dell'Abate, it is apparent that he is a northerner.

Brush and brown wash, some pen and brown ink, heightened with white, over preliminary indications in black chalk

8⅝ x 12⅛ inches (219 x 308 mm)

Watermark: none visible through lining

Provenance: Comte de Southesk (according to Paris and Ottawa 1972-73); Henry Reitlinger (Lugt S. 2274a); his sale, London, Sotheby's, 14 April 1954, lot 307; Mr. and Mrs. Germain Seligman, New York.

Bibliography: Fröhlich-Bum 1923, p. 207, pl. 102 (3); Mongan 1959, no. 51, repr.; Béguin 1960, pp. 73, 141 n. 60; Béguin 1961, no. 1, pp. 301-2; Béguin and Vitz-thum 1970, p. 85, pl. XVIII (in color); Béguin 1972a, nos. 210-11, pp. 12-19, 80-81, repr.; Béguin 1972b, pp. 401-8, repr.; Richardson 1979, no. 55, repr.; PML/*FR*, XIX, 1981, p. 202.

Exhibitions: Bern 1949; Rotterdam and elsewhere 1958-59, no. 11, pl. 8; Paris and Ottawa 1972-73, no. 132, repr.; Ottawa 1973, no. 132, repr.; New York PML 1981, no. 29, repr.; New York PML 1984, no. 5, repr.

Purchased as the gift of the Fellows with the special assistance of Miss Alice Tully, Miss Julia P. Wightman, and the Thorne Foundation

1978.34

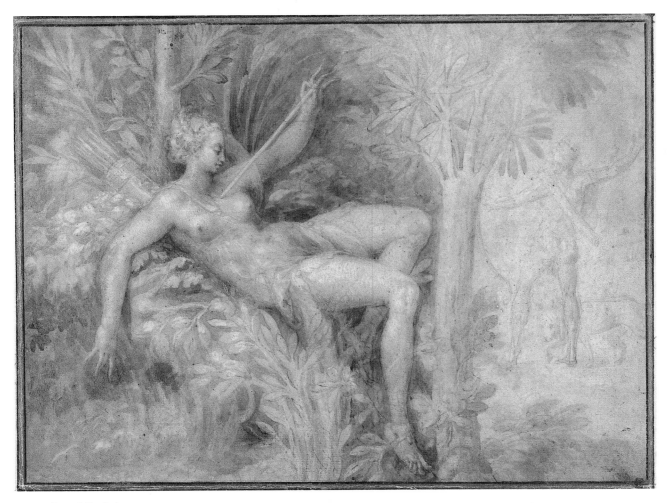

8 Procris and Cephalus

Ambroise Dubois

ANTWERP 1543 – 1614 FONTAINEBLEAU

9 Toilet of Venus or Psyche

THIS DRAWING entered the Morgan Library in 1910 as School of Parmigianino. While it owes much to the Parma mannerist school, it is in fact the work of Ambroise Dubois, a French artist of Flemish extraction who worked at Fontainebleau (the discovery of Mme Sylvie Béguin in 1959).

Born Ambrosius Bosschaert in Antwerp, Dubois was in his twenties when he came to France and to Fontainebleau, where he was greatly influenced by the work of Primaticcio and one of his chief French collaborators, Toussaint Dubreuil.

While Dubois's drawing style has not been fully explored, it is especially noteworthy for its sensitive use of red chalk, as striking as it is lush. Dubois executed two paintings of Psyche that are now known only through an inventory of 1692, and the Morgan sheet might be connected with one of these. That the drawing is preparatory rather than a replica of one of the paintings is indicated by the presence of the *pentimento* in the water jar to the right of Psyche. A painted replica of the Morgan composition, formerly in the collection of Anthony Blunt and presumably a copy of the lost painting, is now in the Musée National du Château de Fontainebleau (repr. Stampfle 1991, fig. 23).

Red chalk, pen and red ink, red wash, heightened with white. Slight repairs at upper center and along right margin

Verso: *Profile Bust of a Woman,* offset in red chalk

13⅞ x 10¹/₁₆ inches (353 x 256 mm)

Watermark: none

Inscribed on verso, at lower center, in graphite, *1450;* below at right, in another hand, *Francesco Mazzuoli, Parmigiano / 1503-1540*

Provenance: Nicolas Lanier (Lugt 2885); Charles Fairfax Murray; J. Pierpont Morgan (no mark; see Lugt 1509).

Bibliography: Fairfax Murray 1905-12, I, no. 50, repr. (School of Parmigianino); Fröhlich-Bum 1921, p. 138, fig. 156; Béguin 1959, pp. 164-68, 168 n. 1, fig. 1; Béguin 1960, pp. 125, 129, repr.; Béguin 1966, pp. 10, 12, 67 n. 24, fig. 11: Béguin and Bessard 1968, p. 56, fig. 56; Lossky 1969, p. 312; Béguin 1970, p. 86, pl. XXXII; Blunt 1973, pp. 38, 41 n.7; Lugt 1968, p. 80 under no. 324; New York and Edinburgh 1987, under no. 14; Stampfle 1991, no. 41, repr.

Exhibitions: Paris and Ottawa 1972-73, no. 90, repr., under no. 92, fig. 204; New York PML 1984, no. 6; Cleveland and elsewhere 1989, no. 3, repr.

I, 50

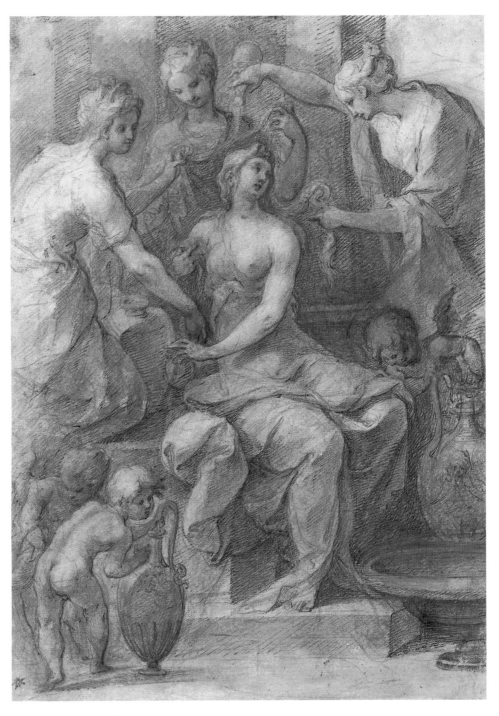

9 Toilet of Venus or Psyche

Daniel Dumonstier

ANTWERP 1574 – 1646 PARIS

10 Portrait of a Gentleman of the French Court

THIS LARGE if not life-size portrait is typical of the work of Daniel Dumonstier, one of a family of artists active in the production of chalk portraits from the mid-sixteenth to mid-seventeenth centuries. Although Dumonstier dated his work at the upper right of the sheet, he did not identify the man who sat to him. In this connection, Mariette says of him, "Il avoit coutume de mettre sur ses portraits l'année et le jour qu'il les avoit fait. Il seroit à souhaiter qu'il eût écrit de même le nom des personnes; ses portraits en seroient plus intéressans, mais c'est ce qui ne lui arrive presque jamais....Il occupoit un logement aux galeries du Louvre" (Mariette, II, p. 131).

The 1955 sale catalogue in which this portrait was sold notes that the sitter is "said to be the Constable de Montmorency." While this identification cannot be substantiated, an old, and probably contemporary inscription on the back of the original mount of the drawing, *M. de Porchere,* may identify Dumonstier's subject as the poet François d'Arbaud de Porchères, then active at court, or another poet, Honoré Laugier de Porchères, contemporary (confusingly) with Arbaud de Porchères. Born in 1590 in Saint-Maximin in Provence, Arbaud de Porchères studied with the poet Malherbe. He died in 1640. Laugier de Porchères's most famous works are the odes addressed to Louis XIII and to Cardinal Richelieu. It is interesting to quote part of the ode to the king in this connection:

> Ces vers, où je peins ton image
> D'un crayon si vif et si beau
> Que le portrait du plus grand homme
> Qu'ait mis au jour la vieille Rome
> N'égalera point ce tableau.

This portrait was sold along with two other examples of Dumonstier's portraiture, one of which, lot 17, *Portrait of a Cardinal,* is in the collection of the National Gallery of Canada, Ottawa (repr. Cleveland and elsewhere 1989, no. 50).

Black, red, yellow, and white chalks

19¼ x 14⅞ inches (488 x 378 mm)

Watermark: none

Dated by the artist at upper right, in red chalk, *ce 31 Aust 1628;* inscribed on back of old mount, in pen and brown ink, in a contemporary hand, *M. de Porchere*

Provenance: sale, London, Christie's, 28 July 1955, lot 14 (said to be a portrait of Constable Montmorency); London, P. & D. Colnaghi and Co. (sold for 180 pounds).

Bibliography: PML/*FR*, VII 1957, p. 68.

Exhibitions: London 1956, no. 3; New York PML 1984, no. 7.

Purchased as the gift of John M. Crawford, Jr.

1956.9

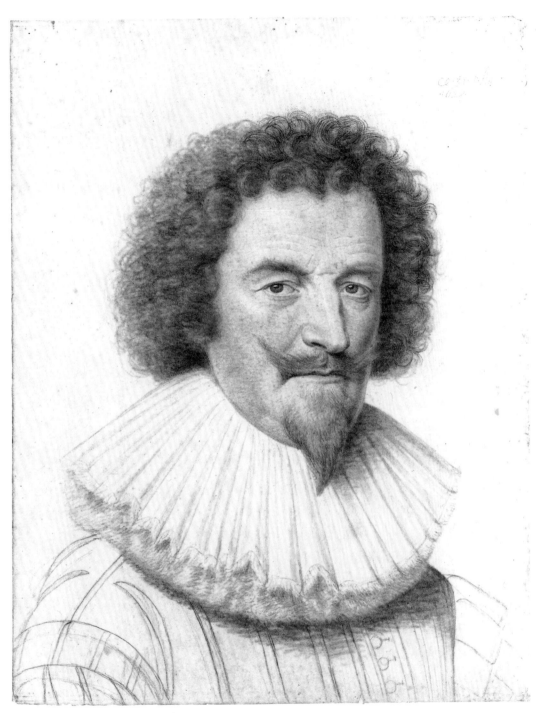

10 Portrait of a Gentleman of the French Court

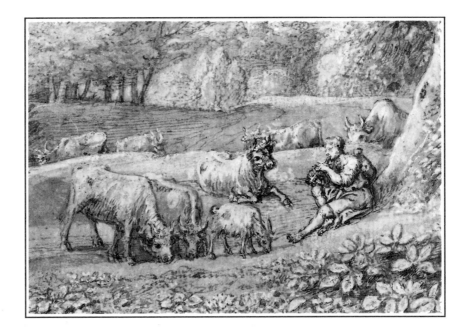

Seventeenth Century

Jacques Bellange

NANCY 1575 – 1616

11 The Hunter Orion Carrying Diana on His Shoulders

IN 1606 Bellange was at work on a series of hunting scenes for the ducal palace gallery at Nancy, and in 1611 he was involved in depicting scenes from Ovid to decorate another gallery in the same residence. The highly personal style of the artist is well exemplified in *The Hunter Orion Carrying Diana on His Shoulders*. The subject is depicted in an elegant, almost choreographic pose. Astride Orion's shoulders sits the lithe and slender goddess, adorned with draperies at the shoulder and armed with a bow and quiver.

Although Nicole Walch has made a case for the work's being a representation of the blind Orion carrying Kedalion, this alternative identification seems unconvincing in light of Bellange's related etching (Robert-Dumesnil 1835-71, XI, 36) where Diana is represented with her traditional attributes of quiver and bow. Moreover, Bellange's etching has some dependence on Giorgio Ghisi's print of 1553 after Luca Penni (Bartsch XV, 43), in which the same subject is similarly depicted.

Pen and brown ink, brown wash; extraneous spots of red chalk and green paint

13¾ x 7⅞ inches (350 x 200 mm)

Watermark: none

Inscribed at lower right corner, in pen and brown ink, *Belange*

Provenance: private collection, England; P. & D. Colnaghi and Co., London; John S. Thacher.

Bibliography: Pariset 1950, pp. 351f., fig. 302; Shoolman and Slatkin 1950, p. 34, pl. 20; Eisler 1963, p. 35; Pariset 1965, p. 65; Vienna 1967-68, p. 254, under no. 380; Walch 1971, p. 142, no. 165; PML/*FR*, XVI, 1973, pp. 96ff., pp. 108ff., pl. 21; Frankfurt 1986-87, p. 14, under no. 7; New Haven 1987, p. 22 n. 7; Young 1990, pp. 272-73, repr.

Exhibitions: Pittsburgh 1951, no. 137; New Haven 1956, no. 188; Rotterdam and elsewhere 1958-59, no. 14, pl. 13; New York PML 1974, no. 24; Des Moines and elsewhere 1975-76, pp. 30-31, no. 10, repr.; New York PML 1981, no 48, repr.; New York PML 1984, no. 13, repr.; Cleveland and elsewhere 1989, no. 4, repr.

Purchased as the gift of the Fellows

1971.8

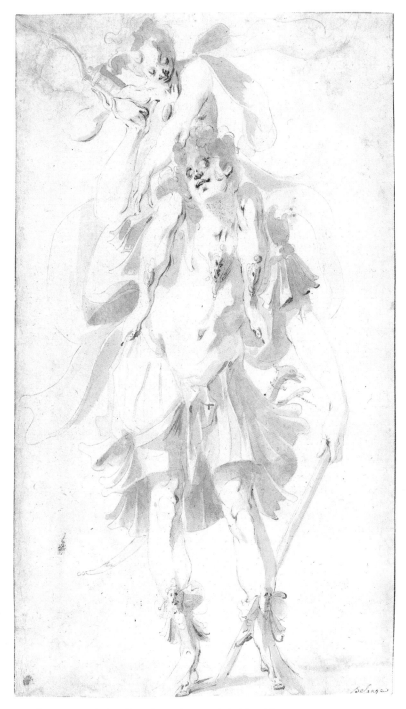

11 The Hunter Orion Carrying Diana on His Shoulders

Claude Deruet

NANCY CA. 1588 – 1660 NANCY

12 Mounted Amazon with a Spear

DERUET'S *AMAZON* entered the Library with an attribution to Bellange based on a nineteenth-century inscription on the drawing as well as another on the old lining paper (where the female warrior was misidentified as Joan of Arc). This is not surprising considering that Deruet was apprenticed to Bellange before he went to Italy to study and in fact succeeded him as court artist of the duchy of Lorraine. The Lorraine School has not been much studied until recently, and there is still much to do in order to properly illuminate this shadowy area of early seventeenth-century French painting. In 1964, not too many years after the Library's acquisition of the sheet, Germain Viatte connected it with a drawing of two mounted Amazons in the Nationalmuseum, Stockholm, and reattributed it to Deruet. Both drawings must be connected with Deruet's series of paintings depicting battles of the Amazons, including four at the Musée des Beaux-Arts, Strasbourg, and another set, now dispersed, two of which are in the Metropolitan Museum of Art, New York, and the other two in a museum in La Fère. As Hilliard Goldfarb noted in his entry for the Morgan sheet (Cleveland and elsewhere 1989, no. 8), both this drawing and the one in Stockholm are closer stylistically to the earlier set of paintings, suggesting a date around 1620, just after the artist's return from Italy.

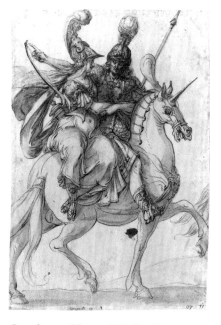

Couple on a Horse. *NM H 178/1863, National Swedish Art Museums*

Pen and brown ink with a yellowish-brown wash containing minute flecks of gold, also in some passages traces of greenish pigment; traces of under-drawing in black chalk

14¼ x 12⅜ inches (362 x 313 mm)

Watermark: none

Inscribed at lower left, possibly in a nineteenth-century hand, in black chalk, *Belange*

Provenance: Kaye Dowland (Lugt 691) (according to an inscription in pen and brown ink on old lining paper, now removed: *Joan of Arc/by/Belange/Kaye Dowland/1862);* P. & D. Colnaghi and Co., London.

Bibliography: PML/*FR,* X, 1960, p. 53; Viatte 1964, p. 222, fig. 3; Pariset 1965, p. 65 n. 2; Roethlisberger 1965, p. 143; Pariset 1967, p. 13, fig. 5; PML 1969, p. 141; Rosenberg 1971, p. 87; Bjurström 1976, under no. 354; Rome and Nancy 1982, p. 49; New York and Edinburgh 1987, p. 44, under no. 18.

Exhibitions: Providence 1970, no. 114; New York PML 1984, no. 8; Cleveland and elsewhere 1989, no. 8, repr.

Purchased as the gift of the Fellows

1959.4

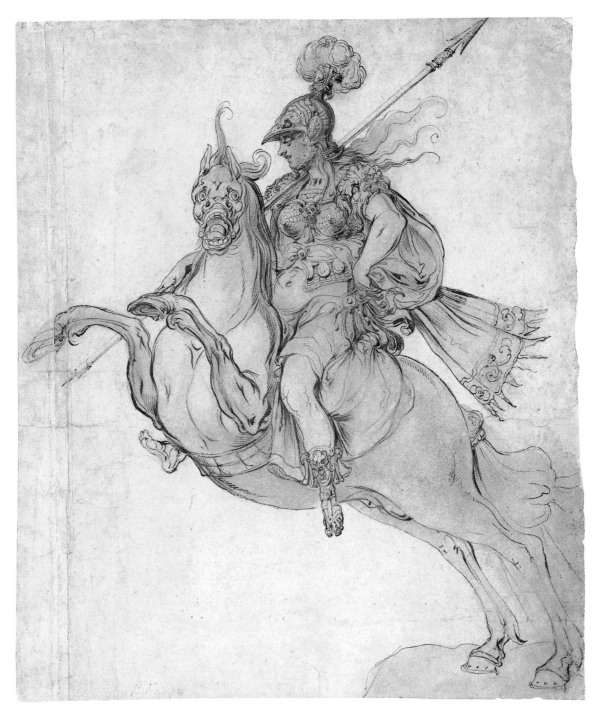

12 Mounted Amazon with a Spear

Simon Vouet

PARIS 1590 – 1649 PARIS

13 Study of a Woman Seated on a Step with Another Study of Her Right Hand

WHILE IT HAS not been possible to connect this study with a known work by Vouet, the pose and type of the woman recur frequently in Vouet's work. She is, for instance, reminiscent of the angel in the *Three Maries at the Sepulchre* and also shares a similarity of pose and gesture with one of the daughters in the painting of *Lot and His Daughters,* in the Musée des Beaux-Arts, Strasbourg (repr. Paris 1987, p. 80, under no. XXXV). She resembles Omphale in *Hercules and Omphale* except that the position of her legs and right arm is different. From her position and the angle of foreshortening it seems clear that the woman was designed to be seen from below, on a ceiling or overdoor. However, she might also have been a preparation for a figure in one of Vouet's tapestry designs; many such drawings that served this purpose survive. Although this figure is nowhere to be found in a composition such as *Moïse sauvé des eaux* (repr. Paris 1987, p. 68, under no. XXIV), the study could well have served for one of the pharaoh's daughter's handmaidens in just such an Old Testament subject.

Black chalk, some white heightening, on light brown paper

Verso: Slight sketch of a reclining woman

9⅝ x 13 inches (244 x 330 mm)

Watermark: none

Provenance: Germain Seligman (stamp at lower right); Mrs. Herbert N. Straus.

Bibliography: PML/*FR,* XVII, 1978, p. 295.

Exhibitions: New York PML 1984, no. 9; Paris 1987, pp. 73-77, no. XXIX, repr.

Bequest of Therese Kuhn Straus in memory of her husband, Herbert N. Straus

1977.59

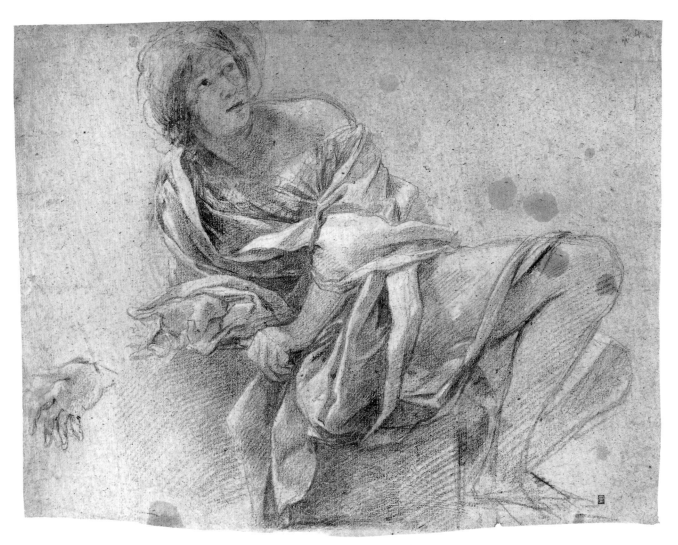

13 Study of a Woman Seated on a Step with Another Study of Her Right Hand

Jacques Callot

NANCY 1592 – 1635 NANCY

14 The Miracle of St. Mansuetus

THERE ARE FOUR KNOWN STUDIES for Callot's etching *The Miracle of St. Mansuetus*. Aside from the present sheet, the other studies are at the Musée Historique, Nancy, the Museum of Fine Arts, Boston, and the Nationalmuseum, Stockholm. The somewhat obscure St. Mansuetus was a fourth-century Scottish bishop sent to Lorraine to convert the pagan community to Christianity. The event here depicted is the recovery from the river of the body of the son of the governor of Toul, a town on the Moselle in Lorraine. The actual miracle concerns the raising of the child from the dead by divine power invoked through the saint's prayers and the resultant conversion of the community to Christianity.

The theatrical ambience of Florence, where Callot received his artistic training, no doubt influenced him in his habit of making several different studies for a work in which the action and poses of the figures undergo changes that a stage director might consider in the manipulation of living actors in a play. The Morgan drawing, second in the sequence of the four studies, shows a marked

Miracle of St. Mansuetus. NM H 2472/ 1863, National Swedish Art Museums

Pen and brown ink, brown wash, over black chalk

Design measuring 8¼ x 7¹⁄₁₆ inches (209 x 180 mm), on sheet measuring 9³⁄₁₆ x 7⅛ inches (233 x 180 mm)

Watermark: none. Numbered in an old hand in pen and brown ink on verso at lower left, *N 4096*

Provenance: Jonkheer Johan Goll van Franckenstein the Younger (Lugt 2987); Jonkheer Pieter Hendrik Goll van Franckenstein (his *no. 4096* on verso); Lord Delamere; his sale, London, Sotheby's, 13 April 1926, lot 362; H. S. Reitlinger (Lugt S. 2274a); his sale, London, Sotheby's, 14 April 1954, lot 294; Mr. and Mrs. Germain Seligman, New York; R. M. Light & Co., Santa Barbara.

Bibliography: Meaume 1860, no. 141; Lieure 1921, no. 378; Freedberg 1957, pp. 41, 43, fig. 3; Paris 1958b, under no. 183; Ternois 1962b, pp. 39 n. 43, III n. 10, 162, and n. 29; Ternois 1962a, no. 571, repr.; New York PML 1969, under no. 84; Richardson 1979, no. 9, repr.; Cleveland and elsewhere 1989, p. 36, under no. 11; Nancy 1992, p. 470 (incorrectly cited as still in the Seligman Collection).

Exhibitions: Bern 1949, no. 110, pl. 35; Providence 1970, no. 58, repr.; Los Angeles 1976, no. 140, repr.; New York PML 1981, no. 49, repr.; New York PML 1984, no. 11.

Purchased as the gift of Mrs. Kenneth A. Spencer

1978.35

14 The Miracle of St. Mansuetus

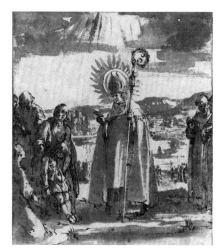 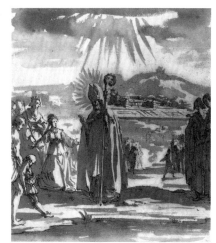

Miracle of St. Mansuetus. *Musée Historique Lorrain, Nancy*

Miracle of St. Mansuetus. *Acc. 56.877, Museum of Fine Arts, Boston*

increase in clarity over the first (Nancy) in the delineation of the figures and the adjustment of their placement. The saint is in the center, his two disciples at the right. To the left, the rescuer is seen holding the drowned boy. The drama of the tableau lies in the contrast between the mixture of hope and uncertainty in the faces of the subsidiary figures and the otherworldliness and conviction of faith that the face of the saint conveys. With hand upraised in the child's direction, he is on the point of performing the miracle of raising the dead. By the time of the third study (now in Boston), the representation of the saint has assumed the features of Msgr. Jean de Porcellet de Maillane, in whose retinue Callot returned from Florence to Nancy in 1621. In the Stockholm sheet, the latest known study for the print, the vertical orientation of the composition has been changed to the horizontal format of the print.

Callot's style here is seen in the transitional phase from Florentine mannerism to the dramatic pictorialism of the early baroque. A full discussion of this sheet in relation to the others in the series and the etching (Meaume 1860, no. 41; Lieure 1921, no. 378) can be found in Anne Blake Freedberg's article (1957). Further confirmation that the work was done after Callot's return to Nancy is provided by Hilliard Goldfarb in his recent work (see Cleveland and elsewhere 1989), where he notes that the view of the town of Toul in the background is much too detailed to have been drawn from memory while Callot remained in Florence.

Nicolas Poussin

VILLERS NEAR LES ANDELYS 1594 – 1665 ROME

15 Ordination

ALTHOUGH THE AUTHENTICITY of the drawing was doubted by Fried-laender and Blunt (1939-74), Blunt later changed his mind about this double-sided study for the sacrament Ordination. Poussin was commissioned to paint the seven sacraments in the 1630s by his learned friend Cassiano del Pozzo, secretary to Francesco Barberini. It is not known whether the idea of painting the sacraments originated with Poussin or with his patron, whose wide circle of friends included not only antiquarians like himself but also philosophical clergymen. It is certain, however, that Poussin was the first artist to conceive of treating the subject in separate paintings. Where other artists had included all the sacraments in one composition, it was Poussin's idea to render each separately, removing, as Walter Friedlaender has said, the subject from the purely liturgical, depicting each in a historical form both precise and ideal. Poussin based four of the sacraments on scenes from the New Testament: the baptism of Christ for *Baptism,* the giving of the keys to St. Peter for *Ordination,* Mary Magdalene washing the feet of Christ for *Penance,* and the Last Supper for the *Eucharist.* In the other three sacraments, *Confirmation, Marriage,* and *Extreme Unction,* Poussin's conception is more general but conforms pictorially to his ideas about early Christian customs.

The sacraments were to become one of the projects by which Poussin was best known in his lifetime and in the years immediately following his death. The first series, except for *Baptism,* was completed by 1637. Less than a decade later, Poussin was asked to paint a second series by Paul Fréart de Chantelou (secretary and cousin of Sublet de Noyer, superintendent of the royal buildings), a friend he had made on his only return visit to France, in the 1640s. Poussin did not repeat his earlier compositions for the second set but radically altered the arrangement of each subject. As Anthony Blunt pointed out in his 1958 Mellon lecture, Poussin freely adapted *Feed My Sheep,* Raphael's tapestry cartoon now in the Victoria and Albert Museum, London, for the composition of the first *Ordination.* Christ is at the left with the apostles in the middle and righthand section of the composition in a frieze-like arrangement. There is something frieze-like about the second *Ordination* too, but this time Christ is seen in the middle flanked by a massive and symmetrical grouping of the apostles. The paintings for the first series were sold in 1785 to the duke of Rutland and went to Belvoir Castle, near Grantham, where five of them remain to the present day.

Penance was destroyed by fire in 1816, and *Baptism* was sold in 1939 (now in the National Gallery of Art, Washington). The Chantelou series was sold to the duke of Bridgewater in 1798 and passed by descent to the earls of Ellesmere and thence to the duke of Sutherland. For some years it has been on loan to the National Gallery of Scotland, Edinburgh, and was the centerpiece of the exhibition *Poussin: Sacraments and Bacchanals,* held there in 1981.

Although Poussin would likely have made a great number of preparatory drawings for such an important project as *The Sacraments,* relatively few have been preserved. The Library's drawing is the only known study for the first *Ordination;* it is very much a working drawing. He began with a tentative sketch for Christ and eight of the apostles on the lower half of what we now consider the verso of the sheet. He then studied Christ's pose and, more specifically, the fall of drapery in two more sketches; both renderings are nearly identical to the figure of Christ as it appears in the finished painting. Christ, left hand raised, holding the keys in his right, is seen striding toward the group of apostles, which fills the middle ground of the composition. Having established Christ's pose in the sketch at the top of the verso, Poussin did not have to repeat the figure in detail in the compositional study at the top of the recto, where he worked out the group of the apostles more fully. Below, he made several studies for individual apostles, but it is this study which most closely approximates the final disposition of the group.

Pen and brown ink

Verso: Another study for the *Ordination* in pen and brown ink and traces of black chalk

5⅞ x 8¹¹⁄₁₆ inches (149 x 220 mm)

Watermark: fragment of a fleur-de-lis within a circle (?)

Inscribed on recto at lower left in pen and brown ink: *Giulio Campi di Cremona*

Provenance: Nicholas Lanier (Lugt 2885); Jonathan Richardson, Jr. (Lugt 2170); Richard Cosway (Lugt 629), not identifiable in his sale; London, Stanley, 14-22 February 1822; George Clausen (Lugt 539); private collection, England; private collection, New York.

Bibliography: Blunt 1966, p. 76, under no. 110; Friedlaender and Blunt 1939-74, V, 1974, nos. 413 (recto) and 414 (verso), pl. 301; Wild 1980, II, p. 75 under no. 76; PML/*FR,* XX, 1984, pp. 219-23, 290-91, pl. 21 (recto).

Exhibitions: New York PML 1984, no. 15; Cleveland and elsewhere 1989, no. 15, repr. (recto and verso).

Gift of a Trustee in honor of Miss Felice Stampfle

1983.8

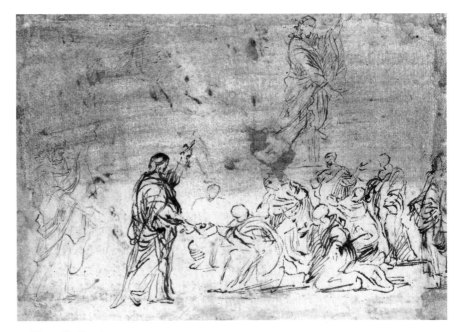

15 *Verso:* Ordination

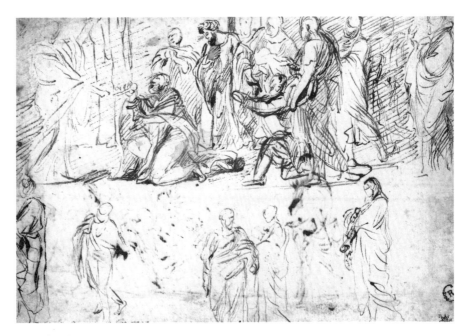

15 Ordination

41

Nicolas Poussin

VILLERS NEAR LES ANDELYS 1594 – 1665 ROME

16 The Death of Hippolytus

SINCE NO PAINTING for this unusual subject, drawn from Ovid's *Metamorphoses* (XV, 497ff.), is known to have survived, it may be—as was suggested by Friedlaender and Blunt (1939-74)—that Poussin made this singularly beautiful drawing as an independent work of art. On the basis of style the work most probably dates to the early 1640s. In the 1630s Poussin worked primarily in line to suggest movement and liveliness, later applying broad areas of wash to model and create dramatic lighting effects. While line and especially brilliant wash are thus used here, Poussin, in the manner of his work of the 1640s, also modeled the figures in the foreground with careful and repeated applications of wash and point of brush.

The subject is somewhat rare in art and depicts the moment after the crash of Hippolytus's chariot, when two witnesses rush to quiet the frightened horses and a third spectator lifts Hippolytus's body out from under the overturned chariot. The two lightly sketched figures seated on the rocks above are probably Theseus and Phaedra, Hippolytus's father and stepmother. The story is continued on the verso with a pen sketch showing Asclepius restoring Hippolytus to life.

16 *Verso:* Asclepius Restoring Hippolytus to Life

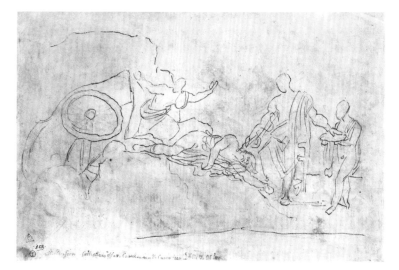

Pen and brown ink, brown wash, over faint indications in black chalk

Verso: Asclepius Restoring Hippolytus to Life in pen and brown ink over black chalk

8⅞ x 13¹/₁₆ inches (224 x 332 mm)

Watermark: none

Provenance: Antonio Cavaceppi (according to Ottley's inscription); Camuccini (according to Ottley's inscription); William Young Ottley; Thomas Dimsdale (Lugt 2426); Sir Thomas Lawrence (Lugt 2445); Robert Staynor Holford (Lugt 2243); Sir John Charles Robinson (Lugt 1433); Charles Fairfax Murray; J. Pierpont Morgan (no mark; see Lugt 1509).

Bibliography: Ottley 1823, no. 80, 2nd plate beyond p. 68; Fairfax Murray 1905-12, I, no. 267, repr.; Shoolman and Slatkin 1950, p. 22, pl. 14; Friedlaender and Blunt 1939-74, III, 1953, no. 222, pl. 169; Moskowitz 1962, III, no. 655, repr.; Blunt 1967, pp. 132f., fig. 124; Blunt 1979, pp. 68ff., figs. 74-75; PML/*FR*, XX, 1984, p. 220.

Exhibitions: London 1835, no. 83; Buffalo 1935, no. 42; New London 1936, no. 54; New York PML 1939, no. 91; Cincinnati 1948, no. 26; Philadelphia 1950, no. 58, repr.; New York PML and elsewhere 1957, no. 91, repr.; New York 1959a, no. 50; Paris 1960, no. 179; New York 1968-69, no. 30, repr.; Stockholm 1970, no. 49, repr.; New York PML 1981, no. 50, repr.; New York PML 1984, no. 14, repr.

I, 267

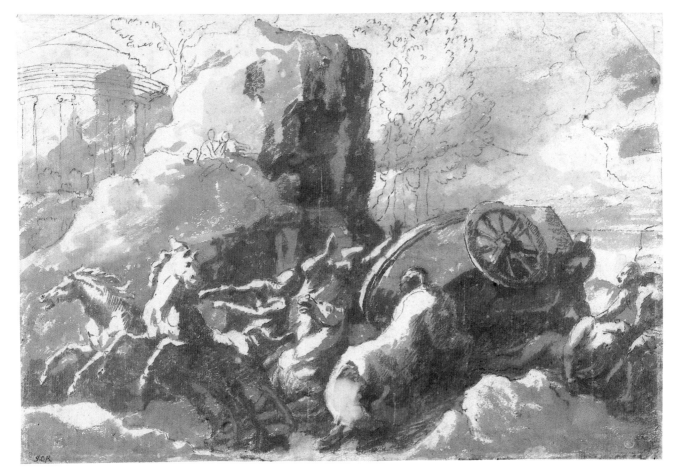

16 The Death of Hippolytus

Nicolas Poussin

VILLERS NEAR LES ANDELYS 1594 – 1665 ROME

17 The Holy Family

THIS IS ONE OF THREE surviving studies for the painting *The Madonna of the Steps,* which is known in two versions, one in the National Gallery of Art, Washington, and the other of around 1648 in the Cleveland Museum of Art. The Morgan sheet, which occupies a middle position between the preliminary sketch in the Musée des Beaux-Arts in Dijon and the drawing in the Louvre, is striking in the richness of its dark washes, the brilliant effect of the lighting of the group from below, and the intricate but sound construction of the composition. Here the figures are posed in a broad triangular composition on the first step of a short flight of stairs that raises them to a *sotto di sù* viewpoint. The steps, a pillar with potted plant, and the screening wall indicate a partition of the space by intersecting planes, a structural device noted by Friedlaender and Blunt (1939-74) as typical of Poussin at this time. The Morgan drawing lacks a few of the major elements of the painting, notably the flight of stairs in the background

The Holy Family on the Steps. *CMA 81.18. The Cleveland Museum of Art*

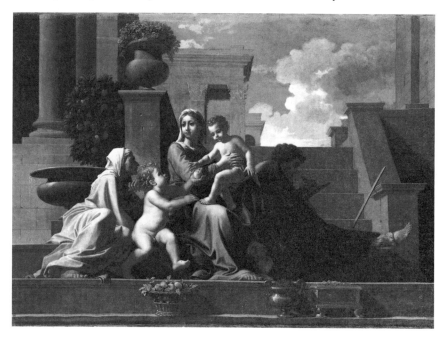

Pen and brown ink, brown and brown-gray wash over slight indications in black chalk

7¼ x 9⅞ inches (184 x 251 mm)

Watermark: none visible through lining

Provenance: Paul Fréart de Chantelou (Lugt 735); Sir John Charles Robinson (Lugt 1433); Charles Fairfax Murray; J. Pierpont Morgan (no mark; see Lugt 1509).

Bibliography: Fairfax Murray 1905-12, III, no. 71, repr.; Friedlaender and Blunt 1939-74, I, 1939, no. 46, pl. 30; Shoolman and Slatkin 1950, pp. 24-25, pl. 15; Vallery-Radot 1953, p. 191; Kauffmann 1960b, pp. 43-49, 56, pl. 3; Kauffmann 1960a, I, p. 147; Vermeule 1964, p. 115; Blunt 1966, p. 40, under no. 53; Einem 1966, pp. 37-39, 44, fig. 25; Hibbard 1974, pp. 73-76, 79, fig. 46; Paris 1977-78, p. 178, under no. 159; Blunt 1979, pp. 55-56, 71, 73, fig. 82; Wild 1980, II, p. 128, under no. 138; Lurie 1982, pp. 667-68, fig. 5; PML/*FR*, XX, 1984, p. 220.

Exhibitions: New York 1939; New York PML 1939, no. 89; Cincinnati 1948, no. 25, repr.; Rotterdam and elsewhere, 1958-59, pp. 42-43, no. 30, pl. 19.; Paris 1960, no. 213; New York PML 1981, no. 51, repr.; New York PML 1984, no. 17; Cleveland and elsewhere 1989, no. 21, repr.

III, 71

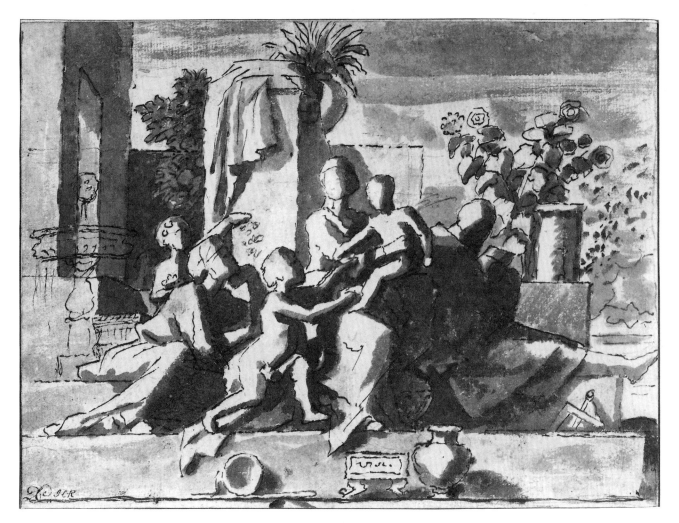

17 The Holy Family

behind St. Joseph at the right of the composition, and was probably executed shortly before the painting (see Friedlaender and Blunt 1939-74, I, 1939, pp. 25ff., for a discussion of the entire group of related drawings). In recent scientific examination, it was revealed that some of the features in the Louvre drawing, such as the elements at the far left of the composition and architectural elements visible above the banister at the right, not visible to the eye in the Cleveland painting, were originally incorporated in the preliminary sketch on the canvas of this picture. This indicates that the latest of the surviving drawings, that in the Louvre, is very likely close to the final transfer of Poussin's thoughts as recorded on paper to his beginning work on the canvas. The presence of the underdrawing constitutes incontrovertible evidence of the authenticity of the Cleveland picture, which had been in question.

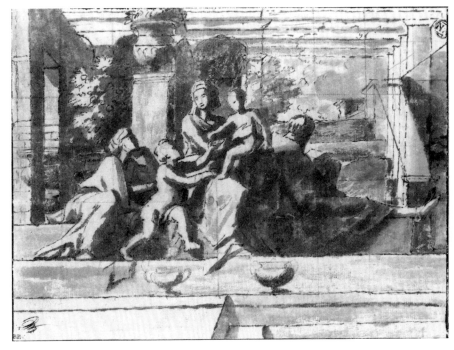

The Holy Family. *Inv. 321.39. Musée du Louvre*

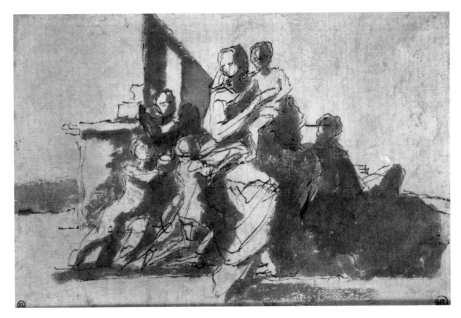

La Sainte Famille. *CA 970, Musée des Beaux-Arts de Dijon*

47

Jacques Stella

LYON 1596 – 1657 PARIS

18 The Angel Appearing to St. Joseph in the Carpenter's Shop; the Virgin Reading Beyond

THIS DRAWING is one of a suite of twenty-two highly finished drawings illustrating the life of the Virgin that remained intact until they were sold at auctions in London and New York in 1986 and 1987. The artist, who belonged to the French expatriate community in Rome, made them fairly late in his life with the intention of having them translated into prints. In fact, two sets of engravings were made after these subjects. The first series (which is very rare) was made by Antoinette Bouzonnet-Stella, one of the artist's nieces, after line drawings by the artist. Much later, in the eighteenth century, Francesco Polanzani and Alessandro Mocchetti made a set of engravings and deliberately misrepresented the author of the designs on which the engravings were based as being Poussin. This rather famous attempt to defraud the public came about in the first place because of the close connection between Stella and Poussin, who were good friends, first in Lyon and then in Rome. Polanzani went so far as to inscribe his engravings after the life of the Virgin as having been designed by Poussin and printed a broadsheet with the certified endorsements of all of the principal artists active in Rome at the time to accompany the set of engravings.

This trickery was first noticed by P. J. Mariette, who mentioned it to a friend, Giovanni Bottari. Anthony Blunt put together the story of the entire album and the intrigue surrounding its later history in 1974.

Francesco Polanzani, The Angel Appearing to St. Joseph in the Carpenter's Shop; The Virgin Reading Beyond. *Acc. no. 1990.5. The Pierpont Morgan Library*

Pen and brown ink, gray wash, over black chalk; ruled border in pen and brown ink

Sheet: 14½ x 10⁷⁄₁₆ inches (368 x 265 mm). Design area: 11¹⁵⁄₁₆ x 8¼ inches (300 x 210 mm)

Watermark: crowned shield with three fleurs-de-lis

Provenance: the artist's niece, Claudine Bouzonnet-Stella; by descent to Michel de Masso; Gaetano Minossi Romano; Thomas Talbot of Margam Abbey; by descent to Christopher Methuen-Campbell of Penrice Castle, Glamorgan; his sale, London, Christie's, 9 December 1986, lot 129, repr.

Bibliography: Blunt 1974, pp. 745ff. (discussion of entire album); PML/*FR*, XXI, 1989, p. 381.

Purchased on the Director's Fund in honor of Mrs. Charles Wrightsman

1986.114

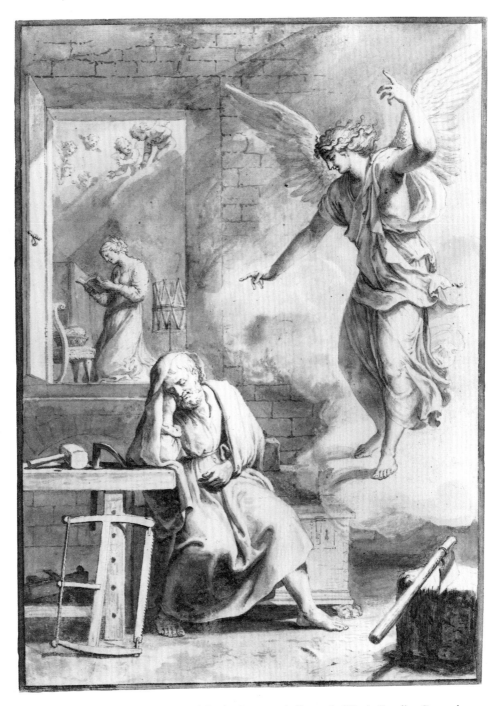

18 The Angel Appearing to St. Joseph in the Carpenter's Shop; the Virgin Reading Beyond

Jean de Saint-Igny

ROUEN END OF THE SIXTEENTH CENTURY – 1647 ROUEN

19 The Sense of Taste

IT WAS CHRISTOPHER COMER who discovered that this drawing, which for many years was kept under the name Jacques Bellange, was actually the work of Jean de Saint-Igny, a somewhat younger artist who was born in Rouen around the turn of the seventeenth century. Apprenticed in his native city, Saint-Igny became a master in 1635 and worked in Paris with Abraham Bosse. He was strongly influenced by the second School of Fontainebleau and the Lorraine School, and his work consequently shows the strong influence of Bellange and Vignon and of the Flemish School. The Morgan drawing is one of a series of drawings of the Senses, previously attributed to Bellange by reason of their obvious connection to the drawing *The Sense of Smell* in the Ecole des Beaux-Arts, Paris, which had been attributed to Bellange by Pierre Lavallée. Also included in the group are two drawings in Berlin, representing the sense of sight and the sense of hearing. Only *The Sense of Touch* in this series has yet to come to light.

Comer's research has led him to reattribute more than forty drawings of heads in red chalk from Bellange to Saint-Igny. Some of these, he has found, are related to Saint-Igny's paintings, such as the *Adoration of the Shepherds* and *Adoration of the Magi* (repr. Rosenberg 1966, nos. 120-21) and to prints in Saint-Igny's *Elemens de pourtraiture ou La Metode de representer et pourtraire toutes les parties du corps humain par le sieur de S. Igny* (one is repr. in Cleveland and elsewhere 1989, p. 154, fig. 76c). An excellent summary of these developments can be found in Hilliard Goldfarb's recent exhibition catalogue (Cleveland and elsewhere 1989, no. 76).

Red chalk

10¼ x 7⅝ inches (260 x 194 mm)

Watermark: partial, indecipherable name (six letters)

Provenance: A. Freiherr von Lanna, Prague (Lugt 2773); Enghert, Vienna; Dr. Arthur Feldmann, Brünn; Charles E. Slatkin Gallery, New York.

Bibliography: Steiner 1932, p. 47; Wescher and Rosenberg 1933, p. 37; PML/ FR, IV, 1953, pp. 62-63; Comstock 1953, p. 134, repr.; PML 1969, p. 131; Rosenberg 1971, p. 81, pl. II; Bergot 1972, p. 60, under no. 78; Toronto and elsewhere 1972-73, p. 132, under no. 5; Schleier 1981, p. 85.

Exhibitions: Rotterdam and elsewhere 1958-59, pp. 34-35, no. 13, pl. 12; New York PML 1984, no. 12 (as Bellange); Cleveland and elsewhere 1989, no. 76, repr. (as Saint-Igny).

Purchased as the gift of Mr. Walter C. Baker

1953.2

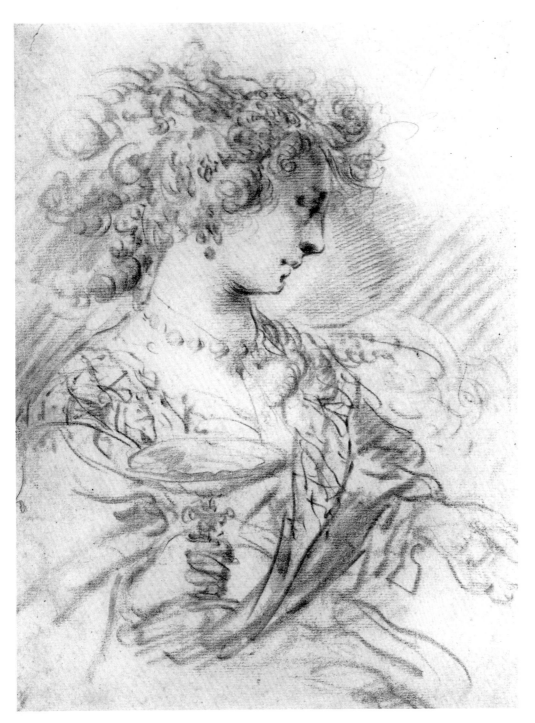

19 The Sense of Taste

Claude Gellée, called Claude Lorrain

CHAMAGNE 1600 – 1682 ROME

20 A Hilly Landscape, with Bare Trees

IT IS DIFFICULT to determine the setting of this particular landscape, although the sheet was once part of the artist's Tivoli book, so called because nearly all of the approximately seventy sheets once included depict Tivoli or its environs. Claude appears to have taken this particular sketchbook with him on his excursions to Tivoli, outside Rome, over a two-year period, between 1639 and 1641. None of the drawings from the book is dated, but some are connected with paintings of this period, and it is known that the view of St. Peter's (once included in the book) dates between 1640 and 1641. Many are signed on the verso in red chalk with an abbreviated version of Claude's name and the letters *R. IV*, which has been interpreted as *Roma in urbe*, "Claude in the city of Rome." The artist numbered the drawings in the sequence they appeared in the book.

No. 13, the Morgan sheet, is unusual in its late autumnal or wintry subject matter, indicated by the bare trees at the right that anchor the center of the composition. Most of the time Claude sketched outdoors in better weather. The drawing is in exceptional condition and must have remained in the sketchbook for a long time. It was apparently never subjected to the stress of being lined or laid down because the surface of the drawing is quite fresh; this is especially true of the black chalk with which the artist began his drawing, freely sketching in the broad outlines of the view before adding the brown wash. Claude also used chalk later for accents and drew in the farm buildings in the foreground. He went over the diagonal forms of the hills in chalk and outlined some of the clouds moving across the sky. A change in the weather, most probably an impending rainstorm, is indicated by brown wash for the shadows and by the reserve of white paper suggesting bright sunlight in the hills along the horizon.

Brush and brown wash, over black chalk
8¼ x 12 inches (210 x 305 mm)
Watermark: fleur-de-lis

Inscribed at bottom right of the recto, the number *13*, deleted; at bottom of verso, *CLAV/R.IV* in red chalk

Provenance: Charles Fairfax Murray; J. Pierpont Morgan (no mark; see Lugt 1509).

Bibliography: Roethlisberger 1968, no. 439, repr.; Russell 1989, no. 3, pp. 50-51, fig. 5.

Exhibitions: Hartford 1931, no. 25; Washington and Paris 1982-83, no. 31, repr. III, 82b

20 A Hilly Landscape with Bare Trees

Claude Gellée, called Claude Lorrain

CHAMAGNE 1600 – 1682 ROME

21 Landscape with Shepherd and Flock at the Edge of a Wood

IN CONTRAST to *A Hilly Landscape, with Bare Trees* (Cat. no 20), which was drawn *en plein air,* this pastoral landscape at the edge of a wooded area was composed by the artist in his studio in 1645. A mood of idyllic tranquility is suggested by the careful arrangement of the composition and the richly varied media. Since no painting corresponding to the subject is known to exist and since the effect of this highly finished drawing is that of a small picture, it is possible that Claude intended the drawing as an independent work. The main focus of the composition is the massed foliage of a grove of trees which extends across most of the immediate foreground. This densely wooded area is worked extensively in pen and brush in a wide range of tones suggesting varied intensities of light and shadow. The shepherd and his flock occupy a thin sliver of space at the edge of a road leading diagonally back to some distant hills, indicated in graphite. One of Claude's most accomplished drawings, this is a work of his full maturity, signed and dated 1645, and may be compared with such drawings as the *Pastoral Landscape* in the Wildenstein album (Roethlisberger 1962a, no. 46, repr.), where a similar arcadian mood is established. In this drawing, too, a shepherd sits at the lower edge of the sheet, looking into the distance toward a densely wooded hill. Claude achieved similar effects with massed foliage in *Wooded Scene* in the British Museum (Roethlisberger 1968, no. 298, repr.) and *Wooded River Banks* in the Teyler Museum, Haarlem (Roethlisberger 1968, no. 543, repr.).

Pen, brush and brown ink, over graphite

8⁷/₁₆ x 13 inches (217 x 330 mm)

Watermark: none

Signed and dated on the verso, *Claudio Gellée / fecit et inventor / Roma 1645*

Provenance: Reverend Henry Wellesley, Oxford; his sale, London, Sotheby's, 25 June – 10 July 1866, lot 664; Charles Fairfax Murray; J. Pierpont Morgan (no mark; see Lugt 1509).

Bibliography: Fairfax Murray 1905-12, III, no. 82, repr.; Hind 1925, p. 11; Knab 1953, p. 146, under no. 17; Knab 1956, p. 112; Roethlisberger 1962a, p. 28, under no. 46; Berenson 1968, repr. p. 86; Chiarini 1968, pl. XLVIII; Roethlisberger 1968, I, no. 592, II, repr.; Cafritz et al. 1988, pp. 108, 111 n. 71, no. 54, fig. 101.

Exhibitions: New York 1919; New York PML 1953, no. 25, pl. VII; New York PML and elsewhere 1957, no. 94, repr.; Utica 1963, no. 27, repr.; New York PML 1981, no. 52, repr.; Washington and Paris 1982-83, no. 37, repr.; New York PML 1984, no. 19, repr.

III, 82

21 Landscape with Shepherd and Flock at the Edge of a Wood

Claude Gellée, called Claude Lorrain

CHAMAGNE 1600 – 1682 ROME

22 Landscape with Procession Crossing a Bridge

BECAUSE OF ITS apparent relation to *View of Delphi with a Procession,* the painting commissioned by Prince Camillo Pamphili, this drawing may be datable to 1650. Eckhart Knab was the first to realize the connection with the painting, which is now in the Galleria Doria-Pamphili, Rome (see Knab 1953, p. 114). Although Claude probably made other preparatory drawings for the painting, the Morgan drawing is one of only two related drawings that survive. While the other drawing, which is in the Accademia in Venice, is larger and more detailed than this sheet, the Morgan drawing is in many respects closer to the painting than is the larger study. It has been suggested (Cleveland and elsewhere 1989, no. 32) that the Morgan sheet is the later of the two. The poetic beauty of this drawing may be due in part to the dark silhouetting of the trees and the figures against the luminous pinkish-brown background, an effect which is enhanced by the rendering of the forms only in soft black chalk and wash with no visible detail. The oblique diagonal of the group crossing the bridge is accented by the large trees that mark the foreground and middle distance, while in the far right corner at the top of the sheet the circular form of the colonnaded temple of Apollo is summarily indicated in black chalk outline.

Black chalk and graphite with brush and brown wash on paper tinted a pinkish brown

7⅞ x 10½ inches (200 x 266 mm)

Watermark: six-pointed star

Inscribed on the verso in pen and brown ink, IVR *Claude Gelee*

Provenance: Sir Charles Greville (Lugt 549); George Guy, fourth earl of Warwick, Warwick (Lugt 2600); his sale, London, Christie's, 20 May 1896, lot 74; Charles Fairfax Murray; J. Pierpont Morgan (no mark; see Lugt 1509).

Bibliography: Fairfax Murray 1905-12, III, no. 76, repr.; Knab 1953, p. 146, under no. 18; Knab 1956, p. 112; Roethlisberger 1961, I, p. 295, under no. LV 119, no. 2; Bologna 1962, p. 246, under no. 98; Knab 1963, p. 114, pl. XXVIII; Knab 1964, pp. 74, under no. 90, 78, under no. 95; Roethlisberger 1968, I, p. 264, no. 683b, II, pl. 683b; Roethlisberger 1975, III, under no. 187.

Exhibitions: New York 1919, no. 4; Buffalo 1935, no. 46; New London 1936, no. 56; New York PML 1981, no. 54, repr.; Washington and Paris 1982-83, p. 162, (under no. 39), no. 45, repr.; New York PML 1984, no. 20; Cleveland and elsewhere 1989, no. 32, repr.

III, 76

22 Landscape with Procession Crossing a Bridge

Claude Gellée, called Claude Lorrain

CHAMAGNE 1600 – 1682 ROME

23 Heroic Landscape

THIS DRAWING, which Claude drew *en plein air* and probably reworked with washes in the studio, has much of the feeling of the artist's earlier nature studies, notably those in his Tivoli sketchbook (see Cat. no. 20). The drawings from the Tivoli book are also fairly large. Since much the same sort of terrain can be seen on the verso, sketched only in black chalk, it may be assumed that he drew it on the same sketching excursion and that the setting of the verso is taken from another vantage point at the same site. The imposing villa indicated in the background is typical of the region, and it appears again on the verso from another viewpoint. The rendering of the building, however, is so summary and secondary to Claude's real subject, the landscape, that it is not possible to identify it.

The drawing was in an album made up either shortly before Claude's death or afterward from the best of his drawings of all periods. Claude himself may have compiled the album between 1677 (the date of the last drawing in the album) and 1682, but it is also possible that his heirs put the album together after his death. Queen Christina of Sweden may have been the recipient of the album, which by 1713 had made its way into the Odescalchi collection. It remained with that family until 1960, when Georges Wildenstein acquired it (see Roethlisberger 1962a and 1968). In addition to the consistently high quality of these drawings, their freshness is remarkable, owing to their preservation for almost three centuries in album format. The Thaw drawing was one of the three largest contained in the album, which was originally made up of sixty leaves including twenty-four nature studies, twenty-one composition drawings, and fifteen figure drawings.

This drawing is clearly one of the most beautiful of the nature studies; its composition is close to that of *The Journey to Emmaus*, which Claude painted in 1652, known today only from the artist's record drawing in the *Liber Veritatis* (see Roethlisberger 1961, LV 125, repr.). The framing trees of the foreground as well as the view of the distant villa or castle closely correspond to these same elements in the copy of the painting in the *Liber Veritatis* (LV 125). Only the figures of Christ and the apostles are not indicated in the drawing. The sketch on the verso was apparently not used by the artist in any known composition.

Black chalk, pen and brown ink, brown, gray, and some blue wash

Verso: Landscape with a coastal town in the distance in black chalk

10¹/₁₆ x 15¹¹/₁₆ inches (254 x 396 mm)

Watermark: fragment of *tête de boeuf*

Provenance: Queen Christina of Sweden (?) in Rome from 1655 to 1689; Cardinal Decio Azzolini (?) Rome; Don Livio Odescalchi, duke of Bracciano, Rome; by descent; Georges Wildenstein, Paris; Norton Simon, Pasadena.

Bibliography: Roethlisberger 1962a, pp. 6, 7, no. 35, repr. in color; Roethlisberger 1962b, pp. 144, 147, no. 7, repr.; Roethlisberger 1968, no. 709, repr.; Roethlisberger 1971, p. 7, no. 34, pl. 34 in color, verso repr. pl. 62.

Exhibitions: Washington and Paris 1982-83, no. 47, repr.; New York PML and Richmond 1985-86, no. 6, repr.

Collection of Eugene Victor and Clare Thaw

23 Heroic Landscape

Claude Gellée, called Claude Lorrain

CHAMAGNE 1600 – 1682 ROME

24 Apollo Watching the Herds of Admetus

THE SUBJECT of this landscape, taken from Ovid, was evidently a favorite of the artist, for he painted it twice, once in 1660 and again in 1666; one painting is in the Wallace Collection, London, and the other is in the collection of Major-General E. H. Goulburn. The story is straightforward and needs little explanation. Apollo, in the guise of a shepherd, is set to guard the herds of Admetus. While Apollo is absorbed in his piping, the herd wanders off, and Mercury, seen in the background at the left, steals them. The drawing, which is intricately worked in complex media of pen and ink and white heightening, is not preparatory for either painting and was evidently intended as an independent work of art; Claude produced a number of these pieces on commission, especially in his later period. Through the dense application of the opaque white, this drawing is given the substantiality and finish of a painting. As Roethlisberger notes (Roethlisberger 1968, no. 896), the composition of the Morgan drawing is close to that of *Mercury and Battus,* which Claude painted in 1663, a connection supported by the date of 1663 on this sheet. Here as in much of his work, Claude invested ordinary landscape with a particular lyric quality, raising it above the level of the naturalistic.

Pen and brown ink, brown wash, heightened with white, over preliminary indications in black chalk; the piper (Apollo), cattle, and the foliage in foreground partially picked out in fine pen and black ink

8½ x 11¹/₁₆ inches (216 x 282 mm)

Watermark: none visible through lining

Inscribed at bottom right, *Claudio Gillee invenit fecit Roma 1663*

Provenance: Jonathan Richardson, Jr. (Lugt 2170); H. C. Jennings (Lugt 2771);

Charles Fairfax Murray; J. Pierpont Morgan (no mark; see Lugt 1509).

Bibliography: Fairfax Murray 1905-12, I, no. 271, repr.; Knab 1953, p. 154; Knab 1956, pp. 121, 122 n. 29; Roethlisberger 1961, p. 402; Roethlisberger 1968, I, no. 896, II, repr.

Exhibitions: Stockholm 1970, no. 51, repr.; New York PML 1981, no. 54, repr.; New York PML 1984, no. 22.

I, 271

24 Apollo Watching the Herds of Admetus

Claude Gellée, called Claude Lorrain

CHAMAGNE 1600 – 1682 ROME

25 Landscape with Aeneas and Achates Hunting the Stag

THIS ELABORATE DRAWING of 1669 is one of four preparatory drawings for the painting of *Aeneas Hunting* in the Musée des Beaux-Arts, Brussels, which was not actually executed by the artist until 1672. Although Claude apparently thought of the Morgan sheet, which is quite detailed in its fine penwork and has been divided into quadrants for transfer, as his final preparation for the painting, he was to revise the composition extensively during the intervening three years. The three other drawings include a figure study in the Metropolitan Museum of Art, New York, and two other compositional drawings, one in the British Museum and the other in the Ecole des Beaux-Arts, Paris. There is a fine painterly quality to the Morgan drawing which is worked up in many subtle gradations of gray and brown, conveying a sense of pervasive atmosphere. Aeneas is seen with his companion, Achates, on a rocky platform, shooting at a herd of deer in the valley below. At the left, in the middle distance, Claude has given a glimpse of the harbor with Aeneas's fleet and a rock arch, beyond which is the distant horizon of open sea.

The work was commissioned by Claude's last major patron, Prince Falconieri (1626-96), who also ordered *Coastal View with Aeneas and the Cumaean Sibyl* (whereabouts unknown) as an appropriate pendant. The subjects of both paintings are taken from Virgil's *Aeneid*. The same patron had earlier commissioned from Claude a pair of paintings with scenes from Tasso's *Gerusalemme liberata*, *Erminia and the Shepherds*, 1666, and *Coast View with the Embarkation of Carlo and Ubaldo*, 1667.

Pen and brown ink and brown wash, heightened with white; divided into quadrants in graphite

9⅞ x 13⅞ inches (251 x 353 mm)

Watermark: only partially legible

Signed and dated in lower left foreground, *ill.ᵐᵒ sig falconier / Claudio inv facit* [sic] / *Roma 1669*. Inscribed on old mount, in pen and brown ink, in Roupell's hand, *R P R / Claude / one of the fifty drawings selected by Messrs Woodburn*

for Exhibition in 1835 – / It forms no 28 of the Claude drawings from Sir T. Lawrences collection. The / description in this Catalogue is as follows. / "Landscape. a rich woody and rocky scene near the ocean – on the right an Eminence / "crowned with trees and a Sybils Temple – In the centre on a platform of rock near / "a large tree Aeneas accompanied by Achates is seen shooting at the herd of deer in the / "valley – The ships of Aeneas are seen at anchor in the creek – a most magnificent / "composition. free pen and bistre wash –

Superb." / From collections of the Marquis Vindé – Sir T. Lawrence / Mr. Esdaile.

Provenance: Paignon-Dijonval, Paris; Charles-Gilbert, vicomte Morel de Vindé (grandson of preceding), Paris (no mark; see Lugt 2520); Samuel Woodburn, London (no mark; see Lugt 2584); Thomas Dimsdale, London (Lugt 2426); Sir Thomas Lawrence, London (Lugt 2445); Samuel Woodburn, London (no mark; see Lugt 2584); William Esdaile, London (Lugt 2617); his sale, London, Christie's, 30 June 1840, lot 61 (to Hodgson for 21 pounds); Reverend Henry Wellesley, Oxford; his sale, London, Sotheby's, 25 June – 10 July 1866, lot 1241; Robert P. Roupell, London (Lugt 2234); his sale, London, Christie's, 12-14 July 1887, lot 1283; Alphonse Wyatt Thibaudeau, Paris and London; his sale, London, Sotheby's, 9-13 December 1889, lot 1057 (sold for 9 pounds 10s); Charles Fairfax Murray; J. Pierpont Morgan (no mark; see Lugt 1509).

Bibliography: Bénard 1810, no. 2597; Fairfax Murray 1905-12, I, no. 273, repr.; Knab 1956, p. 126 and n. 38; Roethlisberger 1961, p. 425, under LV 180 (no. 1); Knab 1964, p. 86, under no. 105; Chiarini 1968, pl. LXVII; Roethlisberger 1968, I, no. 990, II, pl. 990; Paris and elsewhere 1981-82, p. 220, under no. 108.

Exhibitions: London 1835, no. 28; New York PML 1939, no. 93; New York PML 1953, p. 19, no. 22; Hartford 1960, no. 76; New York PML 1981, no. 55, repr.; Washington and Paris, 1982-83, no. 62; New York PML 1984, no. 23; Cleveland and elsewhere 1989, no. 36, repr.

I, 273

25 Landscape with Aeneas and Achates Hunting the Stag

Gaspard Dughet-Poussin

ROME 1615 — 1675 ROME

26 Landscape

POUSSIN'S BROTHER-IN-LAW was born in Rome of an Italian mother and a French father. He owned four houses in or around Rome—all doubtless chosen for their view, since two were located on high points in the city, and the other two were at Frascati and Tivoli.

He not only sketched, but painted from nature. Mariette tells us that he was often seen near Rome with his donkey, who carried all his painting gear, his provisions, and a tent which he needed for his all-day painting excursions.

While many of his paintings exist, only a relatively small number of his drawings are known. The composition with its foreground tree and castle on the hillside occurs in many of Dughet's paintings as well. The drawing was squared for transfer, but a painted version has not as yet been identified. Other drawings by Dughet executed in a similar manner are to be found in the British Museum and the Louvre (see Chiarini 1990, nos. 7, 9, 11, repr.).

Brush and brown wash with some pen and a few indications in black chalk on light-brown paper; squared in graphite

10½ x 15⁹⁄₁₆ inches (266 x 395 mm)

Watermark: none

Provenance: John Thane (Lugt 1544); H. S. Reitlinger (Lugt S. 2274a); P. & D. Colnaghi and Co., London.

Bibliography: PML/*FR,* VI, 1955, pp. 71-72; Chiarini 1990, p. 6, no. 8, repr.

Exhibition: New York PML 1984, no. 26.

Purchased as the gift of the Fellows

1954.13

26 Landscape

Sébastien Bourdon

MONTPELLIER 1616 – 1671 PARIS

27 Design for a Frontispiece

SÉBASTIEN BOURDON, court painter to Queen Christina of Sweden during the last years of her reign (1652-54), is not usually associated with book illustration. His biographer Ponsonailhe, writing in 1886, mentions only that he designed the frontispiece for an edition of the Polyglot Bible (undoubtedly the Paris edition of 1645) engraved by Gilles Rousselet. Karl Erik Steneberg (1955) noted the existence in the Royal Library at Stockholm of a large red chalk drawing (306 x 203 mm), which is a study for the title page engraved by Jeremias Falck for the second part of B. P. Chemnitz, *Königlichen Schwedischen in Teutschland geführten Kriegs* (Stockholm, 1653).

The Library's drawing adds a third design for book illustration. It represents Minerva and Hercules flanking a laurel-framed oval, obviously reserved for a portrait. Above are two cherubs with trumpets holding a drapery with another reserved space, probably for a coat of arms. On the right, Minerva is represented as a warrior, her spear pointed at three captives in chains at her feet; on the left, the goddess is shown as a figure of peace bearing a wreath of laurel in each hand. The Hercules on the left is the Farnese type and holds his club across his shoulder; on the right, the hero, if it is he, is an older figure with the club in the same position. The iconography is such that the sheet would be an appropriate companion for the Chemnitz title page, where Queen Christina is shown receiving the club and lion skin of Hercules from her father in the guise of Jupiter, while a figure of Fame stands below.

The drawing has been traced with a dry stylus, suggesting that it was carried at least one step further toward some final form of execution. It carries the stamp of P. J. Mariette and is laid down on one of the collector's characteristic blue mounts with a cartouche lettered "Sebastiani Bourdon." Mariette owned a number of Bourdon's drawings, but this one is not listed in the catalogue of his sale in 1775.

Black chalk and gray wash, traced for transfer with a dry stylus; laid down on a Mariette mount

18½ x 13³⁄₁₆ inches (469 x 335 mm)

Watermark: none visible through mount

Provenance: P. J. Mariette (Lugt 1852); August Grahl (Lugt 1199); Edmond Fatio; his sale, Geneva, N. Rauch, 3–4 June 1959, no. 53.

Bibliography: PML/FR, XI, 1961, pp. 85-86.

Exhibitions: Zurich 1946, no. 135; Stockholm 1966, no. 199; Paris 1967, no. 217, repr.; New York PML 1984, no. 108.

Purchased as the gift of the Fellows 1961.16

27 Design for a Frontispiece

Michel Dorigny

SAINT QUENTIN 1617 – 1665 PARIS

28 Hercules and Iolaus Slaying the Hydra

MICHEL DORIGNY'S REPUTATION was for many years eclipsed by that of his well-known teacher and father-in-law, Simon Vouet. Known principally for his work as a printmaker, Dorigny was also active as a decorative painter, although unfortunately many of his painted decorations have been destroyed. In light of recent research, however, Dorigny's activity as an artist has been reassessed. Many paintings and drawings traditionally given to Vouet have been reattributed to Dorigny, who is now recognized as one of the most significant artists working in France in the seventeenth century.

Executed in Dorigny's crisp chalk manner, this drawing is one of eight preparatory designs for prints he executed in 1651 after paintings by Vouet in the Hôtel Séguier. Previously known as the Hôtel de Soissons, and located in the quartier de Saint-Eustache, this hôtel was acquired by Pierre Séguier (1588–1672), Le Brun's early patron. The Library's drawing reproduces one of Vouet's lost decorations for the vault in the lower gallery, the program of which alluded to the great events of Louis XIII's reign. It depicts the subject of the second labor of Hercules for which he journeyed to Lerna, near Argos, to fight the hydra. The hydra, a seven- or nine-headed water snake, ravaged the country. No sooner did Hercules cut off one head than two more grew in its place. With the help of his nephew, Iolaus, he slew it, cauterizing its heads with a burning torch. Here Hercules, recognizable in his lion skin, wields his club while Iolaus busies himself with the torch.

The scene is symbolic of the conquest of Languedoc and the overthrow of the Huguenots.

Black chalk, heightened with white; incised for transfer with stylus

8¹¹⁄₁₆ x 7⅝ inches (221 x 193 mm)

Watermark: indecipherable with a coat of arms (?) surmounted by a fleur-de-lis

Provenance: François Heim; David Jones, Paris.

Exhibition: Paris 1988, no. 35, repr.

Purchased on the Lois and Walter C. Baker Fund

1988.8

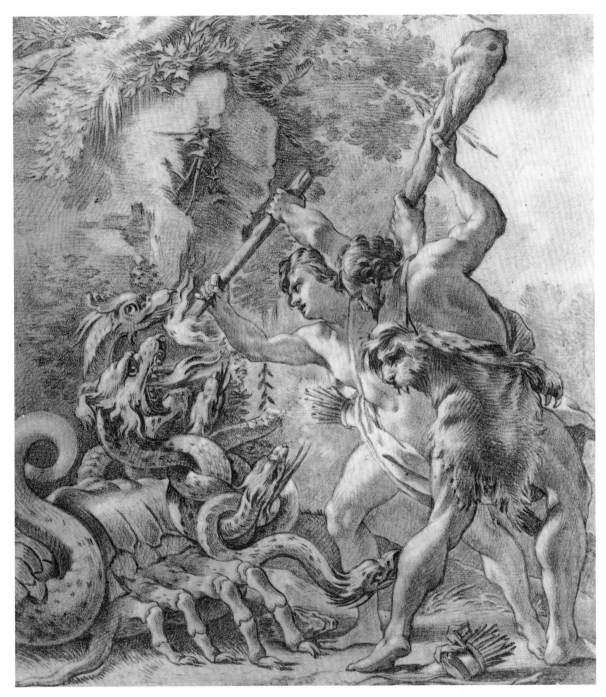

28 Hercules and Iolaus Slaying the Hydra

Charles Le Brun

PARIS 1619 – 1690 PARIS

29 A Caryatid

PREVIOUSLY UNKNOWN, this drawing is Le Brun's design for the upper part of the thesis of Jean Ruzé d'Effiat, dedicated to Cardinal Richelieu in 1642. The design was engraved in reverse by Michel Lasne (repr. *Gazette des Beaux-Arts* 1965, p. 53, no. 284). Drawings for two other sections of the design are known, including the large drawing for the lower part of the thesis at the Metropolitan Museum of Art (Bean 1986, no. 157), with Mars and Apollo and their attributes, a reference to Richelieu's role as *grand-admiral de France* and his eminence in both war and peace. Executed when Le Brun was still under the influence of his master Simon Vouet, his chalk manner drawings of this period can be confused with those of Vouet, as in the case of the *Study for a Figure Blowing a Trumpet* in the National Gallery of Canada, Ottawa, which was formerly believed to be by Vouet but is in fact by Le Brun. Like the Library's study and that in the Metropolitan, the Ottawa sheet is also related to the thesis (see Lavergnée 1986, p. 348, pl. I).

Black chalk and some black wash; incised with stylus for transfer; extraneous traces of red chalk and oil stains

12½ x 13⅞ inches (317 x 351 mm)

Watermark: fleur-de-lis with shield surmounted by crown, indistinct letters below

Inscribed at upper right within cartouche, *ILLVSTRI* [cut off]

Provenance: Nicos Dhikeos, Lyon; Christophe Janet, New York.

Purchased as the gift of Mrs. Charles Wrightsman

1987.6

29 A Caryatid

Charles Le Brun

PARIS 1619 – 1690 PARIS

30 Acquisition of Dunkerque

THIS DRAWING is a study for one of the ceiling paintings for the Long Gallery at Versailles, the project with which Le Brun culminated his achievements as *premier peintre du roy* and decorator between 1679 and 1686. In this working drawing, the artist cropped all four corners to simulate the appearance of the lozenge-shaped decorative form of the painting. He conceived the subject as allegorical, and the city of Dunkerque, personified here as a woman, kneels before a victorious France and hands her the key to the city. France, represented by a Minerva-like woman warrior, is seated on a raised dais. She looks to the right and points at the chest of money and cornucopia of riches displayed by women attendants and a kneeling man. Le Brun has chosen a bas-relief flatness for the composition, using gray wash to indicate the shadows behind the figures.

Pen and ink over black chalk and gray wash

9¾ x 13 inches (246 x 330 mm)

Watermark: none visible through lining

Inscribed at lower edge, in pen and black ink, *Acquisition de Dunkerque;* and further along, in a different hand, *C Le Bruyn*

Provenance: Sir Charles Greville (Lugt 549); George Guy, fourth earl of Warwick (Lugt 2600); possibly his sale, Christie's, London, 20-21 May 1896, part of lot 210; Charles Fairfax Murray; from whom purchased by J. Pierpont Morgan (no mark; see Lugt 1509).

Bibliography: Turčić 1984, pp. 526-27, no. 28, fig. 49.

Exhibition: New York PML 1984, no. 28.

III, 86a

Acquisition de Dunkerque. H Le Brun

30 Acquisition of Dunkerque

73

Israel Silvestre

NANCY 1621 – 1691 NANCY

31 A Panoramic View of Loreto

THIS DRAWING is a leaf from the artist's album of thirty-five views of Italy, which appeared on the market in 1935 and was dismembered and widely dispersed since then to the British Museum, London; the Whitworth Art Gallery, Manchester; Institut Néerlandais, Paris; and the Fogg Art Museum, Harvard University, Cambridge, to name but a few. As has been noted elsewhere, most of these views are of Rome, but some depict Florence and other Italian cities. While it has been surmised that these drawings date to one of Silvestre's visits to Italy between 1640 and 1653, he used the drawings as the basis for his topographical engravings; indeed, this drawing corresponds, although not exactly, to one of his two engravings of Loreto, which he dated 1642 (Le Blanc 1854-56, p. 233 ii/2). The print is much smaller than the drawing and on it Silvestre has included an inscribed key to all the points of interest in his view, noting that he, *Israel Silvestro/Incidit anno 1642/excudit Parisiis/cum privil. Regis/Humilis.mo et Devot.mo ser.re de L.* The date he provided on the print must mean that these drawings were actually made early in the 1640s and could not date as late as 1653.

Black chalk, graphite, brown and gray wash

8⅝ x 28 inches (220 x 711 mm)

Watermark: none

Provenance: Earl of Abingdon, Oxford; sale, London, Sotheby's, 17 July 1935, part of lot 5; purchased by P. & D. Colnaghi and Co., London; Anthony Blunt.

Bibliography: PML/*FR*, XVII, 1976, p. 181.

Exhibitions: London 1935a, no. 19; London 1949, no. 524; London 1964, no. 50; London 1974, no. 35, repr.; New York PML 1984, no. 29.

Purchased as the gift of Franklin H. Kissner

1974.46

Panoramic View of Loreto. *Acc. no. 1974.56. The Pierpont Morgan Library*

31 A Panoramic View of Loreto

Attributed to Noël Coypel

PARIS 1628 – 1707 PARIS

32 The First Passover

THIS VIGOROUS compositional drawing of an unusual subject entered the collection as attributed to Noël Coypel, the artist whose surname is inscribed at the lower left, and subsequent comparison with drawings securely attributed to him supports retention of this attribution. Noël Coypel, founder of an illustrious family of artists, achieved great fame in his lifetime; his earliest works were decorations made in connection with one of the king's operas when he was eighteen. He went on to work at both the Louvre and Tuileries, where he was responsible for the decoration of the Salle des Machines, among other works. Eventually appointed director of the French Academy in Rome, he was admitted in 1673 to the Accademia di San Luca, where his name was duly inscribed in the records. In these records, as Mariette tells us, it is difficult to recognize his name as it is written, *Natale Cohibel; et c'est ainsi que les Italiens défigurent les noms des étrangers qu'ils ont peine à prononcer"* (Mariette, p. 23). Later, after he returned to France, he became director of the Académie Royale. Known primarily as a history painter, Coypel also took the Bible as subject matter.

For many years the precise subject of the Morgan drawing was unknown. It is a complex composition, and because of the classical character of the costumes and furnishings of the room, it was tentatively identified as *Romans at a Feast*. An early penciled note on the original mat suggested that the composition might represent Belshazzar's Feast; another in the hand of Dr. Karel Boon proposed the passover meal before the departure of the Israelites from Egypt.

The subject of Belshazzar's Feast, with its singular dramatic focus on the sudden and fearful appearance of a pointing hand, is not plausible, but the varied components of the composition including the possible Egyptian character of the subject as suggested by the herm in the right background can be understood if the subject as Dr. Boon correctly noted is read as the first Passover. Exodus (12:7-11) describes the sacrifice of an unblemished lamb, whose blood is to be smeared on the doorposts of the house so that the avenging angel may distinguish that house from others (otherwise the firstborn son of that house would be slaughtered along with the other firstborn youths in Egypt). The passage tells how the lamb is to be roasted whole and eaten with "girded loins, shoes on, and staffs in hand." All of these elements are present in the Morgan drawing. The man at the left points at the door to distinguish the doorposts so marked, a roasted lamb is brought to the table, and every man present holds a

Pen and brown ink, brown wash, over black and red chalk, heightened with white

9¼ x 11⅝ inches (235 x 295 mm)

Watermark: none visible through lining

Inscribed at lower left, in pencil, *Coypel;* on back of old mount, in pen and brown ink, above center, *H/ No 39* drawn through, and at lower right, *No 53*

Provenance: Earl Spencer (Lugt 1530); Charles Fairfax Murray; from whom purchased in 1910 by J. Pierpont Morgan (no mark; see Lugt 1509).

Exhibition: New York PML 1984, no. 30.

III, 86b

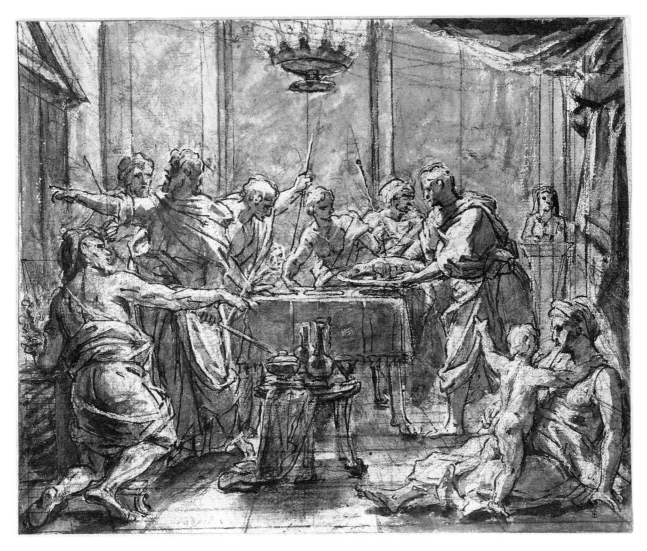

32 The First Passover

staff in his hand. It is interesting to note that the only woman depicted appears with her child in the right foreground, a reference to the firstborn, who leans towards the table and points at the lamb on the platter.

The Morgan sheet is similar in style and technique to a number of drawings by Coypel preparatory for tapestries (Guiffrey and Marcel III, nos. 3132, 3133, 3137, 3138). This suggests that it may be a design for a tapestry although no series of Old Testament tapestries designed by Coypel is known.

Claude Gillot

LANGRES 1673 – 1722 PARIS

33 L'Enfance

THIS HIGHLY PICTORIAL drawing is preparatory for the print, engraved in the opposite direction by François Joullain (1697-1778) for a suite, *Les Quatre Ages du Satyre*, comprising *L'Enfance*, *L'Adolescence*, *La Virilité*, and *La Vieillesse* (see Populus 1930, nos. 390-93). While the suite of four drawings was complete in the Paignon-Dijonval collection, only the drawing for *L'Enfance* is known today.

The print, which is in the reverse direction of the drawing, bears the title *L'Enfance* and beneath it four lines of verse:

> Des plaisirs qu'on a pris à ces innocens jeux,
> Qui jadis amusoient nôtre enfance passée,
> Dès que la mémoire est une fois éfacée.
> On a vû de ses jours couler les plus heureux.

The chronology of Gillot's work is not known, but the artist's handling of the subject in this unusually complex mixture of techniques indicates that this is a work of his maturity. The facial types and the degree of accomplishment shown here suggests a date of around 1710 to 1712.

Red chalk, moistened in places with brush, heightened with white gouache; traced for transfer with stylus

8¼ x 5⅞ inches (212 x 152 mm)

Watermark: none visible through lining

Provenance: Paignon-Dijonval; d'Imécourt; his sale, Paris, 21 April 1858, lot 60; Alfred Beurdeley (Lugt 421); his sales, Paris, Georges Petit, 13-15 March 1905, lot 88, and Paris, Féral and Paulme, 8-10 June 1920, lot 177; Galerie Cailleux, Paris.

Bibliography: Bénard 1810, no. 3135; Populus 1930, pp. 216f.; Michel 1987, pp. 28, 161, 175-76, 246, fig. 16 (in color); PML/*FR*, XXI, 1989, p. 344.

Purchased as the gift of Mrs. Francis Kettaneh and Mrs. Carl Stern

1986.20

33 L'Enfance

Eighteenth Century

Jean Antoine Watteau

VALENCIENNES 1684 – 1721 NOGENT-SUR-MARNE

34 Five Theatrical Figures and Two Studies of a Man Seated on the Ground

AS PARKER AND MATHEY were the first to point out, almost all of the small figures on this sheet of studies appear somewhere in Watteau's paintings. The actor with a quiver at the top center was used as the figure of Love for *Love in the French Theatre,* Berlin, and the young men sprawled in the foreground appear in reverse in *The Garden of Saint-Cloud,* now in the Prado, Madrid. For a recent detailed survey of the use of these figures see Margaret Morgan Grasselli in Washington and elsewhere 1984-85, D 15.

The page seems to combine two styles of drawing: the figures in the upper register recall the earlier style learned from Gillot, while those in the immediate foreground appear to be life studies, which can be dated, according to Grasselli, to 1712.

Red chalk

6⁷⁄₁₆ x 8¹⁄₁₆ inches (163 x 205 mm)

Watermark: none

Provenance: Mr. Riggall; Charles Fairfax Murray; J. Pierpont Morgan (no mark; see Lugt 1509).

Bibliography: Fairfax Murray 1905-12, I, no. 275, repr.; Parker 1931, p. 41, no. 2; Mathey 1938, p. 161; Parker and Mathey 1957, no. 25; Mathey 1960, p. 358, fig. 16; Cailleux 1961, p. iii, figs. 3-4; Camesasca and Rosenberg 1970, under no. 30D; Eidelberg 1970, p. 67, fig. 34; Zolotov and Nemilova 1973, pp. 28, 146, repr.; Michel 1984, p. 94, fig. 58; Posner 1984, pp. 47, 258, 290 n. 56., fig. 41.

Exhibitions: Richmond 1956; Los Angeles 1961, no. 12; Providence 1975, no. 34, repr.; Washington and elsewhere 1984-85, no. 15, repr.

I, 275

34 Five Theatrical Figures and Two Studies of a Man Seated on the Ground

Jean Antoine Watteau

VALENCIENNES 1684 – 1721 NOGENT-SUR-MARNE

35 Study of a Young Man Seen from the Back and Another Study of His Right Arm

WATTEAU'S SKETCH of an elegantly sprawled young man epitomizes the artist's gift for effortless figure drawing. The assured execution of this rapid sketch is typical of the artist's work in the latter part of the second decade of the eighteenth century. Margaret Morgan Grasselli (Washington and elsewhere 1984-85, D 95) dates it 1717 by reason of its apparent connection to the painting *The Pleasures of the Ball,* in the Dulwich Picture Gallery. The young man's pose is repeated in a full compositional study in Dresden (repr. Washington and elsewhere 1984-85, D 98). In the Dulwich picture, the artist modified the pose of this figure and employed the sketch of his right arm and shoulder on this sheet for another young man who appears in the lower right *tête à tête* with a young woman toying with a fan.

While Watteau executed the drawing *en trois crayons,* that special combination of black, red, and white chalk which he perfected, here he worked primarily in black chalk, with some additions in red and much less in white chalk.

Black, red, and white chalk on light brown paper; lower left corner made up

8³⁄₁₆ x 9 inches (208 x 227 mm)

Watermark: none visible through lining

Numbered in pen and brown ink on back of old lining, *43*

Provenance: Sir Thomas Lawrence (Lugt 2445); Miss James; her sale, London, Christie's, 22-23 June 1891, lot 300; Camille Groult, Paris; his descendant, Pierre Bordeaux-Groult; sale, Paris, Palais Galliera, 30 March 1963, no. 17; Henri Farman; his sale, Paris, 15 March 1973, lot G; Otto Wertheimer, Paris and Zurich.

Bibliography: Parker and Mathey 1957, no. 641, repr.; Moureau and Grasselli 1987, pp. 97-98, 97 n. 11, fig. 5.

Exhibitions: Washington and elsewhere 1984-85, no. 95, repr.; New York PML and Richmond 1985-86, no. 9, repr.

Collection of Eugene Victor and Clare Thaw

35 Study of a Young Man Seen from the Back and Another Study of his Right Arm

Jean Antoine Watteau

VALENCIENNES 1684 – 1721 NOGENT-SUR-MARNE

36 A Member of the Persian Embassy

THE VISIT of the Persian Embassy to Versailles in 1715 gave Watteau the opportunity to sketch several of its members in their exotic costumes. The group included this slender young man wearing a peaked fur-trimmed cap and cloaks, whom the artist sketched at least twice; for he can be recognized again, this time seated, in the drawing in the Victoria and Albert Museum, London (repr. Parker and Mathey 1957, no. 798). After Watteau's death Boucher was to engrave both studies for the *Figures de différents caractères*. The Thaw study appears in reverse as plate 4 in Volume I, published in 1726, and two years later the second and final volume of the *Figures* included Boucher's engraving of the London study of the young Persian as plate 215. A counterproof of the latter is in the Ashmolean Museum, Oxford. The overall impression of the Thaw sheet is one of great immediacy and freshness.

The back of the old mount of the drawing carries a clue to the early ownership of the drawing in the inscription, *Claire Amélie Masson/1795 née Falaize 1839.*

Red and black chalk

12½ x 6⅝ inches (316 x 167 mm)

Watermark: none visible through lining

Provenance: Claire Amélie Masson (according to back of old mount); Mme Chauffard, Paris; Mme Ader Picard Tajan; sale, Paris, Palais Galliera, 7 December 1971, no. 5, repr.

Bibliography: Parker and Mathey 1957, no. 796, repr.; L'Oeil 1977, p. 43, fig. 8.

Exhibitions: New York PML and elsewhere 1975-76, no. 33; Washington and elsewhere 1984-85, p. 57, no. 48 and under no. 47, repr.

Collection of Eugene Victor and Clare Thaw

36 A Member of the Persian Embassy

Jean Antoine Watteau

VALENCIENNES 1684 — 1721 NOGENT-SUR-MARNE

37 The Temple of Diana

AT SOME TIME after leaving Gillot's studio in 1706, Watteau went to work with the ornament designer Claude Audran. Under Audran's influence and with his own innate taste for color and light decoration, Watteau fell under the spell of the newly emerging rococo style. He produced a number of designs for decorative arabesques, some of which have survived and some of which are known only from prints made after them in the *Figures de différents caractères, de paysages et d'études,* which Watteau's friend the noted collector Jean de Jullienne had executed after the artist's untimely death in 1721. A number of these arabesques, as Margaret Morgan Grasselli has shown, were actually produced later than the Audran years; this is apparent because of their relation to paintings of later date. The Morgan sheet must date about 1716, for instance, because of its relation to *The Bower,* now in the National Gallery of Art, Washington, and the connection of that drawing to a painting of 1716.

The inexhaustible inventiveness of the artist's imagination is displayed in the proliferation of decorative motives and ideas in *The Temple of Diana.* Here, the ideas came to him so rapidly that he sketched alternates as well. At the center Diana and attendant nymphs are seen on a pedestal under a leafy arch. A stag's head atop the arch divides the two halves of the design. At one side, the arch becomes a rococo arbor supported by herms, while at the other, it is transformed into a stone structure culminating in a fantastic shell-like decoration. This side is supported by a column with a putto perched on a fountain; a vase motif emerges from a bracket. To the right, elegant couples, including a nymph and satyr, are lightly sketched. On the other side, two whippets pose on a line of tracery under which a suspended net is looped through a circular hunting horn; above, birds fly.

From Watteau's design, Huquier derived two prints, fully developing the draughtsman's alternate suggestions. In *The Temple of Neptune* (Dacier and Vuaflart 1921-29, I, no. 224), Huquier supplied the figure of Neptune, absent in Watteau's drawing, and completed the rusticated arch motif in conjunction with the bracketed vase and the nymphs and satyrs. In *The Temple of Diana* (Dacier and Vuaflart 1921-29, III, no. 225), he picked up Watteau's other solution for the arbor or trellis with the herms and used the nymphs along with the hunting horn and nets, while balancing Watteau's whippets with a running stag of his own invention.

Red chalk

10½ x 14¼ inches (267 x 362 mm)

Watermark: fragment of chaplet (cf. Heawood 222)

Provenance: Edmond and Jules de Goncourt (Lugt 1089); their sale, Paris, 15-17 February 1897, lot 350 (to Camille Groult for 250 francs); Camille Groult; J. Groult.

Bibliography: Goncourt 1875, p. 216, no. 279; Portalis and Béraldi 1880-82, p. 447 (mentions the prints); de Fourcaud 1908-9, p. 131 n. 2; Deshairs 1913, p. 292; Réau 1928, p. 55, nos. 58, 59; Dacier and Vuaflart 1921-29, III, p. 103, under no. 225, repr.; Parker and Mathey 1957, p. 29, no. 191, repr.; Bruand and Hébert 1970, pp. 573f., nos. 1733-34; PML/FR, XIX, p. 221; Eidelberg 1984, pp. 158, 160, 164 n. 9, fig. 3; Posner 1984, p. 61, colorpl. 11; Michel 1984, p. 128, fig. LII (colorpl.); Michel 1987, pp. 137, 168, fig. 145.

Exhibitions: New York PML 1981, no. 98, repr.; New York 1984, no. 39, repr.; Washington and elsewhere 1984-85, p. 55, no. 71, repr. in color.

Purchased as the gift of Mr. and Mrs. Claus von Bulow

1980.9

37 The Temple of Diana

Jean Antoine Watteau

VALENCIENNES 1684 – 1721 NOGENT-SUR-MARNE

38 Seated Young Woman

WATTEAU'S STYLE matured while he lived in the Paris town house of Pierre Crozat, where he was able to study Rubens's drawings in the collection of this famous financier and patron of artists. Influenced by the virtuosity of the great Flemish master's technique in *trois crayons,* Watteau began to draw in a mixture of three chalks with magical effect. In this study of a casually posed young woman turning attentively to the right, his gift for suggesting the life and luminosity of flesh is superbly realized in a few crisp but subtle strokes of chalk. The pretty blonde model appears to have sat for him often and may be the same woman who posed for the nude study of *Flora,* the drawing now in the Louvre (repr. Parker and Mathey 1957, no. 513), which was preparatory for the series of the *Seasons* that Watteau was commissioned to paint for Crozat's dining room. It is well known that the artist did not as a rule draw figures with any immediate purpose in mind but kept these studies in a book, using and reusing them in his paintings.

Although the *Seated Young Woman* does not appear in any of the surviving paintings of the artist, the drawing was one of one hundred and three etched by the young Boucher.

Black, red, and white chalk

10 x 6¾ inches (255 x 172 mm)

Watermark: none visible through lining

Provenance: Miss James; probably her sale, London, Christie's, 22-23 June 1891; Thomas Agnew & Sons, London; J. Pierpont Morgan (no mark; see Lugt 1509).

Bibliography: Goncourt 1875, no. 591; Mantz 1892, no. 63; Shoolman and Slatkin 1942, p. 540, pl. 485; Shoolman and Slatkin 1950, p. 46, pl. 27; Parker and Mathey 1957, no. 531; Schneider 1967, p. 89; Cormack 1970, p. 29, pl. 47; Eckhardt 1975, under no. 25; Michel 1984, colorpl. XXXI; Posner 1984, pp. 71-72, colorpl. 13; Moureau and Grasselli 1987, pp. 97-98, fig. 6.

Exhibitions: New York 1919; Buffalo 1935, no. 58; New York PML 1939, no. 95; Hartford 1960, no. 80; Stockholm 1970, no. 53, repr.; Washington and Chicago 1973-74, p. 62, no. 47; Providence 1975, no. 44, repr.; New York 1977b, no. 95, fig. 86; New York PML 1981, no. 99, repr.; Washington and elsewhere 1984-85, pp. 54, 58, no. 61, repr. in color.

I, 278a

38 Seated Young Woman

Jean Antoine Watteau

VALENCIENNES 1684 – 1721 NOGENT-SUR-MARNE

39 Two Studies of the Head and Shoulders of a Little Girl

FROM THESE TWO RADIANT STUDIES of a small girl, Watteau chose the one on the right to play a role in his painting, *Pour nous prouver que cette belle,* known familiarly as *The Music Lesson,* in the Wallace Collection, London. She becomes the small listener who leans against her mother's knee and turns her eyes in fascination on the lute. Watteau's finesse in the use of the *trois crayons* technique is virtually unmatched; here, his handling of the three chalks is particularly rich. In the study on the left, the white chalk heightening is applied pleasingly to suggest the freshness of the child's skin and starched cap. Diagonal strokes of red and black chalk are skillfully used to shade the face of the girl in the other study, and strong accents are used sparingly. The same young model is also represented in a drawing at Orléans (repr. Parker and Mathey 1957, no. 271).

Like the *Seated Young Woman,* the present sheet was once part of the notable collection of Watteau drawings belonging to Miss James, most of which passed into the British Museum, where they form the largest part of this great holding of the artist's drawings.

Red, black, and white chalk on light brown paper; drawn over black chalk sketch of legs

7⅜ x 9⅝ inches (187 x 245 mm) (irregular vertical strip added to left side)

Watermark: none visible through lining

Provenance: Miss James; probably her sale, London, Christie's, 22-23 June 1891; anonymous sale, London, Christie's, 16 June 1911, lot 76; Thomas Agnew & Sons, London; J. Pierpont Morgan (no mark; see Lugt 1509).

Bibliography: Parker 1931, p. 31, pl. 41; Shoolman and Slatkin 1942, p. 540, pl. 491; Adhémar and Huyghe 1950, pp. 216, 222, nos. 126, 162; Parker and Mathey 1957, no. 709; Watrous 1957, pp. 96, 153; Rosenberg 1959, p. 96, fig. 179; Schneider 1967, p. 93; Cormack 1970, p. 35, pl. 82; Eckhardt 1975, under no. 21.

Exhibitions: Buffalo 1935, no. 59; New London 1936, no. 92; New York PML 1939, no. 96; New York PML and elsewhere 1957, no. 99, pl. 63; New York PML 1981, no. 100, repr. in color (detail, front cover); New York PML 1984, no. 40; Washington and elsewhere 1984-85, no. 89, repr.

I, 278b

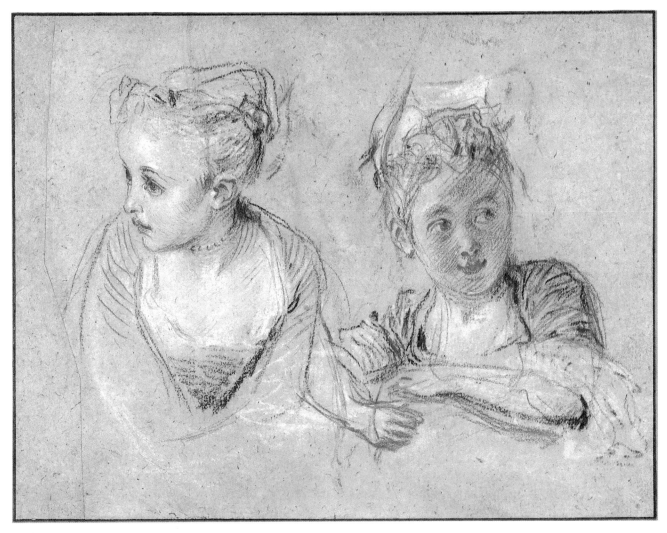

39 Two Studies of the Head and Shoulders of a Little Girl

Jean-Baptiste Oudry

PARIS 1686 – 1755 BEAUVAIS

40 The Rond-Point in the Park at Arcueil

THIS DRAWING is one of a group of at least fifty surviving views that Oudry drew between 1744 and 1747 when he lived near the small château and gardens belonging to the Prince de Guise at Arcueil near Paris. Most of these are in European public collections, including four views in the Louvre, one each in the Musée Carnavalet and the Ecole des Beaux-Arts, two in the Musée de l'Ile-de-France at Sceaux, and one in the Albertina. One other view is in New York at the Metropolitan Museum of Art.

Known primarily as a painter of still lifes, Oudry received his early training from Largillière and was made director of the tapestry works at Beauvais in 1744. It was there that his interest in landscape developed and he consequently produced these views, which are generally considered to be one of his major achievements as a draughtsman. Contemporary sources tell us that the gardens of Arcueil, at this time already neglected, offered a new aspect and inspiration for many artists, including Boucher, Natoire, Pierre, Portail, and Wille. The picturesque ruin and romantic charm of Arcueil seem to have especially appealed to Oudry, who is believed to have produced as many as one hundred views of the park.

The Library's view was one of a group of four views of parks by Oudry that were sold in 1923 in the Masson sale. Because of its unusually complex media, it seems likely that Oudry made only a simple black chalk sketch at the park, later reworking it in a mixture of point of brush and another type of black chalk, which he partially stumped. Unlike some existing views of Arcueil this view is unpopulated, giving it a somewhat unearthly, almost surreal air.

Black chalks (two shades), heightened with white, in places gone over with a wet brush or stumped, on blue paper; traces of a ruled border in black ink

11¹³/₁₆ x 20¼ inches (302 x 523 mm)

Watermark: fragment with letters *M GIS*

Provenance: E. Desperet (Lugt 721); his sale, Paris, Hôtel Drouot, 7-13 June 1865, part of no. 449 (62 frs., to Noizy); Jean Masson (Lugt 1494a); his sale, Paris, Galerie Georges Petit, 7-8 May 1923, lot 177, repr. (1050 frs., to Meyer Bleneau); Katrin Bellinger, Munich.

Bibliography: Desguine 1950, p. 9, pl. 5; Opperman 1977, II, p. 862, no. D1087.

Exhibitions: London 1990b, no. 33, repr. in color and on cover in color; New York 1990b, no. 25, repr. in color.

Purchased on the Martha Crawford von Bulow Memorial Fund

1990.24

40　The Rond-Point in the Park at Arcueil

Jean-Baptiste Oudry

PARIS 1686 – 1755 BEAUVAIS

41 The Monkey and the Cat

BETWEEN 1729 AND 1734 Oudry prepared a set of drawings for Jean de la Fontaine's *Fables choisies mises en vers,* but the series in four volumes did not appear until 1755-59, when it was published in Paris by Desaint and Saillant. This is Oudry's preparatory design for "Le singe et le chat," Fable CLXXXVI, no. XVII, Book 9, in volume III. The series was originally bound into two albums, probably after being engraved, and consisted of 276 drawings for the 245 fables, including a frontispiece designed by Oudry in 1752 for the printed edition. Although it was probably always Oudry's intention to have the series engraved, it was not until after Montenault bought the drawings in 1751 that the latter began to look for engravers, printers, typesetters, booksellers, and patrons for the publication. Charles-Nicolas Cochin, le fils (1715-90), whom Montenault put in charge of the illustration, redrew Oudry's original drawings in graphite in a more finished form.

Oudry's drawings for the fables are all drawn in pen and brush with wash and white heightening on blue paper. The spontaneous quality of Oudry's brush technique led several earlier authors mistakenly to describe these drawings as a series of chalk sketches. Oudry's summary handling of the details of the composition was probably elaborated upon by Cochin in his rendering of the subject. The engraving, executed in reverse of the drawing by Pierre-Quentin Chedel (1705-63) for the Montenault edition, follows Oudry's original design closely. The Cochin drawing after Oudry's *Monkey and the Cat* was sold at Sotheby's, London, 9 April 1970, lot 127, repr.

The drawing shown here illustrates the fable in which the monkey persuades the cat to pull the chestnuts out of the fire, but they are interrupted by the servant before the cat gets his share of the nuts. It points up the moral that those who are easily flattered are just as easily taken in. It is one of three such drawings for the series acquired by the Library in 1976; the other two are *The English Fox* and *The Fortune Teller.* Another drawing for the series, *The Man Who Runs after Fortune and the Man Who Waits in His Bed* was presented to the Library in 1984.

Pen and point of brush and black ink, gray wash, heightened with gouache on blue paper

Design area within painted border: 9⁷/₁₆ x 7⁷/₁₆ (240 x 190 mm). Full sheet: 12³/₁₆ x 10³/₁₆ inches (308 x 258 mm), including border washed in dark blue

Watermark: none

Signed and dated at lower right, *J.B Oudry 1732*

Provenance: Montenault (publisher of the 1755-59 edition of the *Fables*); J.J. de Bure; his sale, Paris, 1 December 1853, in lot 344; Count Adolphe-Narcisse Thibaudeau; Félix Solar; his sale, Paris, 19 November 1860, in lot 627; Baron Isidore Taylor; E. Péreire; Librairie Morgand et Fatout; Louis Roederer; Raphael Esmerian; his sale, Paris, Palais Galliera, 6 June 1973, in lot 46 (this sheet was bound with the other designs for the *Fables,* and the ensemble was not dismembered until after the 1973 sale); Claus Virch, Paris.

Bibliography: (references are to the albums and not specifically to the Morgan Library sheets) Brunet 1862, III, p. 753; Bulletin 1877, p. 482, no. 2904; Portalis 1877, II, pp. 483-89; Cohen 1880, pp. 336-37; Cohen 1912, p. 548; Locquin 1912, pp. 152-73; Opperman 1977, II, pp. 682-85 and 704, no. D425; *Gazette des Beaux-Arts* 1977, p. 52, fig. 209; PML/FR, XVIII, 1978, pp. 279-80; Cleveland Bulletin 1978, p. 5.

Exhibition: New York PML 1984, no. 110, repr.

Purchased on the Fellows Fund

1976.6

41 The Monkey and the Cat

Nicolas Lancret

PARIS 1690 – 1743 PARIS

42 Studies of Two Men

THIS DRAWING is one of Lancret's preparations for *Le Déjeuner au jambon,* a painting commissioned by Louis XV in 1735 for the dining room of the *petits-appartements* at Versailles. The painting was one of a pair, the companion piece, *Le Déjeuner d'huîtres,* was painted by François de Troy. Both works are today at the Musée Condé at Chantilly. The 1991 exhibition devoted to Lancret paintings and drawings brought the Morgan drawing together with Lancret's small replica of *Le Déjeuner au jambon* that Lalive de Jully had commissioned from the artist for his town house in Paris. For the smaller work, now in the Museum of Fine Arts, Boston, Lancret made a few changes. As Mary Tavener Holmes has pointed out in the catalogue of the recent Lancret exhibition, the pendant paintings must have much delighted the king, who had a taste for informality. In the Morgan drawing, the artist depicts the hunter seated, his legs spread wide apart, at the far right of the dining table set outside in the park, and another man who is seen standing precariously, one foot on a chair and the other on a table, pouring wine into his glass.

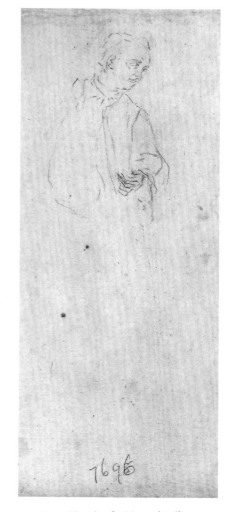

42 *Verso:* Sketch of a Man *(detail)*

Red chalk; verso: sketch of a man

7⁵/₁₆ x 9¹⁵/₁₆ inches (186 x 252 mm)

Watermark: none

Provenance: Pierre Defer-Henri Dumesnil (Lugt 739); sale, Paris, Hôtel Drouot, 10-12 May 1900, lot 168; H. Haro; sale, Paris, Hôtel Drouot, 3 February 1912, lot 44; Walter Burns; sale, London, Sotheby's, 22 March 1923, lot 8, repr.; Casimir Stralem; Donald S. Stralem, New York; Mrs. Donald S. Stralem, New York; her sale, London, Christie's, 13 December 1984, lot 154, repr. in color.

Bibliography: Wildenstein 1924, p. 76, under no. 73; Sutton 1949, no. LI, repr.; Shoolman and Slatkin 1950, p. 56, pl. 32; Grasselli 1986, pp. 386, 31ff., fig. 14; PML/ *FR,* XXI, 1989, pp. 355-56, fig. 17.

Exhibitions: Buffalo 1935, no. 62, repr.; San Francisco 1940, no. 63, repr.; Rotterdam and elsewhere 1958-59, no. 62, repr.; London 1968, no. 398; New York and Fort Worth 1991, no. 32, pl. 37 (in color).

Purchased on the bequest of Mrs. Herbert N. Straus

1985.11

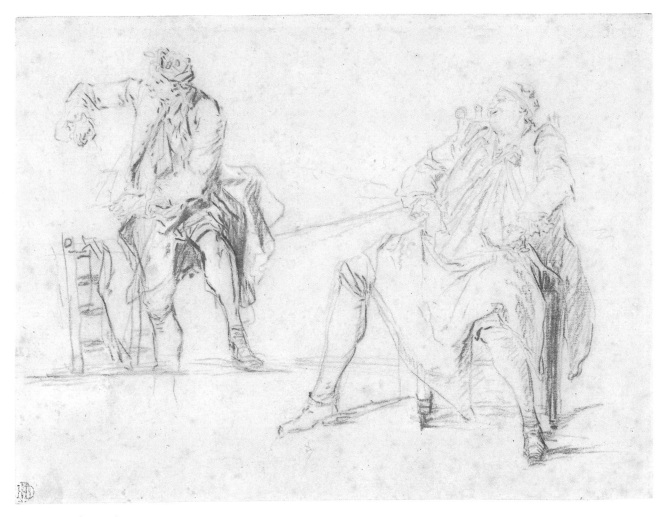

42 Studies of Two Men

Nicolas Lancret

PARIS 1690 – 1743 PARIS

43 Four Figures

THESE FOUR SEPARATE DRAWINGS on different shades of paper pasted together to form a composite sheet entered the collection in 1910 under the name of Pater, who, like Lancret, was a follower of Watteau. Margaret Morgan Grasselli has reattributed all four drawings to Lancret and connected them with known paintings by the artist (Grasselli 1986). While the *Seated Man,* top left, appears to be executed in the early 1720s possibly at the same time as *La Récréation champêtre,* a work now known only through the engraving by Joullain, the *Seated Woman Seen from Behind,* bottom left, is actually a study for one of the figures in *La Camargo Dancing,* executed about 1726, now in the National Gallery of Art, Washington. The other two studies, executed on blue paper, the *Hurdy-Gurdy Player,* top left, and the *Pierrot Seated on the Ground,* bottom left, are related to work of the artist in the 1730s. The *Hurdy-Gurdy Man* is preparatory for the *Fête in the Open Air* (repr. Wildenstein 1924, pl. 95), while the *Pierrot* is a study for *A Scene from Italian Comedy,* the painting of the mid-1730s now at Waddeston Manor in Buckinghamshire.

Studies put together as one sheet: upper left, red and white chalks with highlights on light brown paper; upper right, red and white chalks with highlights on blue paper; lower left, red and black chalks with touches of white chalk, some stumping on light brown paper; lower right, black and white chalks with highlights on blue paper

Full sheet: 13⅝ x 11⁷/₁₆ inches (347 x 290 mm)

Each study: upper left, 7³/₁₆ x 6½ inches (183 x 165 mm); upper right, 7⅛ x 5⁷/₁₆ inches (180 x 139 mm); lower left 6⅜ x 5¼ inches (163 x 134 mm); lower right, 6⁷/₁₆ x 6⅛ inches (164 x 156 mm)

Watermark: none visible through lining

Provenance: Sir Charles Greville (Lugt 549); earl of Warwick (Lugt 2600); Charles Fairfax Murray; J. Pierpont Morgan (no mark; see Lugt 1509).

Bibliography: Fairfax Murray 1905-12, I, no. 280, repr.; Grasselli 1986, pp. 379, 383-87, 388 n. 9, pl. 45.

Exhibitions: New York 1919; Richmond 1956 (as Pater); New York PML 1984, no. 45 (as Pater but with the suggestion that the drawings may be by Lancret).

I, 280

43 Four Figures

Jacques André Portail

BREST 1695 – 1759 VERSAILLES

44 Lady Sketching at a Table

TRAINED AS AN ENGINEER and architect, Portail eventually became *dessinateur du roi* at Versailles; he held various other posts including that of *garde des plans et tableaux du roi*. He became a member of the Académie Royale in 1746 and showed flower and fruit paintings.

Although Portail's drawings are usually executed in a combination of black and red chalks, the Morgan drawing is enhanced by touches of watercolor, especially noticeable in the young woman's corsage. The drawing is more detailed than other examples of the artist's work and affords a glimpse of the furnishings of a Louis XV room, specifically the mantelpiece and mirror, ornamental sconce, and *boiseries*. The young lady's pet dog, a small hound, is curled up asleep on a stool before her.

The identification of the sitter as Mme de Lalive de Jully, wife of Ange-Laurent de Lalive de Jully (1725-75), the well-known amateur and collector, can neither be confirmed nor denied on the evidence at hand. The tradition goes back at least as far as 1900, when the drawing was exhibited in the Exposition Universelle with this identification. At that time, the drawing was in the collection of M. G. Cain, who was the father of the first curator of the Musée Carnavalet, Paris. A letter, dated 1906, preserved with the drawing, notes among other things that a companion drawing existed, which was sold to M. Jacques Doucet in 1903 for 25,000 francs.

Black and red chalk, black and gray wash with touches of pink and blue watercolor

10¹/₁₆ x 8⅜ inches (255 x 212 mm)

Watermark: Hunting horn within a coat of arms, initials *VDL* below (Vanderley; cf. Heawood 2749)

Provenance: G. Cain, Paris; Eugene Glaenzer, New York; from whom purchased by J. Pierpont Morgan in 1907 (no mark; see Lugt 1509).

Bibliography: London, Sotheby's, sale cat., 4 July 1988, under no. 75.

Exhibitions: Paris 1900, no. 11; New York 1919; New York PML 1939, no. 104; London 1968, no. 574, fig. 163; New York PML 1984, no. 46.

III, 98a

44 Lady Sketching at a Table

Edme Bouchardon

CHAUMONT-EN-BASSIGNY 1698 – 1762 PARIS

45 Vade Mecum at Rome

THE THREE SMALL SKETCHBOOKS, two of which are bound in limp vellum, comprising Edme Bouchardon's *Vade Mecum* have been housed in the Morgan Library for more than eighty years, but they have never been published. The sculptor Bouchardon is equally well known as a draughtsman. Indeed, he is the only French sculptor of the eighteenth century who is known to have produced a body of drawings of equal importance. His drawings complement his sculpted work, making his artistic personality better known.

Born in 1698, Bouchardon traveled to Rome in 1723, where he studied for nine years before he was recalled to Paris by Louis XV. As a sculptor he naturally gravitated to all the monuments Rome had to offer. Most of the drawings in the *Vade Mecum* are executed in red chalk, which was always his medium of choice; however, a number are executed in pen and ink and/or black chalk or graphite. The sketchbooks contain many careful sketches of statues and monuments in

Sketchbook of 147 drawings and sketches from ancient statues and paintings, in two volumes and one small unbound gathering

Various media: chiefly red chalk, with some drawings in pen and brown ink, black chalk, or graphite; bound in limp vellum

Binding: Vol. I, 8⅛ x 5⁷/₁₆ inches (204 x 138 mm); Vol. II, 7⅜ x 5⅛ inches (187 x 131 mm)

Leaf: Vol. I, approx. 7¾ x 5⁷/₁₆ inches (198 x 138 mm); Vol. II, approx. 7¹/₁₆ x 5 inches (182 x 125 mm)

Watermark: three hills within circle (cf. Heawood 2611)

Provenance: P. J. Mariette; his sale, 1775, no. 1152 ("Un Portefeuille, contenante 90 dessins, faits à Rome, d'après différents Figures & Monuments antiques, à la sanguine, de petit in-fol."); purchased by Earl Gower (who inscribed in Volume I, *Vade mecum / de Bouchardon / à Rome &c / acheté a la Vente de Mr Mariette);* De Bure, Paris; purchased in 1836 by the duke of Sutherland (inscribed and signed by him in pen and brown ink on fly leaf: *B n. 1698. élève de Coustou le jeune. / étudia à Rome – mort à Paris 1762. / ce livre fut acheté chez De Bure / à Paris 1836. / Sutherland;* purchased from the Sutherland Library by Francis Harvey, London; from whom purchased in 1907 by J. Pierpont Morgan for £125 (no mark; see Lugt 1509).

Exhibition: New York PML 1984, no. 111.

Purchased in 1907

45 Study for Figure from the Tomb of Gregory XIII, *f. 15 of* Vade Mecum

45 Copy of Jonah from Chigi chapel, *f. 6. of* Vade Mecum

45 Self-portrait of the Artist *from* Vade Mecum

Rome, including the Jonah in the Chigi chapel in S. Maria del Popolo (which Raphael designed and Lorenzetti carried out), Maderno's statues of saints ornamenting S. Andrea della Valle, and the turtle fountain in the Piazza Mattei, which dates to the sixteenth century. Bouchardon was not only interested in the earlier monuments of Rome but also included in his sketchbook drawings of contemporary work such as the sculptures for the tomb of Gregory XIII in St. Peter's, which Camillo Rusconi had just completed in 1723.

The second volume begins with a pencil sketch of a fountain by Giambattista Bologna and continues with several red chalk copies of Roman portrait busts, many of which are today in the Vatican Museum but which were then in the Palazzo Belvedere. There are also some sketches for the Fontana di Trevi. (It is interesting to note in this connection that Bouchardon was one of the artists who entered the competition to complete the fountain.) Eventually, one comes to perhaps the most striking opening in the book, the portrait study of a man holding his head in his hands. Although the man's eyes are closed, Bouchardon's own features are recognizable; his full-lipped mouth and aquiline nose can be compared with his self-portrait in profile, the counterproof of which is in the Louvre (inv. 787). This portrait is unique in the *Vade Mecum* and is followed closely by Bouchardon's copy of Bernini's bust of Cardinal Scipio Borghese.

French School, Eighteenth Century

46 Plan des Maisons royales, ca. 1747–ca. 1749

Volume I, Départment de Paris: Recüeil des Plans du Palais des Thuilleries & des Hôtels qui en dépendent. 37 plans.

THIS BOOK is part of a set of five volumes of architectural plans of the French royal palaces. They were made for Abel François Poisson (1727-81), brother of Mme de Pompadour, the future marquis de Marigny, as part of his preparation for the post of *directeur et ordonnateur général des bâtiments, jardins, arts, académies et manufactures du roi,* in which he succeeded Lenormant de Tournehem (the uncle of Mme de Pompadour's husband) in 1749. The young Marigny was immediately dispatched on the grand tour to Italy with the architect Soufflot, the engraver Cochin, and the Abbé Le Blanc. Since the books were probably not ready before his departure, it seems most likely that he received them only in 1751 upon his return to Paris. Although one of the title pages bears the date 1747, none of the books in the set could have been bound until 1749 or shortly thereafter since the flyleaf of all five volumes bears a watermark dated 1749.

Marigny retained this important position for twenty-three years, and the set of royal plans remained in his possession until his death. They are fully described in the catalogue of the sale of "differens objets de curiosité dans les sciences et arts qui composoient le Cabinet de feu M. le Marquis de Ménars," which was scheduled for the end of February 1782 at his hôtel on the Place des Victoires and finally took place between March 18 and April 6 of that year.

Volume I, which opens with a large folding plan in watercolor of the "Champs Elisées avec partie des Fauxbourgs de St. Honoré & du Roulle & les Environs," contains thirty-seven of the original total of thirty-eight plans. Plan 2, listed in the manuscript table of contents as "Plan du Louvre et des Thuilleries," is missing. There are nine plans devoted to the Louvre, five to the Tuileries and gardens, and two each to the hôtels Armagnac, de la Vallière, and Lesdiguières. Three are reserved for the hôtel of M. le Premier ("Chief Equerry of the Small Stable"). Finally, there are various plans of the small dwellings owned by the crown in the rue St. Vincent, the place du Louvre, the rue Fromenteau, and the rues du Chantre and Champ Fleury, as well as plans of the Orangerie of the Tuileries, the "Maison du Controlle," and the "Château d'Eau."

All of the plans are drawn to scale, based presumably on *la toise de Paris,* and many are washed in color in accordance with the eighteenth-century rules of architectural rendering: red for masonry, gray-blue for slate, yellow-brown for

wood, yellow-red for tile, green for turf, and so on. The numerous *entresols* or mezzanines are indicated by neat systems of movable flaps. A great many of the plans are folding sheets, some measuring as much as thirty-six inches in length.

The series has strong interest for students of the architecture and topography of mid-eighteenth-century Paris. One can study, story by story and in the most exact detail, the palaces of the Louvre, the Tuileries, and the Luxembourg as they then existed, even to a count of the stalls of the various royal stables, including those of Mme de Ventadour, the governess of Louis XV. It is possible to follow the course of streets such as the rue Champ Fleury, the rue du Chantre, and rue Fromenteau, which disappeared when the Louvre was completed. Unfolding the plan of the Champs-Elysées and environs, one can see at a glance who occupied the fashionable hôtels of the area or who owned the gardens near the rue de Chaillot. The "Plan du Palais et Jardin des Thuilleries" includes the "Manège découvert" and the "Manège couvert," along with the gardens of the Capucines and the Daughters of the Assumption where Napoleon half a century later opened the rue de Rivoli.

The Marigny set is smaller in size than the large versions in the Archives Nationales, Paris, and the Musée National at Versailles. Alden Rand Gordon has noted that the format was small so that the *surintendant* could easily carry it with him.

Pen and black ink, watercolor

Red morocco binding stamped in gold with the addorsed fish of the arms of Abel François Poisson: 10⅝ x 8 inches (270 x 203 mm)

Leaf: 10⅜ x 7 inches (264 x 176 mm)

Watermarks: fleur-de-lis; various Auvergne watermarks, sometimes incorporating grapes or a date and the maker's name within a bounding wire line.

Provenance: Abel François Poisson, marquis de Marigny; his sale, Paris, 1782, lot 46; Colonel Henry Hughes; his sale, New York, American Art Association, 17 April 1923; Mrs. J. P. Morgan; her sons, Henry S. and Junius S. Morgan.

Bibliography: PML/*FR*, VII, 1957, pp. 72ff., pl. opp. p. 74.

Exhibition: New York PML 1984, no. 124.

Gift of Mr. Henry S. and Mr. Junius S. Morgan

1955.11

46 Plan des Maisons royales, ca. 1747-1749

French School, Eighteenth Century

47 Plan des Maisons royales, ca. 1747–ca. 1749

Département de Versailles: Recüeil des Batimens, Jardins, Bosquets & Fontaines du Château de Versailles, Trianon & la Ménagerie, 2 title pages and 50 plans.

THE VERSAILLES VOLUME has two ornamental title pages in watercolor, one preceding the thirty-six plans relating to the palace and gardens of Versailles, and the other placed before the fourteen plans of the Trianon and the Ménagerie. The theater of Versailles is nowhere in evidence, for the architect Gabriel was just drawing up the first of many plans for it in 1748 when these volumes were being compiled. The Salle des Ballets of Louis XIV, however, is clearly marked. It does not seem likely that the plans of the Trianon and the Ménagerie reflect any of the innovations of the marquise de Pompadour, which also date from the very end of the 1740s.

Pen and black ink, watercolor

Red morocco binding stamped in gold with the addorsed fish of the arms of Abel François Poisson: 10⅝ x 8 inches (270 x 203 mm)

Leaf: 10⅜ x 7 inches (264 x 176 mm)

Watermarks: fleur-de-lis in shield; letters IHS between cross and heart with three swords in a circle, letters *P* and *C* flanking a heart below (cf. Heawood 2986; Paris 1743); various Auvergne watermarks, sometimes incorporating grapes or a date and the maker's name within a bounding wire line.

Provenance: Abel François Poisson, marquis de Marigny; his sale, Paris, 1782, lot 46; Colonel Henry Hughes; his sale, New York, American Art Association, 17 April 1923; Mrs. J. P. Morgan; her sons, Henry S. and Junius S. Morgan.

Bibliography: PML/*FR*, VIII, 1958, pp. 79f.

Exhibition: New York PML 1984, no. 124.

Gift of Mr. Henry S. and Mr. Junius S. Morgan

1956.30

RECUEIL

DES BATIMENS, JARDINS,

Bosquets & Fontaines du

CHATEAU DE VERSAILLES,

Trianon & la Menagerie.

47 Plan des Maisons royales, ca. 1747-1749

Charles Joseph Natoire

NÎMES 1700 – 1777 CASTEL GANDOLFO

48 The Camel Driver

THIS STUDY is preparatory for the painting *The Adoration of the Magi,* which is part of Natoire's extensive painted decoration (1746-50) for the Chapel of the Foundling Hospital, constructed by Germain Boffrand on the site of the present Hôtel Dieu, Paris. Natoire's decorations, which consisted of a suite of fourteen paintings, were destroyed along with the Foundling Hospital between 1868 and 1878 but are today known from the engravings of Etienne Fessard (1714-77) after the paintings.

Five related drawings for the same decorative program are in the Cabinet des Dessins, Louvre, Paris (repr. *Inventaire général des dessins: Ecole française,* XII, Paris, 1975, pp. 19-21) and other studies are in museums in Orléans, Montpellier, Vienna (Albertina), and Florence (Uffizi).

Black chalk, stumped, on blue paper

16⅞ x 9½ inches (430 x 244 mm)

Watermark: none

Provenance: Marquis de Lagoy (Lugt 1710); Kate de Rothschild, London.

Bibliography: Duclaux 1971, pp. 49, 50, 50 n. 28, fig. 16; PML/*FR*, XXIX, pp. 206-7.

Exhibitions: London 1980, no. 1, repr.; New York PML 1984, no. 47.

Purchased as the gift of Mrs. Allerton Cushman, John S. Thacher, and Mrs. Gerrit P. van de Bovenkamp

1980.39

48 The Camel Driver

Charles Joseph Natoire

NÎMES 1700 – 1777 CASTEL GANDOLFO

49 The Cascade at the Villa Aldobrandini, Frascati

NATOIRE SPENT a good deal of his life in Rome. As a winner of the Prix de Rome, he spent the years from 1723 to 1729 as a student at the French Academy there, and late in 1751 he returned as the academy's director, an office he held until 1775. Natoire encouraged the study of landscape draughtsmanship among his students by practicing it himself. In June 1752, at the residence of the duc de Nivernois at Frascati, he drew it from "quelques points de veue." He remarked in a letter to the marquis de Marigny that he hoped to add to these works from time to time. The marquis, brother of the marquise de Pompadour, was director of buildings; and it was Natoire's obligation to make regular reports to him with regard to academy affairs.

Again at Frascati ten years later he wrote to Marigny on 21 July 1762 that he was sending Pierre-Jean Mariette four drawings by Pannini, eight by Robert, and four sketches by Durameau. He added that he was also sending Marigny two drawings which he himself had made during his visit to Frascati which were views of the cascade taken from the two opposite sides.

The present sheet which the Library acquired in 1965 and the drawing which entered a New York private collection at the same time are the very pair Natoire referred to. Both drawings are worked in his distinctive mixture of pen and wash, colored chalks, and white heightening. Each is dated 1762 and the artist has inscribed the verso of the drawing in the private collection, *pour monsieur le marquis…*; while this view is taken from the head of the cascade, the Library's drawing shows the foot of the cascade on the terrace above the Nymphaeum. To the Morgan sheet Natoire has added the small figure of an artist drawing, perhaps an allusion to one of his students. In 1755 the Library acquired one of the artist's earlier views of Frascati dated 1755 (Acc. no. 1955.3). Possibly these sheets were once part of the album of more than one hundred and six views of Rome by Natoire sold in 1778 after his death.

Pen and black ink, brown wash, black and red chalk, heightened with white on light brown paper

12 x 18½ inches (305 x 469 mm)

Watermark: none visible through lining

Inscribed by the artist at lower left in pen and brown ink, *Belvedere di Fescati,* and signed and dated, *C. Natoire 1762* at lower right

Provenance: Abel François Poisson, marquis de Marigny; P. & D. Colnaghi and Co., London.

Bibliography: PML/*FR*, XIV, 1967, pp. 125ff.; PML 1969, pp. 156f.; Duclaux 1975, under no. 55; Duclaux 1991, pp. 10, 11, no. 44, repr.

Exhibitions: London 1965, no. 18, pl. XIV; New York PML 1974, pp. xxf., no. 26, repr.; New York PML 1981, no. 101, repr.; New York PML 1984, no. 48.

Purchased as the gift of the Fellows

1965.18

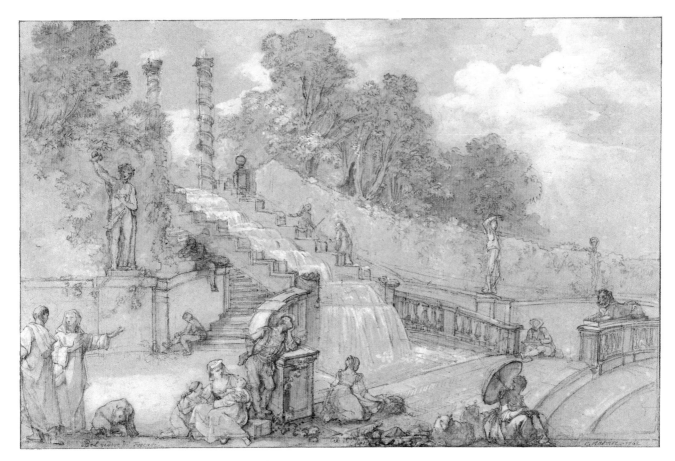

49 The Cascade at the Villa Aldobrandini, Frascati

Jacques Dumont, called le Romain

PARIS 1701 – 1781 PARIS

50 A Young Gentleman Leaning on a Chair Seen from Behind

THIS DRAWING is a study for the figure on the extreme left of a large portrait group in the Louvre, dating to 1731 (see Dimier 1930, p. 236, no. 9). The painting includes nine figures and depicts Louis XV's nurse Mme Mercier and her family. Drawings by Dumont are fairly rare. There are two portraits of him in the Louvre, one by La Tour and the other by Roslin.

In his *Abecedario* Mariette tells us that Dumont was called le Romain to distinguish him from another painter in the Académie Royale with the same name and because in his youth Dumont had gone to Rome. There he may have studied with Francesco Castiglione, although Mariette notes that he studied with Francesco's father, Benedetto. Returning to France in 1725, Dumont was received at the Académie Royale in 1728. "Il a de la dureté dans son dessin quoyque correct, et peu de finesse dans les expressions. Sa couleur n'est pas mauvaise, et c'est ce qui me plaît davantage dans ses tableaux. Son caractère caustique et sauvage n'étoit pas fait pour la société. Il n'a pu rompre et tout le monde l'a craint et l'a fui; c'est dommage, car il a du sens" (Mariette II, p. 133).

Red chalk

12⁷/₁₆ x 7⅛ inches (316 x 182 mm)

Watermark: none visible through lining

Signed at lower left in pen and brown ink, *J Dumont Le Romain*

Provenance: K. T. Parker, Oxford; P. & D. Colnaghi and Co., London; private collection, London; private collection, New York.

Bibliography: PML/*FR*, XXI, 1989, p. 336.

Exhibitions: London 1953, no. 398; London 1968, no. 211.

Gift of a Trustee

1985.75

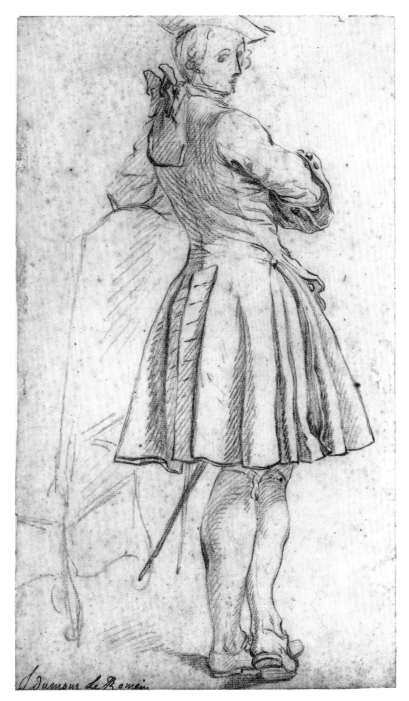

50 A Young Gentleman Leaning on a Chair Seen from Behind

François Boucher

PARIS 1703 – 1770 PARIS

51 Design for Frontispiece to "Tombeau du comte Sidney Godolphin"

Design for Frontispiece.
Inv. Nr. 15.274. Albertina, Vienna

LES TOMBEAUX DES PRINCES began as a money-making scheme designed by Owen MacSwiny, an Irishman living in Venice in the early 1700s. It was MacSwiny's intention to sell an important collection of twenty-four paintings, which he had commissioned of well-known contemporary Italian artists, of allegorical tombs memorializing a number of famous English heroes, statesmen, and scientists. The list of artists to paint these elaborate allegorical tombs included Marco Ricci, G. B. Pittoni, Canaletto, Creti, and Piazzetta. He sold only ten or eleven of the paintings, to the duke of Richmond, but he also published an expensive illustrated catalogue of engravings after the paintings and embellished these full-page engravings with engraved half titles as well. The full-page engravings were executed by Domenico Maria Fratta after designs made by such French artists as Cochin, Beauvais, and Le Bas. For this work, Boucher was commissioned to design eight half titles along with Carle van Loo. The collection appeared in 1736 under the title *Tombeaux des Princes, des Grands Capitaines et autres Hommes illustres qui ont fleuri dans la Grande Bretagne vers la fin du XVII et le commencement du XVIII Siècle. Gravés Par les plus Habiles Maitres de Paris, d'après les Tableaux et desseins originaux des plus célèbres Peintres d'Italie.*

Of Boucher's eight designs for this work, only three are known to have survived, including the Morgan sheet, a drawing for Sir Clowdisley Shovell (1650-1707), admiral of the fleet, (Inv. 15.274) in the Albertina, Vienna, and a design for the tomb of William III of England, which is in the collection of Sir Francis Watson, London. A black chalk copy in the Cooper-Hewitt Museum (repr. Washington and Chicago 1973-74, no. 13) records Boucher's lost design for the tomb of William Cowper, first lord chancellor.

Boucher's designs for this work were executed in the early 1730s, when he was closely associated with Juste Aurèle Meissonier, the famous *ornemaniste,* and they reflect his inventive rococo manner.

The Library's drawing was engraved by Cochin. Sidney Godolphin was the first lord of the Treasury under Queen Anne. The allegorical painting that was to follow Boucher's half title was painted by Francesco Monti.

Pen and black ink, gray and brown wash, heightened with white, over black chalk

24⅞ x 17¼ inches (630 x 437 mm)

Watermark: none

Signed at lower right in pen and black ink, *Boucher*

Provenance: Eugène Marich, Paris; Galerie Arnoldi-Livie, Munich.

Bibliography: PML/*FR*, XXI, 1989, pp. 321-23, fig. 15.

Exhibition: Berlin 1985, no. 5/1, repr.

Purchased as the gift of Mrs. Charles Wrightsman in honor of Mrs. Charles W. Engelhard

1985.68

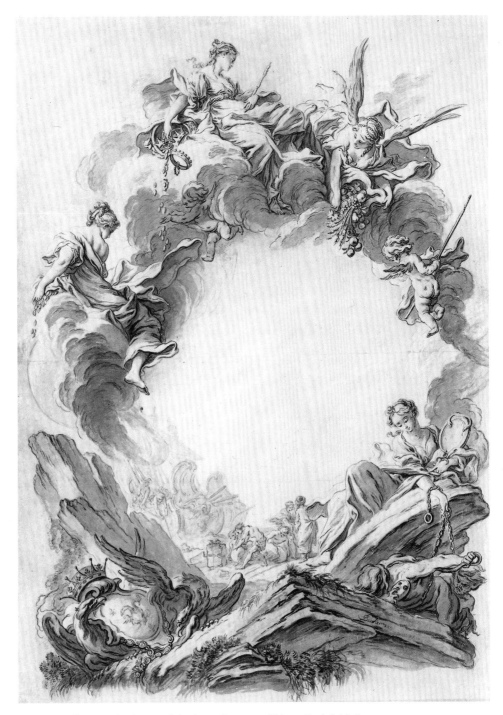

51 Design for Frontispiece to "Tombeau du comte Sidney Godolphin"

François Boucher

PARIS 1703 – 1770 PARIS

52 Thatched Mill Cottage and Shed with Two Trees at the Edge of a Stream

THIS DRAWING and another Boucher landscape in the Albertina were engraved in 1759 by the young Jean Hoüel, who visited Blondel Dazaincourt at Saumur for the express purpose of teaching him how to engrave. Dazaincourt, the renowned collector and amateur, is said to have owned some five hundred drawings by Boucher. While Hoüel's engraving of the Albertina drawing is dedicated to Blondel, the print that Hoüel made after the drawing now in the Library is dedicated to Dazaincourt's sister-in-law, Mme de La Haye Dazaincourt. It is possible that Boucher's drawing dates to the 1730s, when the artist went to Beauvais with Oudry to make designs for tapestries, and that the landscape depicted here reflects the surrounding countryside. As Felice Stampfle noted at the time of the Library's acquisition of the drawing (PML/*FR*, X, 1960, pp. 62f.), Hoüel's engraving extends Boucher's composition at the left adding a little footbridge and a church spire.

Black chalk and pale gray wash on gray paper

8¹¹/₁₆ x 12⁵/₁₆ inches (220 x 312 mm)

Watermark: laid down

Provenance: Blondel Dazaincourt; private collection, Saumur.

Bibliography: PML/*FR*, X, 1960, pp. 62-63, repr.; Jean-Richard 1978, under no. 1081.

Exhibitions: New York 1978, no. 7, fig. 33; Washington and Chicago 1973-74, no. 59, repr.; New York 1980, no. 56, repr.; Richmond 1981, no. 35, repr.; New York PML 1984, no. 51.

Purchased as the gift of the Fellows

1960.10

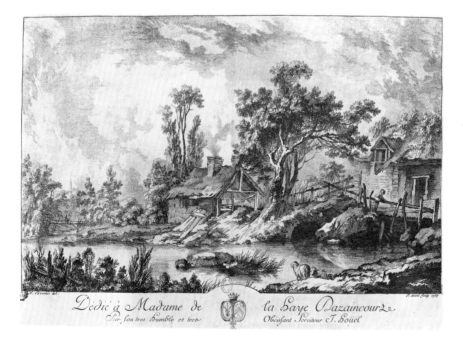

Jean Hoüel. Thatched Mill Cottage and Shed with Two Trees at the Edge of a Stream.

EIGHTEENTH CENTURY

52 Thatched Mill Cottage and Shed with Two Trees at the Edge of a Stream

François Boucher

PARIS 1703 – 1770 PARIS

53 Arion and the Dolphin

THIS DRAWING is connected to Boucher's painting, dated 1748, of the same subject. Although the artist received a commission from the king for a series of four paintings representing the four elements, he completed only two paintings, for which he was paid 1400 livres on 28 September 1749. The series was originally designed for use as overdoors in the château de la Muette, near the Bois de Boulogne, but apparently was never put into place there (see New York and elsewhere 1986-87, nos. 55, 56). In 1786 the paintings are mentioned in the sale catalogue of M. Bergeret, who, according to the catalogue, had acquired the paintings in 1764, "Deux charmantes compositions de cet artiste. L'une Vertumne et Pomone dans un riche fond de paysage et l'autre Arion porté sur un Dauphin jouant du luth, entouré de Tritons et Nayades: on voit plus loin le vaisseau qu'il vient d'abandonner."

While Boucher's painting *Arion and the Dolphin,* representing water, is now in the Princeton Art Museum, New Jersey, *Vertumnus and Pomona,* which represents the element earth, is in the Columbus Museum of Art, Ohio (repr. New York and elsewhere 1986-87, no. 56). The story of Arion and the dolphin comes from Herodotus: Arion, a Greek poet and musician, cast into the sea by pirates, was saved from certain death by a dolphin who came to his rescue when he heard the sound of his lyre. Both paintings were translated into engravings by Augustin de Saint-Aubin and Jacques-Jean Pasquier (repr. Jean-Richard 1978, no. 1443). In the de Sireul sale in 1781 this drawing was described as "Un superbe dessin....Il représente Arion sur les flots, échappé au naufrage."

Pen and brown ink, brown wash, heightened with white, over black chalk, on blue paper

7¹⁵/₁₆ x 11⅝ inches (200 x 295 mm)

Watermark: none visible through lining

Provenance: M. de Sireul, Paris; his sale, Paris, 3 December 1781, lot 88 (45 livres 1 sol); M. Boulle; sale, London, Christie's, 10 December 1991, lot 204; Artemis Fine Arts, London.

Bibliography: Michel 1889, no. 449; Ananoff 1966, no. 1006; Ananoff and Wildenstein 1976, II, under no. 328, fig. 953; Jean-Richard 1978, under no. 1443; New York and elsewhere 1986-87, under no. 55-56, p. 241 n. 1; Artemis 1993, p. 26, no. 10, repr. (in color).

Purchased on the Martha Crawford von Bulow Memorial Fund

1991.45

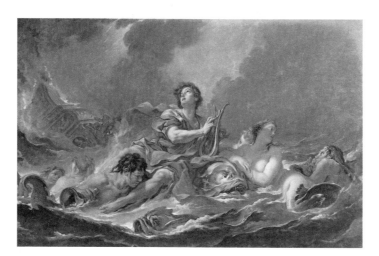

Arion and the Dolphin.
*1980-2. The Art Museum,
Princeton University.*

53 Arion and the Dolphin

François Boucher

PARIS 1703 – 1770 PARIS

54 Four Heads of Cherubim

AS THE MOST FASHIONABLE EXPONENT of the rococo style, Boucher was in demand not only as painter and engraver but also as decorator. He worked at Versailles, in many of the hôtels of Paris, at the Opéra, and in the tapestry manufactories of Beauvais and the Gobelins as well as the porcelain factories of Vincennes and Sèvres. The favorite artist of Mme de Pompadour, he is known to have executed many paintings on her commission, including a number of religious subjects such as *The Adoration of the Shepherds, The Education of the Virgin,* and *The Virgin and Child with the Infant Saint John.*

This highly finished drawing has such obvious decorative appeal that it might seem the artist intended it as an independent work to be framed and enjoyed in the salon or boudoir. In fact, as Regina Slatkin (1975) has pointed out, the studies are connected with Boucher's *Saint John the Baptist,* now in the Minneapolis Institute of Arts. The cherubs form a *gloire d'ange* above Saint John in this painting, which was executed by Boucher during the 1750s and was most probably destined for the altar of Mme de Pompadour's tomb. Groups of cherubs are present in all of Boucher's devotional paintings, and the artist, who had a son and two daughters, demonstrated a genuine feeling for children that comes across in his paintings and drawings. No fewer than five *livres de groupes d'enfants* are included in his engraved work.

St. John the Baptist. *Acc. 75.8.*
The Minneapolis Institute of Arts.

Black, red, and white chalk on gray paper
12⁹/₁₆ x 9⅞ inches (319 x 252 mm)
Watermark: none visible through lining
Inscribed in pen and brown ink at lower left, *f. Boucher* (with paraph)
Provenance: R. Langton Douglas, London; J. Pierpont Morgan (no mark; see Lugt 1509).
Bibliography: PML 1949, p. 93; Ananoff and Wildenstein 1976, p. 40, fig. 988; Michel 1987, p. 194, fig. 229 (in color).

Exhibitions: New York PML and elsewhere 1957, no. 100, pl. 62; Hartford 1960, no. 82; Stockholm 1970, no. 52; Washington and Chicago 1973-74, no. 8, repr.; New York PML 1974, p. xiii, no. 27, repr.; New York 1977b, no. 85, fig. 87; New York PML 1981, no. 102, repr.; New York PML 1984, no. 52.

Purchased from the estate of J. P. Morgan in 1943.

III, 104b

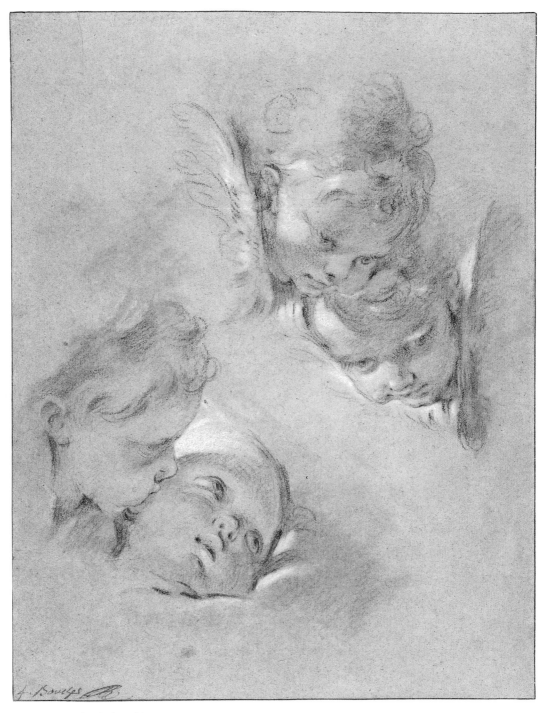

54 Four Heads of Cherubim

125

François Boucher

PARIS 1703 – 1770 PARIS

55　Young Woman in Classical Dress

THE UNUSUAL COSTUME of this young woman with her flowing robe, fringed stole, and turban-like headdress is very similar to that affected by both the Parthian princess and the queen of Syria in Boucher's study for the frontispiece to Corneille's tragedy *Rodogune,* which Mme de Pompadour had privately printed in 1759. The drawing for this frontispiece has for a long time been in the Morgan Library (III, 104a), and it is possible that the present drawing is also related to the same project. According to Regina Slatkin (Washington and Chicago 1973-74, nos. 80, 81), at least two other drawings connected with Boucher's work on the Corneille publication are known: one, a black chalk sketch, was in the Jourdeuil Collection and was sold at Christie's in the late 1960s (26 November 1968, lot 131); the other, in red chalk, heightened with Chinese white, was last seen in the Mühlbacher sale (1899, no. 90) and was at that time listed as *Rodogune. Scène à six personnages de la tragédie de Corneille. Illustration unique d'une édition publiée par Mme de Pompadour, en 1760.*

Black chalk, heightened with white, on gray-blue paper, faded to light brown

13¹¹⁄₁₆ x 8¹¹⁄₁₆ inches (348 x 222 mm)

Watermark: none visible through lining

Provenance: Camille Groult; J. Groult; sale, Paris, Georges Petit, 21-22 June 1920, lot 130; Thomas Agnew and Sons, Ltd., London; C. R. Rudolf (Lugt S. 2811b); his sale, London, Sotheby's, 21 May 1963, lot 50, repr.; N. L. H. Roesler, New York; Mrs. Charles E. Slatkin, New York.

Bibliography: Ananoff 1966, no. 755; PML/*FR*, XX 1984, pp. 239-40, fig. 25.

Exhibitions: London 1953, no. 428; London 1962, no. 166, pl. 26; New York 1964a, no. 10, repr.; Washington and Chicago 1973-74, no. 81, repr.; New York PML 1984, no. 50, repr.

Purchased on the Martha Crawford von Bulow Memorial Fund

1983.1

55 Young Woman in Classical Dress

Maurice Quentin de La Tour

SAINT-QUENTIN 1704 – 1788 SAINT-QUENTIN

56 Portrait of Mlle Dangeville
(Marie-Anne Botot, 1714-1796)

MLLE DANGEVILLE was a celebrity of the Comédie Française from 1730 to 1763. La Tour executed three portraits of the actress in pastel, two are in the Musée de Saint-Quentin, and the other is in the Louvre (R. F. 4099). In this sketch, one of La Tour's preparations for a full portrait, the artist has captured vividly the personality of the actress whose direct gaze seems to study the artist himself at work, a somewhat wicked smile enlivening her face. The portrait was included in a major exhibition of pastels at the turn of this century where it was described as "quelques coups de crayon de couleurs heurtées, de larges lumières à la craie, des balafres de sanguine et de noir, rien que cela, et c'est une tête. Vous regardez toujours: cette tête vient à vous, elle sort du cadre, elle s'enlève du papier et il vous semble n'avoir jamais vu dans aucun dessin de n'importe quelle école une pareille représentation d'une figure, quelque chose de crayonné qui fut autant quelqu'un de vivant."

The identification of the sitter was the subject of debate by Emile Dacier and Gabriel Henriot in the 1920s. M. Dacier doubted that the subject of this pastel could be the lady depicted in the pastels at Saint-Quentin and in the Louvre, but M. Henriot pointed out that there could be no doubt if one compared the likeness of Mlle Dangeville with the busts of her by Jean-Baptiste Lemoyne in the Comédie Française and (unknown to M. Dacier) by Defernex in the David-Weill Collection, which is signed, inscribed, and dated, *Melle Dangeville, par J.-Bte Deferneix, 1752*.

Colored chalks, stumped, on light blue paper

11¼ x 9⅛ inches (287 x 232 mm)

Watermark: none visible through lining

Provenance: J. Auguste Carrier, Paris; his sale, Paris, Féral, 5 May 1875, lot 9; Mme Becq de Fouquières, Paris; David David-Weill, Neuilly; Mrs. Byron Foy, New York; private collection, New York; E. V. Thaw and Co., New York.

Bibliography: Tourneux 1908, p. 9; Dacier 1913, [n.p.], repr.; Henriot 1925, p. 11, pl. XXI; Henriot 1927, pp. 29-30, repr.; Besnard and Wildenstein 1928, no. 92, pl. LXXII, fig. 127; Fleury and Brière 1954, p. 50, no. 13; PML/*FR*, XX, 1984, p. 270.

Exhibitions: Paris 1908, no. 30, repr. opp. p. 22; Paris 1927, no. 61; New York 1938, no. 7; New York PML 1984, no. 53.

Purchased on the von Bulow Fund

1981.12

56 Portrait of Mlle Dangeville (Marie-Anne Botot, 1714-1796)

Carle van Loo

NICE 1705 — 1765 PARIS

57 Portrait of a Seated Man

THIS DRAWING is one of a series of six large portrait drawings by Van Loo, three of which depict men, and three, women. All were done in 1743 and are signed and dated by the artist. All the subjects sat to the artist in the same room, perhaps the atelier of the artist himself.

In his time Carle van Loo became the most famous of a family of painters of Flemish descent who worked in France. Beginning his studies in Paris, he completed them in Italy and returned to France in 1734. Elected to the Académie Royale in 1735, appointed principal painter to the king in 1762, he became director of the academy in 1763. Van Loo was recognized by all his contemporaries, not only those in France but elsewhere on the Continent, as the first painter of Europe. His many works are located in museums all over the world. His portraits of the king and queen, for instance, are at Versailles. Early on, Van Loo showed a particular facility for drawing, his handling of the medium winning him first prize at the academy in 1723 when he was only eighteen. While his reputation as a painter has diminished over the course of time, he is still recognized today for his fine draughtsmanship, especially for his work in chalk because of the dexterity of his handling and the deft rendering of his forms. The present example speaks for itself in the polish of the fine details of dress and furniture, while the easy and natural pose of the sitter attests to the skillful grace of Van Loo's art.

While tradition has this drawing as a portrait of Jean Pâris de Montmartel, it is not possible to confirm this or any other identification of the sitter. In fact, it has not been possible to identify any of the remaining five portraits in the series which are today in the Morgan Library (Cat. no. 58), the Société Historique et Littéraire Polonaise, Paris; the Nelson Gallery-Atkins Museum, Kansas City, Missouri; and two whose present locations are unknown. The entire group as it is now constituted is discussed in the monographic exhibition devoted to the artist (Nice and elsewhere 1977, nos. 404-9, repr.)

Black and white chalk on blue paper faded to light brown

18⁷/₁₆ x 12¹¹/₁₆ inches (467 x 323 mm)

Watermark: none visible through lining

Signed and dated in pen and brown ink at lower left, *Carle vanloo f. 1743.*

Provenance: M. Dœuillet; his sale Paris, Galerie Georges Petit, 27 April 1932, no. 38, repr. pl. III; Louis Dumoulin; Camille Plantevignes; sale, Versailles, 16 May 1971, no. 29; Germain Seligman (stamp at lower left corner).

Bibliography: Réau 1938, p. 82, no. 27; Toronto and elsewhere 1972-73, p. 217, under no. 141; PML/*FR*, XVI, 1973, pp. 117-18; Nice and elsewhere 1977, no. 406, repr.; PML/*FR*, XX, 1984, p. 272; New York 1990a, under no. 5, repr.

Exhibitions: Paris 1933a, no. 279; Copenhagen 1935, no. 524; New York 1971, no. 29; New York PML 1984, no. 54.

Purchased on the Fellows Fund

1971.11

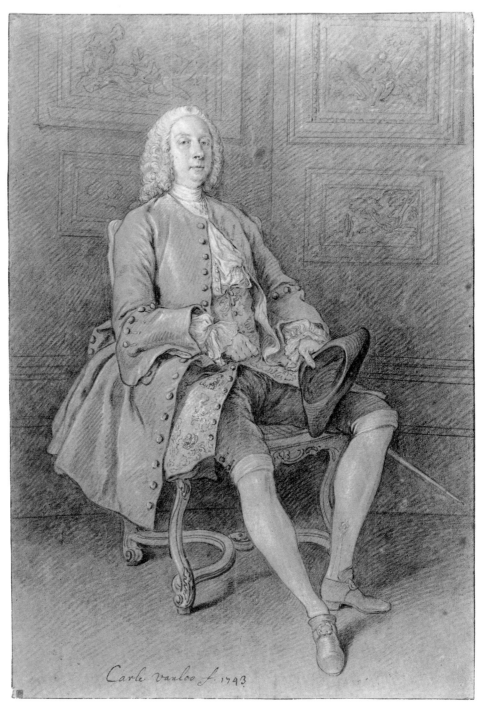

Carle vanloo f. 1743

57 Portrait of a Seated Man

Carle van Loo

NICE 1705 – 1765 PARIS

58 Portrait of a Seated Woman

NO IDENTIFICATION of this sitter has yet been advanced.
See Cat. no. 57.

Black chalk, heightened with white, on blue paper

18⁵/₁₆ x 12¹³/₁₆ inches (464 x 326 mm)

Watermark: fleur-de-lis (cf. Heawood 1517).

Signed and dated at lower left, in pen and brown ink, *Carle Vanloo 1743*

Provenance: Jean Masson (Lugt S. 1494a); his sale, Paris, Galerie Georges Petit, 7-8 May 1923, lot 232, repr. (for 800 frs.); M. Mohrange; sale, Casablanca, 25 March 1966, lot 32 (no catalogue); André Meyer, New York; his sale, New York, Sotheby Parke Bernet, 22 October 1980, lot 6, repr.; Richard J. Collins, Inc., New York; E. V. Thaw and Co., New York.

Bibliography: Goncourt 1881, pp. 166-68; Toronto and elsewhere 1972-73, pp. 216-17, under no. 141; PML/*FR*, XX, 1984, pp. 272-73.

Exhibitions: Nice and elsewhere 1977, no. 409, repr.; New York PML 1984, no. 55.

Purchased on the von Bulow Fund

1982.4

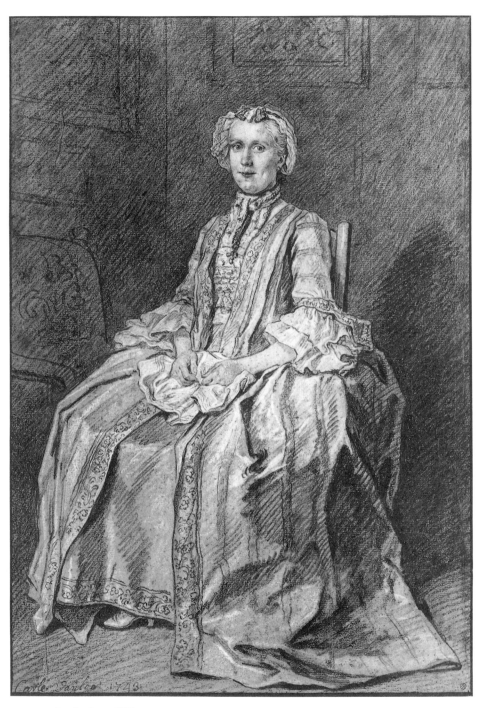

58 Portrait of a Seated Woman

133

Louis Carrogis called Carmontelle

PARIS 1717 – 1806 PARIS

59 Portrait of Mme de Castellane

CARMONTELLE was a skillful and facile draughtsman. He was also a *lecteur du duc de Chartres* (later duc d'Orléans) and the author of *Proverbes,* a volume of short plays and skits that were based primarily on proverbs and written for the duc's theater at Bagnolet. Many of the artist's portraits, most of which are done in profile, are now in the Musée Condé, Chantilly, and are valuable both as aesthetic and historical documents, depicting a wide cross-section of late eighteenth-century Parisian society. Carmontelle is truly a chronicler of the period, someone who, in the words of Edmond de Goncourt "let pass before his eyes the society of his time" and left a colorful record of it in these often very charming portraits.

The charming sitter, drawn here in profile, is identified as Madame de Castellane. She is shown seated in an armchair, protected against the chill of a cold day by a heavy black shawl and a long woolen skirt, decorated with a floral pattern; even her hands are being kept warm by a shaggy, red muff. She is seated before a fireplace which, judging from the high color on her cheeks and the strong cast shadows, probably contains a small fire.

In addition to the present drawing, the artist made at least two other versions of the subject. One, a somewhat larger and less finished study, is in a private collection in Switzerland. Another, which remains with the sitter's family, confirms that the subject is Jeanne de Castellane-Mazaugues, who was married to the marquis de Pontevès Castellane in 1788.

Black, red, and white chalk, watercolor, with a touch of pen and black ink to accent the sitter's eye

7¹¹/₁₆ x 8⁹/₁₆ inches (194 x 217 mm)

Watermark: not visible through lining

Provenance: sale, Paris, Hôtel Drouot, 1 June 1981, lot 21 (as Mme de Castellane), repr. on cover; Baskett & Day, London.

Bibliography: PML/*FR*, XX, 1984, pp. 246-47.

Exhibition: New York PML 1984, no. 60.

Purchased on the Lois and Walter C. Baker Fund

1981.51

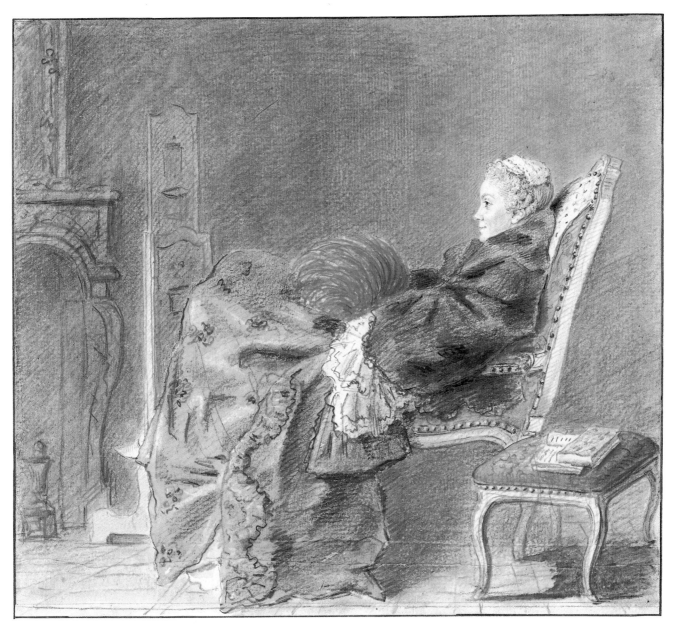

59 Portrait of Mme de Castellane

Charles Germain de Saint-Aubin

PARIS 1721 – 1786 PARIS

60 Title page lettered "Plantes et Fleurs Naturel[les] Par Saint Aubin," 1740

IN THEIR CHAPTER on the Saint-Aubin brothers in *L'Art du dix-huitième siècle* (1859-75), the Goncourts describe at some length an album of floral drawings made by the eldest, Charles Germain, who followed his father in the embroidery trade, although he practiced as a designer rather than as an artisan. The album, known as *Le Recueil des Plantes,* contains more than 250 watercolors and gouaches of flowers, birds, etc., executed by Charles Germain over a period of nearly fifty years, and on its title page was pasted a portrait of the artist executed by his younger brother, Augustin. The title page and the portrait of its artist came to the Library, and the album is now in an American private collection.

The album descended first to his eldest daughter, Marie-Françoise de Saint-Aubin, later Mme Dounebecq, and she willed it in 1822 to the engraver Pierre Antoine Tardieu, the husband of her niece. M. Tardieu proved a worthy recipient, for he was interested enough to record the foregoing facts at the front of the album, and to provide the note on the title page.

The drawings in the album carry dates ranging from 1736 to 1785, showing that Charles Germain was only fifteen when he began the series to which he continued to add pages up to the year before his death. It may be assumed that the artist must have accumulated a substantial group of drawings by 1740 when he executed and dated this title page. The title "Plantes et Fleurs Naturel[les]" is enclosed in the fanciful blue framework of an elaborate rococo cartouche, unexpectedly three-dimensional in places, and decorated with the trophies and tools of art and music.

As *dessinateur du roi* under Louis XV, Charles Germain enjoyed the patronage of the court, including the favor and friendship of the marquise de Pompadour, who made him gifts of fine furniture and porcelains and embroidered one of his designs. In 1770 he designed the wedding coat of Louis XVI. His engraved works include *Les Papillonneries humaines, Mes petits bouquets,* dedicated to the duchess of Chevreuse, *Mes fleurettes, Les bouquets champêtres,* and *Les fleurs chinoises et de caprice.*

Gouache and watercolor

14 x 9⁷⁄₁₆ inches (356 x 240 mm)

Lettered, at top, A LA NATURE; in small cartouche, *1740;* in large cartouche, *PLANTES / ET / FLEURS NATUREL / Par Saint Aubin;* at bottom, *1740*

Inscribed possibly in the hand of Pierre Antoine Tardieu, at lower right, in pen, *Portrait de Charles Germain de Saint Aubin auteur de ce livre / dessiné en 1767 à l'âge de 46 ans par Augustin de Saint Aubin / son frère; collé sur le premier titre de ce livre*

Watermark: Letter *P* followed by a fleur-de-lis and *CUSSON* (?) *MOYEN*, and an illegible word below

Provenance: Charles Germain de Saint-Aubin; Mme Dounebecq (Marie-Françoise de Saint-Aubin, the artist's eldest daughter); willed in 1822 to the husband of her niece, Pierre Antoine Tardieu; Hippolyte Destailleur; his sale, Paris, Damascène Morgand, 26-27 May 1893, lot 124; Baron Alphonse de Rothschild.

Bibliography: Moreau 1903, pp. 73-78, 129-34; PML/FR, VIII, 1958, pp. 77-79; Michel 1987, p. 157, fig. 132 (in color).

Exhibitions: New York PML 1980, no. 96; New York PML 1984, no. 116.

Purchased as the gift of the Fellows 1956.13

60 Title page lettered "Plantes et Fleurs Naturel[les]" Par Saint Aubin

Gabriel de Saint-Aubin

PARIS 1724 – 1780 PARIS

61 Design for a Fireworks Display Given by the City of Paris in Celebration of the Marriage of the Dauphin in 1747

LOUIS OF FRANCE, son of Louis XV, married his second wife, Marie-Josèphe of Saxony, in 1747. On the occasion of the first marriage, there had been a great public fête in Paris which lasted for two days; the public celebration marking the second marriage was limited to one day, but for both occasions sumptuous commemorative folios of engravings were issued. On 13 February 1747, the day of the dauphin's second marriage, a procession of cavalry and five magnificent floats traversed the city of Paris. First came floats dedicated to Mars and to Hymen, each occupied by thirty to forty musicians, then floats representing Ceres, Bacchus, and the city of Paris, which were laden with refreshments of all sorts for distribution to the citizenry along the way. Pausing once to replenish supplies, the procession made its way to all quarters of the city during the day. In the evening, the celebration reached its climax in a display of fireworks before the Hôtel de Ville.

The last of the large double plates of the commemorative volume of 1747 is devoted to the fireworks: "Représentation du Feu d'Artifice...." It shows in the center the Corinthian temple of Hymen rising from the water on an octagonal stepped base, and in the interior the god of marriage lighting the fire of the altar. In the water below is the nuptial car of Neptune and Amphitrite drawn by sea horses and appropriately attended by dolphins, the symbol of the dauphin. Other marine figures occupy the summit of the high rocks that flank the scene.

This in general is what one also sees in the Morgan drawing. The long central octagonal unit of the temple, the god at the altar, the inhabited clouds above, the lateral rocks, and Neptune's chariot are all present, but in no detail do drawing and engraving coincide. The temple in the drawing has no balustrade and no statues at the upper level, the god at the altar is a youth rather than an infant, the figures in the clouds are quite different, the rocks are covered with putti instead of the engraving's figures symbolic of the rivers of France and Saxony, the Neptune of the drawing is more amorous than regal in his pose. Playful touches in the drawing, such as the putto flourishing Neptune's great trident, the billowing arc of Amphitrite's draperies, the remarkable energy of the Triton's tail, and the spouting dolphin, are absent from the more sedate en-

Pen and black ink, black and gray washes, over preliminary indications in black chalk; a few passages in pen and brown ink, and three sketches of ornament and a dolphin in black chalk. Squared for enlargement in black chalk

16⅜ x 23⅝ inches (416 x 599 mm)

Watermark: a cluster of grapes and the name, D. MAR... / AUVERGNE (cf. Heawood 3377)

Inscribed at the lower left in pen and brown ink: *Feu du mariage du Dauphin tiré le 12 février 1747/ L'artifice tirer par les deux artificiers Italien, et francais/ la feste des chars le 9. jour du mariage.* In the lower center is an indication of the scale in *pieds* and *toises*. Inscribed in black chalk at left center *obscure*, at right center *clair*

Provenance: W. R. Jeudwine, London.

Bibliography: Dacier 1929-31, p. 27; PML/*FR*, XIII, 1964, pp. 105-8, repr. (det.); PML 1969, p. 168.

Exhibitions: Middletown and Baltimore 1975, no. 33, repr.; New York PML 1984, no. 63.

Purchased as the gift of Mr. and Mrs. Carl Stern

1962.10

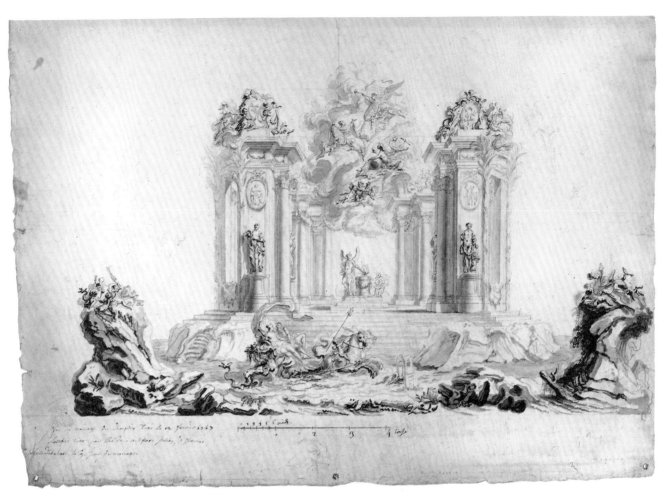

61 Design for a Fireworks Display

graving. Tamer, too, is the byplay of the heraldic eagle and the Gallic cock: in the
drawing they are delightfully caught up in a circlet and held by two cherubs
while a third holds another marriage garland above the group.

According to the inscription on the title page, the author of the designs
engraved in the 1747 book was "François Blondel, Architecte du Roy," but there
is reason to believe that our drawing was the work of a young teacher in the
Ecole des arts, the school of architectural studies that Blondel had established in
Paris in 1742. That young teacher was Gabriel de Saint-Aubin, who is first
mentioned in print as an instructor at Blondel's school. In Blondel's brochure,

published in the year of the dauphin's marriage, "M. de Saint-Aubin, peintre" is mentioned as teaching on Wednesdays, Thursdays, and Saturdays from three in the afternoon until eight in the evening. He was prepared to give instruction in the principles and proportions of the human body, such history as might be necessary to deal properly with attributes and allegories suitable for the palace of the king, sacred buildings, country houses, public buildings, fêtes, etc.

Title page for Blondel's Fête Publique.
PML 53100

Description page from Fête Publique,
designed by Joseph Le Lorrain. PML 53100

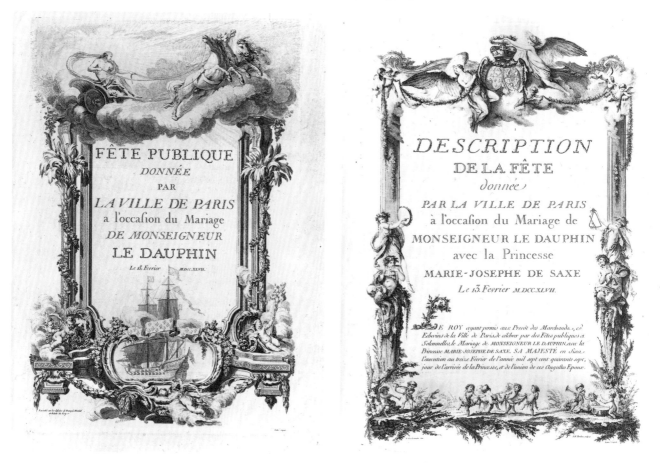

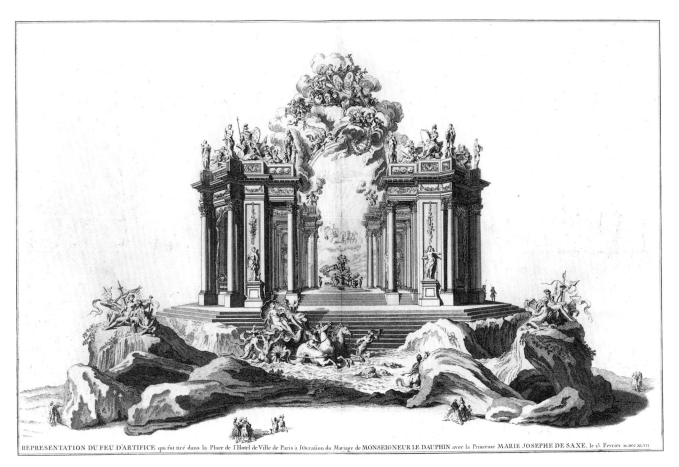

REPRESENTATION DU FEU D'ARTIFICE qui fut tiré dans la Place de l'Hotel de Ville de Paris à l'Occasion du Mariage de MONSEIGNEUR LE DAUPHIN avec la Princesse MARIE JOSEPHE DE SAXE. le 13. Fevrier M.DCC.XLVII

Engraving, Representation du Feu D'Artifice, *from* Fête Publique. *PML 53100*

Gabriel de Saint-Aubin

PARIS 1724 – 1780 PARIS

62 Momus

GABRIEL DE SAINT-AUBIN all but abandoned painting at the age of twenty-eight when he lost the 1752 competition for the *Prix de Rome* to Fragonard, but he drew and continued to make prints throughout his life, leaving a vivid and witty record of every aspect of Parisian life in more than a thousand drawings.

Given its size and technique, the Morgan drawing is unusual in the oeuvre of the artist, who is known chiefly for his lively interior scenes animated by crowds of people quickly indicated in a few strokes of brush or chalk. The *Momus* is, however, a relatively early work and its quality is entirely consistent with Saint-Aubin's keen sense of movement and style. The drawing is executed chiefly in red and black chalk with all of the artist's customary ease and assurance and his own peculiar manner of applying accents.

Momus, the god of banter, is here represented as a ballet dancer. In his raised left hand he grasps the fool's rattle, an attribute belied by the elegance of his costume and the assured grace of his stance. In his right hand he holds a long scroll advertising a collection of costume designs for the ball at St. Cloud in 1752. Although no further drawings or any prints can be associated specifically with this event, Saint-Aubin probably intended his *Momus* to adorn the title page of a collection of engraved costumes.

Red and black chalk, with a few touches of white

13⅞ x 9½ inches (353 x 242 mm)

Watermark: partially decipherable letters in cartouche and, below, *Auvergne* in cartouche

Inscribed in scroll, probably by the artist, *Recue*[il] / *de* / *Déguisem*[ents] / *du Bal de* / *Saint Cloud* / *1752* / *D.s Gl. de Saint-Aubin*

Provenance: Gilbert Levy; David David-Weill, Neuilly; Mrs. D. Peck; George de Batz.

Bibliography: PML/*FR*, VI, 1955, pp. 72-74, repr.; PML 1969, p. 168, pl. 47; Vaissière 1981, p. 58, repr.

Exhibitions: Baltimore 1940 (no catalogue); New York 1944-46, no. 98; New York PML and elsewhere 1957, no. 103, pl. 69; Baltimore 1959, no. 74; London 1968, no. 637, fig. 321; New York PML 1974, p. xxi, no. 28, repr.; Middletown and Baltimore 1975, no. 35, repr.; Providence 1979, no. 54, repr.; New York PML 1981, no. 103, repr.; New York PML 1984, no. 64 (repr. in color on back cover).

Purchased as the gift of the Fellows 1954.9

62 Momus

Gabriel de Saint-Aubin

PARIS 1724 – 1780 PARIS

63 Young Woman Standing on the Seat of a Carriage

ALMOST A HUNDRED YEARS AGO this subject was identified as Mlle Duthé on the Champs Elysées. It was thought to reflect Saint-Aubin's interest in the anecdote, recorded in the *Mémoires secrets* of the famous courtesan, in which she called attention to herself by standing on top of her carriage in the manner of a lady of quality at the Champs Elysées (Pichon sale catalogue, under lot 130). This particular interpretation has not been considered viable for some time, and it seems most likely that Saint-Aubin simply made a sketch of this young lady on the spot, having seen her standing outside her carriage with her coachman and footmen, most likely in order to get a better view of a royal entry or some other ceremonial occasion. That the young woman is the real subject of the drawing is borne out by Saint-Aubin's detailed study of her rather than her servants and horses, who are only lightly sketched in.

Black chalk, with touches of black ink and gray wash

6½ x 8¹⁵/₁₆ inches (166 x 226 mm)

Watermark: fragment of a coat of arms surmounted by a crown within a circle

Inscribed on verso at lower center in graphite, *dessin J.(?)S Aubin acheté à* [illegible]

Provenance: Baron Jérôme Pichon; his sale, Paris, 17 May 1897, lot 130 (as *Mlle Duthé aux Champs Elysées* [55 francs with lot 129]; Henri Pannier; his sale, Paris, 9 May 1919, lot 39 (2,000 francs); Paul Helleu; his sale, Paris, 28-29 March 1928, lot 84, repr. (13,100 francs); F. Koenigs, Haarlem; M. and Mme Boerlage-Koenigs, Laren; Artemis Fine Arts, Ltd., London.

Bibliography: Dacier 1929-31, II, no. 722; PML/*FR*, XXI, 1989, p. 377.

Exhibitions: Paris and Amsterdam 1964, no. 85, pl. 103; New York PML 1984, no. 65.

Purchased on the von Bulow Fund

1984.7

63 Young Woman Standing on the Seat of a Carriage

Gabriel de Saint-Aubin

PARIS 1724 – 1780 PARIS

64 The Lesson of the Chemist Sage at the Hôtel des Monnaies, 1779

ON 11 JUNE 1778, Balthasar Georges Sage (1740-1824) was appointed to the newly created chair of domestic minerology and metallurgy at the Hôtel des Monnaies. The hôtel was established on the rue de la Monnaie at the beginning of the fourteenth century. In 1768 Louis XV ordered the demolition of the hôtel, and that year Jacques Denis Antoine was commissioned to design a new building, which was completed in 1777. The new hôtel attracted the attention of many artists because of the "harmonie de ses proportions et la magnificence de l'ensemble." This is one of three known drawings by Saint-Aubin recording Sage's lectures and demonstrations (see Dacier 1929-31, II, nos. 435-37). It joins five other drawings by Saint-Aubin in the Library and is in many ways the most typical drawing by the artist, who is especially known for his brilliant drawings recording contemporary life in Paris.

Black chalk with some stumping and graphite, point of brush and brown ink, gray wash, some bodycolor

7⅞ x 5¹⁄₁₆ inches (198 x 128 mm)

Watermark: fragment of a crown

Signed and dated in pen and black ink at lower margin, *par Gabriel St. Aubin 1779;* in graphite, *La leçon de M. Sage a l'hotel de la Monaye*

Provenance: Jacques Doucet, Paris; his sale, Galerie Georges Petit, Paris, 5 June 1912, vol. I, lot 54, repr. no. 50; G. Pardinel (for 30,200 francs); François Coty, Paris; sale, Galerie Jean Charpentier, Paris, 30 November -1 December 1936, lot 15, repr.; Samuel Kress, New York; Mrs. Kilvert, New York; Audrey Cory de Ayala, New York and Paris; Mr. and Mrs. Robert H. Smith, Bethesda, Md.; Rosenberg & Stiebel, New York.

Bibliography: Dilke 1902, p. 134, repr. opp. p. 134; Tourneux 1904, p. 28, repr.; Dacier 1911; Dacier 1929-31, II, no. 435; Paris 1984, under no. 3.

Exhibitions: Paris 1925b, no. 81; Ann Arbor 1969, no. 69; Middletown and Baltimore 1975, no. 57, repr.

Purchased on the Martha Crawford von Bulow Memorial Fund

1991.4

64 The Lesson of the Chemist Sage at the Hôtel des Monnaies, 1779

Jean-Baptiste Greuze
TOURNUS 1725 – 1805 PARIS

65 Portrait of Denis Diderot (1713-1784)

GREUZE'S strong life-size portrait of Diderot shows the subject in profile. This was a fashionable mode of rendering at the time because of the ease with which the profile portrait could then be engraved in quasi-antique medallion style. Such treatment, of course, was most appropriately applied to sitters of rank or eminence. Denis Diderot, the famous French *philosophe* and chief editor of the renowned *Encyclopédie*, falls naturally into the latter class. The Morgan drawing has been engraved many times, by Augustin de Saint-Aubin among others.

Diderot left an often-quoted account of his own self-image written in 1767 in which he compares himself with classical prototypes:

> J'avais un grand front, des yeux tres-vifs, d'assez grands traits, la tête tout a fait du caractère d'un ancien orateur, une bonhomie qui touchait de bien près à la betise, à la rusticité des anciens temps. Sans l'exagération de tous les traits dans la gravure qu'on a faite d'après le crayon de Greuze, je serais infiniment mieux.

Greuze obviously stressed these supposed qualities in an attempt to portray the sitter on his own terms. It is ironic that in 1765 Diderot in effect declared that Greuze was the greatest French artist but within the space of four years he reversed this opinion completely, placing Greuze outside the orbit of his critical favor.

The artist is also represented in the collection by several large *têtes d'expression* in red chalk (see Cat. no. 66) and by the drawing *Anacreon in His Old Age Crowned by Love,* which is executed in much the same media as this portrait of Diderot.

Black and white chalk, stumped, on warm brown paper

14¼ x 11³⁄₁₆ inches (361 x 283 mm)

Watermark: none visible through lining

Signed, in upper right: *J. B. Greuze.* Inscription on an old label once pasted on back of frame, *Portrait de Diderot / Dessiné par Greuze pour le Baron d'Holbach / donné par M' d'Holbach fils à Made. de Vandeul, fille, de Diderot. / Après la mort de Made. de Vandeul, il m'a été donné / par Monsr. de Vandeul son fils, le 21 Décembre 1824. / E. S.*

Provenance: Denis Diderot, Paris (according to Baron Grimm in 1767); Paul-Henri Dietrich, Baron d'Holbach, Paris; his son, M. d'Holbach; Mme de Vandeul, Diderot's daughter; her son, M. de Vandeul; E. S. ("E. S." may be Eugène Salverte according to Arthur M. Wilson); Martial François Marcille (according to Martin), Paris, (1790-1856; no mark; see under Lugt S. 605a); his sale, 4-7 March 1857 (sold for 135 francs according to Martin, not listed in sale catalogue); Hippolyte Walferdin, Paris; his sale, Paris, Féral, 3 April 1880, lot 76 (sold for 200 francs according to Martin); David David-Weill, Neuilly.

Bibliography: Valori 1813 (reprinted by A. Montaiglon, ed., in *Revue universelle des arts,* XI, 1860, p. 367 n. 1); Smith 1837 (*Supplement* 1842, no. 124); Thoré 1846, p. 5; Diderot 1875-77, XX, pp. 116-17; Tourneux 1878, pp. 124-25; Grimm 1879, VII, p. 202; Portalis and Béraldi 1880-82, I, p. 159, II, pp. 64, 266; Martin and Masson 1908, no. 1108; Henriot 1928, pp. 209, 211; Seznec and Adhémar 1967, IV, p. 164; PML/FR, IX, 1959, pp. 108-9; Wilson 1972, repr. opp. p. 364; Seznec 1972, p. 535, repr.; Rosenberg and Compin 1974, pp. 186-87, fig. 7; Preston 1977, p. 137, fig. 2; Schnapper 1977, p. 91; Bukdahl 1980, pp. 148-49; Apgar 1985, p. 109, repr.

Exhibitions: Paris 1846; New York 1938, no. 97; New York 1943b, no. 10; New York 1944c, no. 43; London 1968, no. 321; Ann Arbor 1969, no. 47; Hartford and elsewhere 1976-77, p. 89, no. 50, repr.; New York PML 1981, no. 104, repr.; New York PML 1984, no. 67; Clermont-Ferrand 1984, pp. 27 (mentioned under no. 3), 28 (mentioned under no. 4); Paris 1984-85, pp. 252-53, fig. 68; Brussels 1985, no. 1, p. 3.

Purchased as the gift of John M. Crawford 1958.3

65 Portrait of Denis Diderot (1713-1784)

Jean-Baptiste Greuze

TOURNUS 1725 – 1805 PARIS

66 Head of a Young Man

GREUZE'S distinctively lush use of red chalk is shown to advantage in the Library's large study of a young man's head. The artist made more than one version of this study which, while related to Greuze's painting of 1777, *The Father's Curse: The Ungrateful Son,* is not really preparatory for it. As Edgar Munhall has shown (see Hartford and elsewhere 1976-77, under no. 85), this drawing and one in a private collection in Baltimore (repr. ibid.) are actually *têtes d'expression,* studies intended to represent a particular emotional condition. Here, as Munhall points out, the specific state represented is pain and this, according to Munhall, actually depends on Charles Le Brun's representation of physical pain in his book *Conférence sur l'expression générale et particulière,* which in turn depends on the *Laocoön* group.

Red chalk

15 x 12³⁄₁₆ inches (382 x 310 mm)

Inscribed at lower right, in graphite, *Greuze*

Provenance: Charles Fairfax Murray; J. Pierpont Morgan (no mark; see Lugt 1509).

Bibliography: Fairfax Murray 1905-12, I, no. 286, repr.; Hartford and elsewhere 1976-77, under no. 85.

Exhibition: New York PML 1984, no. 66.

I, 286

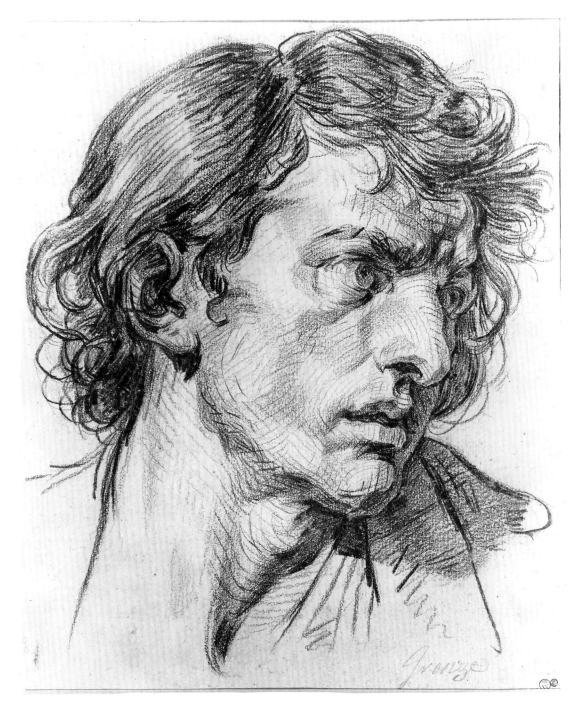

66 Head of a Young Man

François-Hubert Drouais

PARIS 1727 – 1775 PARIS

67 Portrait of the Artist's Wife

FRANÇOIS-HUBERT was the most well-known of the three generations of artists bearing the Drouais name. At the time Mariette compiled his *Abecedario*, he wrote, "il se distingue dans le genre du portrait et est en vogue." His success had begun with the salon of 1755 where he exhibited among other pieces the portrait of a little boy entitled *Le Petit Polisson*. Almost immediately thereafter he found favor at the court, and in 1757 his double portrait of the infant sons of the dauphin, the future Louis XVI and Louis XVIII, insured his success as a portraitist, particularly as a painter of children. The young *peintre à la mode* was married the following year, and about this time he produced the likeness of his wife, Anne-Françoise Doré (1732-1809), the picture from the Beistegui Collection which is now in the Louvre. Drouais became *peintre du roi* in 1758, the year of his marriage, and *premier peintre* in 1772.

Femme de l'artiste.
Musée du Louvre

Mme Drouais is quite young in the Library's drawing, which cannot be too far in date from the Louvre painting. It could conceivably even have been one of a series of studies which preceded the formal painted portrait. Since, however, in the drawing the young woman is much more simply attired, and possibly a trifle younger, it could just as easily be a drawing made for the sheer pleasure of recording the winsome, fresh countenance and open gaze of the artist's new wife. Whether or not the drawing and painting have more in common than the appealing subject, the drawing is, as Jean Guiffrey remarked of the latter work, "une oeuvre exécutée dans la joie d'un amour récent et partagé."

Black, brown, red, and yellow chalk with some stumping

13¾ x 9³⁄₁₆ inches (346 x 250 mm)

Watermark: fleur-de-lis over date, *1742*

Provenance: Nathan Chaikin, Switzerland.

Bibliography: PML/*FR*, XV, 1969, pp. 119-20, repr. opp. p. 120.

Exhibition: New York PML 1984, no. 68.

Purchased as the gift of the Fellows, with the assistance of Anne and Carl Stern

1967.3

67 Portrait of the Artist's Wife

Jean Honoré Fragonard

GRASSE 1732 – 1806 PARIS

68 The Sacrifice of Coresus

NO PREPARATORY DRAWINGS are known for *The Sacrifice of Coresus to Save Callirhoé,* the painting Fragonard exhibited at the Academy in March 1765. This highly finished wash drawing, which the artist apparently made after the painting in the Louvre, is, however, extremely close to the oil sketch for the project, now in the Academy of San Fernando, Madrid.

The subject, which is taken from Pausanius (VII, 21, 1), is unusual in art, although Fragonard made the most of its dramatic possibilities. André Cardinal Destouches (1672-1749) wrote an opera based on the story, *Callirhoé,* which had its premiere in Paris in 1714 and was revived several times during the eighteenth century. Natoire, who was director of the French Academy in Rome during Fragonard's tenure, is also known to have tried his hand at the subject and may possibly have suggested it to the younger artist.

According to the story, Coresus, a priest of Dionysus, falls in love with the young girl Callirhoé, but she is not interested in him. In a spirit of revenge he turns to Dionysus, who visits plagues and disasters on the land. The only way to end these calamities is apparently the sacrifice of Callirhoé, but Coresus kills himself instead. In the painting Fragonard has depicted the moment when Coresus stabs himself as horrified spectators look on.

Black chalk, brush and brown wash

13¾ x 18⅛ inches (347 x 465 mm)

Watermark: none visible

Provenance: Varanchan de Saint-Geniès; his sale, Paris, 29-31 December 1777, no. 58; M. Morel; anonymous sale, Paris, 19 April 1788, no. 375; Maherault; his sale, 27-29 May 1880, no. 58; Charles Fairfax Murray; J. Pierpont Morgan (no mark; see Lugt 1509).

Bibliography: Goncourt 1865, p. 324; Portalis 1889, p. 297; Nolhac 1906, p. 51, repr.; Fairfax Murray, 1905-12, I, no. 288, repr.; Wildenstein 1926, pp. 9-10; Shoolman and Slatkin 1950, p. 82; Réau 1956, pp. 148, 192; Ananoff 1968, no. 1714, fig. 433 under no. 236; London 1968, under 236; Massengale 1979, p. 271; Ashton 1988, pp. 115-16, fig. 17; Cuzin 1988, pp. 89, 252 n. 11, fig. 114.

Exhibitions: Baltimore 1959, no. 47; New York 1977b, no. 87; Washington and elsewhere 1978-79, pp. 19-21, no. 18, repr.; New York PML 1984, no. 70; Paris and New York 1987-88, no. 106, repr.

I, 288

Le Grand prêtre Corésus se sacrifie pour sauver Callirhoé.
Inv. 4541, Musée du Louvre

68 The Sacrifice of Coresus

Jean Honoré Fragonard

GRASSE 1732 – 1806 PARIS

69 A Young Woman Seated

FRAGONARD produced a whole series of drawings in red chalk of fashionably dressed young women, some of which were later engraved. Unlike most of these studies, however, this drawing begins with a slight sketch in graphite and is generally less spontaneous and more fully composed.

It has been suggested that the girl in the drawing may be a member of Fragonard's family since a similar young woman appears in several other works by the artist, notably the *Girl with the Marmot* in the Albertina, identified as the artist's daughter, Rosalie. In 1907, when Mr. Morgan purchased the present drawing, it was believed to be a portrait of Marguerite Gérard, Fragonard's sister-in-law. As Eunice Williams noted (Washington and elsewhere 1978-79, no. 31), the Morgan sheet is related to another highly finished red chalk drawing by the artist in the Musée des Beaux-Arts, Orléans, *Girl Standing in a Garden Seen from Behind,* where the subjects are similar and where the artist begins with a lightly sketched underdrawing in black chalk.

Red chalk with a few slight indications in graphite

8¾ x 11¹/₁₆ inches (222 x 281 mm)

Watermark: none visible through lining

Provenance: M. de Bèze; his sale, Paris, 3 April 1775, no. 329; Lasquin (according to inscription on verso of old mount; see Lugt S. 1139a); Eugene Glaenzer, New York; from whom purchased by J. Pierpont Morgan in 1907 (no mark; see Lugt 1509).

Bibliography: Portalis 1889, p. 304; Ananoff 1961, I, no. 197.

Exhibitions: New York PML 1939, no. 116; Hartford 1960, no. 85; Stockholm 1970, no. 54; Washington and elsewhere 1978-79, p. 21, no. 31, repr.; New York PML 1984, no. 73.

I, 289a

69 A Young Woman Seated

Jean Honoré Fragonard

GRASSE 1732 – 1806 PARIS

70 Landscape, with Flock and Trees (Shepherd Boy and Sheep on a Sunny Hillside)

THIS FRESH and detailed landscape contrasts dramatically with Fragonard's sanguine drawings of elegant villas and gardens which were either executed in Italy or recalled his sojourn there. Fragonard's response to the northern seventeenth-century landscapists, Ruisdael in particular, who were popular with French eighteenth-century collectors, is well demonstrated in the Morgan sheet. A brilliant draughtsman whose drawings are often quick and seemingly effortless in execution, Fragonard has here used a careful pointillist technique, which he seems to have developed in the 1770s, to render form and especially foliage in tone upon tone of brown wash. While such compositional devices as the silhouetting of the large trees in the foreground and the paralleled diagonals of the hill and the areas of sunlight in the sky are borrowed from Ruisdael, the view itself appears to be entirely French. Eunice Williams cites and characterizes two related drawings in the Groult Collection, *L'Abreuvoir sous l'avance d'une roche* and *Le Troupeau sous l'orage* (Ananoff 1963, nos. 832, 843), both of which are similar in execution and in the artist's adaptation of the Dutch manner.

Brush and brown wash over graphite

13⁹⁄₁₆ x 18³⁄₈ inches (344 x 466 mm)

Watermark: none visible through lining

Inscribed on back of mount, in pen and red ink, *No. 3,* and *No. 44./F*

Provenance: Sir James Knowles (Lugt 1546); his sale, London, Christie's, 27-29 May 1908, lot 238; Charles Fairfax Murray; J. Pierpont Morgan (no mark; see Lugt 1509).

Bibliography: Portalis 1889, p. 309 (possibly this drawing); Fairfax Murray 1905-12, III, no. 114, repr.; Ananoff 1968, p. 272, no. 1380, fig. 389; Massengale 1979, p. 271, fig. 104; Sutton 1987, p. 106; Cuzin 1988, pp. 197, 255 n. 25, fig. 242.

Exhibitions: Montreal 1950, no. 75; New York PML 1953, no. 32, pl. XI; New York PML and elsewhere 1957, no. 105, repr.; Washington and elsewhere 1978-79, no. 49, repr. in color; New York PML 1981, no. 105, repr.; New York PML 1984, no. 71; Paris and New York 1987-88, no. 95, repr.

III, 114

70 Landscape, with Flock and Trees (Shepherd Boy and Sheep on a Sunny Hillside)

Jean Honoré Fragonard

GRASSE 1732 – 1806 PARIS

71 La Récompense *or* Il a gagné le prix

THE CHARMING DOMESTIC SCENE depicted here with such spontaneity
is traditionally associated with Fragonard's visits to the home of his friend and
patron, Pierre Bergeret de Grancourt. Here, Bergeret's young son, fresh from
some schoolroom triumph, is borne into the salon to the welcoming arms of his
family.

The Library's drawing is Fragonard's first sketch for *La Récompense* or *Il a
gagné le prix,* which the artist then transferred with a dry stylus and very few
changes to the sheet of the finished drawing (in the Marcille Collection). Gray
wash is rapidly brushed over the preliminary sketch in black chalk in a brilliant
display of technique. A pendant composition, *Le Concours,* exists, also in a first
sketch, now in the Städelschen Kunstinstitut at Frankfurt am Main, and in a
finished drawing which, like the final version of *La Récompense,* is in the Marcille
Collection.

Felice Stampfle convincingly dated the Morgan drawing to the early 1780s on
the basis of style as well as on the facts of M. Bergeret's second marriage in 1777,
the approximate age of the child in the drawing (five or six), and M. Bergeret's
death, which occurred in 1785.

Black chalk and gray washes; outlines
traced for transfer with stylus. Verso:
faint sketch of a figure group under a tree
in black chalk

16⅞ x 13½ inches (429 x 342 mm)

Watermark: none

Provenance: H. Walferdin; his sale, Paris,
12-16 April 1880, no. 261; Camille Groult;
anonymous sale, Paris, 19 December 1941,
no. 46; Ancel; Mme Mottart; sale, Paris,
Galerie Charpentier, 8 February 1945, no.
38; Galerie de Bayser, Paris.

Bibliography: Goncourt 1865, p. 342;
Portalis 1889, p. 331; Réau 1956, p. 204;
PML/*FR*, VII, 1957, pp. 76-79, repr.
(frontispiece); Ananoff 1957, p. 522; PML
1969, p. 145; PML 1974, no. 29.

Exhibitions: Baltimore 1959, no. 48;
London 1968, no. 278, fig 293; New York
PML 1974, no. 29; Washington and
elsewhere 1978-79, p. 23, no. 58, repr.; New
York PML 1984, no. 72; Paris and New
York 1987-88, no. 278, repr.

Purchased as the gift of the Fellows

1955.5

71 La Récompense *or* Il a gagné le prix

Jean Honoré Fragonard

GRASSE 1732 – 1806 PARIS

72 Portrait of a Neapolitan Girl

TWO YEARS after his sojourn in Rome as *pensionnaire* at the French Academy, Fragonard returned to Italy with his friend and patron, Bergeret de Grancourt. In this instance the artist acted as guide for Bergeret, who had never before visited Italy. The two men set out in the autumn of 1773 and did not return to France until the summer of 1774. During the course of this extended trip, Fragonard made numerous drawings of the people and places they saw. This beautiful wash drawing of a young Neapolitan was executed in May 1774 when they visited Naples. Eunice Williams has pointed out that Fragonard's inscription indicates that the drawing was made on the *passegiata di Santa Lucia*, a favorite gathering place on Sundays. Although not specifically mentioned in Bergeret's journal, François-André Vincent (1746-1816), who visited them earlier in Rome, must have accompanied the two men to Naples. He also drew the young woman in preparation for the painting, once owned by Bergeret, and now on the Paris art market (repr. in color in Atlanta 1983, no. 35). The full details of the model's distinctive costume can be fully appreciated in the painting. Since it was during the feast of Januarius, she wore her best clothes, a black velvet jacket and red skirt trimmed with much gold lace. Fragonard's portrait is a study of her head and shoulders, concentrating on her face. Charming as Vincent's portrait is, Fragonard's drawing–worked almost exclusively in brush and wash–captures something of the psychological presence of the young woman as well as her features and interesting clothes and is one of the most memorable drawings by Fragonard.

Brush and brown wash over slight traces of black chalk

14⁷⁄₁₆ x 11⅛ inches (367 x 282 mm)

Watermark: Vanderley (cf. Heawood 2749)

Inscribed in pen and brown ink at lower right, *Naples 1774–femme de / St.t Lucie*

Provenance: Antoine Marmontel; his sale, Paris, Hôtel Drouot, 28 March 1868, lot 24; E. M. Hodgkins; his sale, Paris, Galerie Georges Petit, 30 April 1914, lot 28; Mrs. C. I. Stralem, New York; her son, Donald S. Stralem; his wife, Mrs. Donald S. Stralem, New York.

Bibliography: Portalis 1889, p. 314; Shoolman and Slatkin 1950, p. 92; Wilhelm 1948, p. 102, pl. XIV; Réau 1956, p. 215; Ananoff 1961, no. 119, fig. 495; Atlanta 1983, under no. 35, fig. III. 6; Michel 1987, pp. 23-27, 106, 208, 210, fig. 248 (in color); Sutton 1987, fig. 8; Cuzin 1988, pp. 166, 255 n. 27, fig. 202 (as *Portrait of a Woman of Santa Lucia*).

Exhibitions: Paris 1921b, no. 173; Paris 1931c, no. 64; Rotterdam and elsewhere 1958-59, no. 50; London 1968, no. 270; New York 1972, no. 20; Washington and elsewhere 1978-79, pp. 22-23, no. 33, repr.; New York PML and Richmond 1985-86, no. 11, repr.; Paris and New York 1987-88, no. 192, and under no. 193, repr.; Rome 1990-91, no. 168, and under no. 173, repr.

Collection of Eugene Victor and Clare Thaw

72 Portrait of a Neapolitan Girl

Jean Honoré Fragonard

GRASSE 1732 – 1806 PARIS

73 Interior of a Park: The Gardens of the Villa d'Este

DURING THE SUMMER of 1760 the Abbé de Saint-Non received permission from the Este family to stay at the Villa d'Este at Tivoli. The abbé invited Fragonard to stay for a month and a half; inspired by the beauty and picturesque neglect, the young artist turned out many red chalk views of the lovely old gardens. This fact is well documented in Natoire's letters to the marquis de Marigny, where he reports that "our young artist is creating some very lovely studies which can only be very useful to him and bring him much honor" (see Montaiglon and Guiffrey 1901, p. 354, no. 5459), and also by Saint-Non himself. Shortly after his return from Italy in 1761, Fragonard made two highly finished red chalk drawings of this view of the gardens (Ananoff 1961, nos. 351 and 352), followed by his etching *Le Petit Parc*.

This rare gouache by Fragonard, last recorded in 1898 in the Bryas sale, is a reduction of his painting of the same subject now in the Wallace Collection. The Wallace Collection painting also dates from this time, although Wildenstein believes that it was the painting exhibited by Fragonard in 1785 in the Salon de la Correspondance. It is impossible to identify the precise spot in the extensive gardens of the Villa d'Este, but Fragonard's view of these lovely gardens is generally impressionistic and may be based in part on his specific recollection of the Dragon Fountain, as was suggested by David Coffin in 1969 (Coffin 1969, p. 131).

The only other known gouache landscape by Fragonard is also a reduction of a painting, *The Fête at Rambouillet,* in the Gulbenkian Foundation, Lisbon. This gouache, which is in the Straus Collection, New York (Paris and New York 1987-88, no. 169, repr. in color p. 358), and the present work were probably executed some time after the compositions they replicate and on special commission from clients.

Gouache on vellum

7¾ x 9½ inches (197 x 242 mm)

Provenance: Jacques de Bryas, sale, Paris, 4-6 April 1898, lot 55; sold to Stettiner for 4,650 francs; Bernice C. Bowles; sale, New York, Sotheby's, 14 January 1987, no. 181, repr. in color.

Bibliography: Réau 1956, p. 258; Ananoff 1968, no. 1575; Paris and New York 1987-88 under no. 66, p. 154, fig. 6 (as New York, private collection); Ingamells 1989, under P379, p. 150 (as New York, private collection); New York 1990b, under no. 35, 188 n. 5.

Collection of Eugene Victor and Clare Thaw

73 Interior of a Park: The Gardens of the Villa d'Este

Hubert Robert

PARIS 1733 – 1808 PARIS

74 The Stables at the Villa Giulia

THE STABLES at the Villa Giulia in Rome were a favorite subject of Robert, to judge from his many paintings and drawings of them. One of these, also a sketch in red chalk, in Valence (see Beau 1968, no. 36), which may date from around 1760, is preparatory for the painting in the Pushkin Museum in Moscow. Other painted versions of the subject are in the Hermitage and the Musée des Arts Décoratifs, Paris. The Paris version corresponds to Janinet's engraving of 1775, *Restes de l'écurie du Pape Jules,* and a watercolor variant exists in the Albertina. Judging from the mount, which is identical, the Thaw drawing was in the same private collection for many years as another of Robert's sanguine drawings, a *Draughtsman Sketching at the Villa Madama* (see Montreal 1993, no. 95); indeed, the pair were purchased at the same auction in New York in 1989 by Mr. Thaw. It may even be that these drawings were together in one of Robert's *Albums factices* and that the blue mount which surrounds both drawings was made up by the artist himself.

The variations discernible in all of these views of the stables at the Villa Giulia depend on Robert's viewpoint when he drew or painted each one. Robert made a counterproof of a drawing with a view similar to this to which he added pen and ink and brown wash. It was on the art market in the spring of 1992.

Red chalk

18½ x 14 inches (468 x 356 mm)

Watermark: fleur-de-lis within a double circle

Provenance: possibly the artist's family, perhaps one of the many drawings sold in lots in his sale 5 April 1809; possibly Destailleur; art market, Paris (customs stamp on verso of mount of the *Draughtsman Sketching at the Villa Madama* indicates that it passed through Paris, probably in the 1930s); private collection, Florida; sale, New York, William Doyle Galleries, 25 January 1989, lot 86.

Bibliography: Rome 1990-91, under no. 19, fig. 19b; Paris 1991, under no. 64 (as no. 19 in Rome 1990-91).

Collection of Eugene Victor and Clare Thaw

74 The Stables at the Villa Giulia

Hubert Robert

PARIS 1733 — 1808 PARIS

75 View in an Italian Garden

WHILE THE GARDEN depicted here is Italianate in character, it is not certain whether the villa to which it belonged was in Italy or France since villas of this type were quite popular in both countries during the eighteenth century. The architecture of the garden in this drawing is similar to that of the Nymphaeum at the Villa Giulia, which Robert often visited and sketched (see Cat. no. 74). The slight rippling of the sheet indicates that the drawing was wet at one time, probably intentionally, since the artist took at least one counterproof from it now in Besançon (see Cornillot 1957, D-2978); as recently as 1957 Robert's painting of this subject was in the Groult Collection in Paris.

Red chalk

10½ x 14¼ inches (267 x 362 mm)

Watermark: Vanderley, hunting horn with a shield (cf. Heawood 2749)

Provenance: William Mayor (Lugt 2799); Charles Fairfax Murray; from whom purchased in 1910 by J. Pierpont Morgan (no mark; see Lugt 1509).

Bibliography: Fairfax Murray 1905-12, I, 290, repr.

Exhibitions: Hartford 1960, no. 86; Los Angeles 1961, no. 51.

I, 290

75 View in an Italian Garden

Hubert Robert

PARIS 1733 – 1808 PARIS

76 The Avenue of Trees

IT IS DEBATABLE whether this wide tree-lined *allée* is Italian or French in inspiration, but there is no question as to the artist's interest in recording the effect of sunlight filtering through the tall trees that arch over the group of strollers. It is probably a scene in a French garden, drawn after Robert's return to Paris in 1765 following his long sojourn in Italy. The artist depicted a similar view in a drawing in Besançon (Cornillot 1957, D-2981) which is identified as a view in the park at Chanteloup. It belonged to Robert's patron, the duc de Choiseul. Victor Carlson (Washington 1978) has noted a similar handling of red chalk as characteristic of the artist's work in the late 1760s and early 1770s (see Beau 1968, nos. 2, 7, and nos. 28, 35, and 40).

According to Charles Fairfax Murray, who once owned the drawing, there was a small picture closely resembling it in the Doucet Collection.

Red chalk

14½ x 11¼ inches (367 x 286 mm)

Watermark: none

Provenance: Charles Fairfax Murray; J. Pierpont Morgan (no mark; see Lugt 1509).

Bibliography: Fairfax Murray 1905-12, III, no. 118, repr.

Exhibitions: San Francisco 1940, no. 87; Montreal 1950, no. 92; Stockholm 1970, no. 55; Washington 1978, p. 22, no. 30, repr.

III, 118

76 The Avenue of Trees

Hubert Robert

PARIS 1733 — 1808 PARIS

77 Young Woman, Seated before a Fireplace, Playing with a Baby

THIS CHARMING DOMESTIC SUBJECT must date to the 1770s, when Hubert Robert's children were babies. The young woman would then be Anne-Gabrielle Soos, whom he married in 1767. It is a matter of speculation that the baby depicted is Adélaïde-Catherine, Robert's second daughter, who was born 8 July 1772.

In the inventory of Mme Robert's estate, made on 18 August 1821 after her death in April, mention is made among the list of framed drawings of a work described as a drawing, "lightly tinted, where one sees a young woman and a child near a fireplace." The drawing is related to Robert's oval painting *"Mange, mon petit"* (Collection of Arthur Veil-Picard), which is dated 1773 and was exhibited in the salon of that year with the title *Un enfant que sa bonne fait déjeuner*. This work shows a young woman with a plate on her lap, feeding a child who stands at her knee in front of the same fireplace, which is ornamented with a head in a medallion and furnished with the same andirons that appear in the Library's drawing. That painting was shown together with a companion piece showing a young girl reciting her lesson before her mother, for which there also exists a watercolor (Henriot 1928, p. 371).

A variant treatment of the subject, in oil, on the Paris art market in the spring of 1992, was recently sold to the Musée des Beaux-Arts, Valence. In this oil sketch, Robert represents a similar domestic interior with a young mother seated on a low stool before a bassinet, getting ready to feed the baby.

Pen and brown ink, gray-brown washes, with blue watercolor over black chalk

8³/₁₆ x 9¹⁵/₁₆ inches (208 x 257 mm)

Watermark: none visible through lining

Provenance: F. Renaud (Lugt 1042); Alfred Sensier; David David-Weill, Neuilly.

Bibliography: Henriot 1928, p. 375;

PML/*FR*, IX, 1959, pp. 106-7; PML 1969, p. 165.

Exhibitions: Minneapolis 1961, no. 79; Poughkeepsie 1962, no. 23; London 1968, no. 615; Washington 1978, p. 22, no. 38, repr. in color; New York PML 1984, no. 77.

Purchased as the gift of the Fellows

1958.4

77 Young Woman, Seated before a Fireplace, Playing with a Baby

Jean-Baptiste Leprince

METZ 1734 – 1781 SAINT-DENIS-DU-PORT, NEAR LAGNY

78 Imaginary Landscape with Fishermen Pulling in Their Nets

THIS IMAGINARY LANDSCAPE with its graceful fishermen dragging nets near their sailboat shows the rococo aspect of Leprince's talent. At the Masson sale in Paris in 1923 it was entitled *Pêcheurs russes*, a reference to the Russian subject matter for which he is primarily known.

Pierre-Jean Mariette, whose original estimate of Leprince's talent was not high, "ses talens me paroissoient assez médiocres," found to his surprise that Leprince's trip to Russia seemed to have improved him as an artist. Mariette discovered in the painting which Leprince used as the *morceau de reception* that "il a fait tels progrès…il a été reçu avec applaudissement."

Pen and black ink, gray wash, over preliminary indications in black chalk; *pentimenti* in trees in black chalk

15⅞ x 11⅝ inches (402 x 294 mm)

Watermark: none visible through lining

Signed and dated at lower left, in pen and black ink, *J. B. Le Prince. 1765*

Provenance: Jean Masson (see Lugt S. 1494a); his sale, Paris, Féral, 7-8 May 1923, lot 134 (as *Pêcheurs russes*), repr.; Comte du Parc, Château de Villebertin; Baskett & Day, London.

Bibliography: PML/*FR*, XX, 1984, p. 271.

Exhibitions: London 1982, no. 43, repr.; New York PML 1984, no. 78.

Purchased as the gift of Mrs. Christian H. Aall and Miss Elizabeth T. Ely

1983.29

78 Imaginary Landscape with Fishermen Pulling in Their Nets

Jean-Baptiste Leprince

METZ 1734 – 1781 SAINT-DENIS-DU-PORT, NEAR LAGNY

79 Russian Scene with a Log House and Peasants

LEPRINCE spent some five years in Russia where he executed various commissions at the Winter Palace in St. Petersburg. Returning to Paris in 1763 with numerous sketches and studies of Russia, he made a number of etchings and aquatints of what he had seen, creating a short-lived vogue for "Russerie" which rivaled the prevailing taste for "Chinoiserie" and "Turquerie." Temperamentally close to Fragonard and Robert, his close contemporaries, Leprince treats the Russian rural subject in chalk and wash, a technique much used by his master, Boucher.

Black and brown chalk, black and brown washes, heightened with white gouache

$12^{5}/_{16}$ x $18^{9}/_{16}$ inches (314 x 472 mm)

Watermark: none visible through lining

Provenance: A. Grahl (Lugt 1199); L. Voillemot (Lugt S. 789d); H. M. Calmann, Ltd., London.

Bibliography: PML/*FR*, III, 1952, pp. 68-69.

Exhibitions: Kansas City 1956, no. 144 (see *Bulletin*, I, 1, no. 144); Stockholm 1970, no. 56; New York PML 1984, no. 79.

Purchased as the gift of the Fellows 1952.2

79 Russian Scene with a Log House and Peasants

Jean Pierre Laurent Hoüel

ROUEN 1735 – 1813 PARIS

80 Rocky Landscape with a Waterfall and Fishermen

HOÜEL, who studied first with Jean-Baptiste Descamps and later, in Paris, with Lebas and Casanova, was proficient as an engraver and a landscape painter. While he is known for the engravings he made after a series of drawings by Boucher (Cat. no. 52), it was the series of landscapes he painted for the duc de Choiseul's château at Chanteloup that brought him the most attention and earned him sufficient recognition to get him lodgings, if not a pensioner's place, at the French Academy in Rome. Mariette tells us in his *Abecedario*, "il a trouvé à Rome des Anglois qui lui ont fait faire le voyage de Naples, et d'autres qui tout de suite l'ont conduit en Sicile, et, dans ces contrées, il a fait, à ce que j'entends, quantité d'études qui servirent à améliorer sa manière qui est agréable, et qui rend assez parfaitement les effets de la nature. Car c'est au genre de paysage qu'il s'est consacré." Hoüel traveled extensively in Italy on two trips and brought back numerous watercolors and gouaches. A series of forty-six gouache drawings made in connection with his trip to Sicily between 1776 and 1779 was the subject of a recent exhibition at the Louvre (Paris 1990). The drawings were part of extensive preparations for his own version of a *voyage pittoresque* to Sicily, a project he had conceived while in the company of Watelet.

While Italianate in character, the *mise en scène* of the present drawing is not specific enough to be identifiable, and it seems most likely that the landscape was inspired by Italy rather than based on a real view. Indeed, the spontaneous and naturalistic character of this landscape is not unlike that of the work of Moreau l'Aîné (Cat. no. 84). As Marianne Roland Michel has observed, the treatment of the shadows and stormy sky is reminiscent of a painting of the Castle of Saint-Ouen-les-Vignes, now in the Musée de Tours, which the artist executed for the duc de Choiseul at Chanteloup. Hoüel's subject matter and treatment of the sky is typical of his work in the late 1780s.

Gouache and point of brush

15³⁄₁₆ x 20½ inches (386 x 520 mm)

Watermark: fragment of a coat of arms, letter *T* on a globe

Provenance: Galerie Cailleux, Paris.

Purchased on the Martha Crawford von Bulow Memorial Fund

1992.4

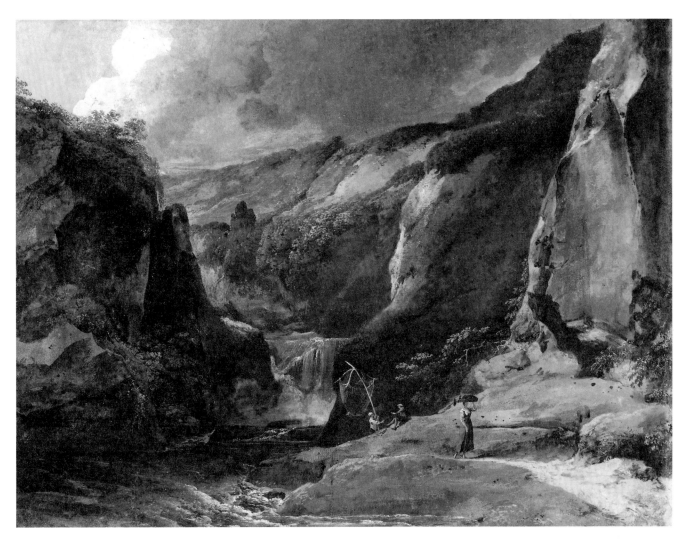

80 Rocky Landscape with a Waterfall and Fishermen

Jean-Jacques de Boissieu

LYON 1736 – 1810 LYON

81 View of the Hospital at Lyon

JEAN-JACQUES DE BOISSIEU studied painting first in his native Lyon with the history painter Jean-Charles Frontier and then in Paris, where he was further encouraged by Pierre Alexandre Wille. Some of his earliest works are the series of landscape etchings he called *Griffonnements,* which date to 1759 and consist of views around Lyon. Following the success of these prints, Boissieu was in considerable demand and turned eventually to the production of composed landscapes, although he always retained his interest in topography.

A sizable group of his drawings is preserved today in the museum at Darmstadt (see Bergträsser 1970, pp. 89ff.); however, a number of his drawings have appeared on the market in recent years, including at least two self-portraits, one of which is now in the Metropolitan Museum of Art and the other in a private collection in New York (repr. London 1990c, no. 24).

The Library has four drawings by this artist, three landscape subjects and a sheet of studies of heads (possibly made in connection with a print), which came with the purchase of the Fairfax Murray collection in 1910.

The view of Lyon is rendered in Boissieu's characteristic crisp brush and gray wash manner and identified and dated by him in an inscription now pasted on the back of the drawing. The view depicted, which as the artist notes was taken from the Brotteaux side, shows St. John's Hospital with the Church of St. John. The bridge crosses the river Saône, and in the background the hills of Fourvier can be seen.

Brush and gray wash

8⅝ x 14¾ inches (219 x 374 mm)

Inscribed by the artist on a strip of paper pasted to the backing of the sheet, *vüe De L'hôpital general de Lyon et D'une partie du pont De La guilliolier.dessinée des Breteaux par J.J. De Boissieu 1768*

Signed with initials at lower left, in pen and brown ink, *DB.f*

Provenance: George Knapton; General George Morrison (by bequest from Knapton); Knapton-Morrison sale, London, T. Philipe, 25 May-3 June 1807, lot 86; Lord Aberdeen; Charles Fairfax Murray; J. Pierpont Morgan (no mark; see Lugt 1509).

Bibliography: Fairfax Murray 1905-12, III, no. 119, repr.; Michel 1987, p. 241, fig. 287.

Exhibition: New York PML 1984, no. 80.

III, 119

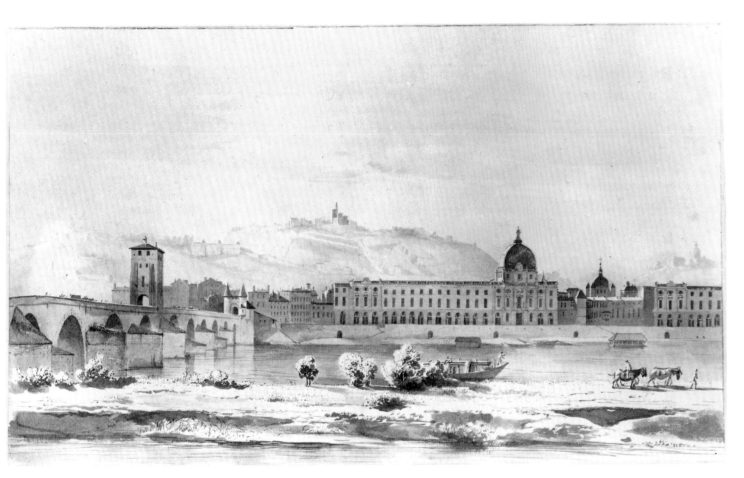

81 View of the Hospital at Lyon

Augustin de Saint-Aubin

PARIS 1736 – 1808 PARIS

82 Portrait of the Artist's Brother, Charles Germain de Saint-Aubin (1721 - 1786) at age 46, 1767

In 1767, Augustin de Saint-Aubin, then a rising young engraver, skillfully drew the profile of his eldest brother, Charles Germain, a man of forty-six, successful and prospering, first in his profession, as he confides in a note accompanying *Le Recueil des Plantes*. He enjoyed the patronage of the court, including the favor and friendship of the marquise de Pompadour, who made him gifts of fine furniture and porcelains and in 1757 embroidered one of the designs in *Le Recueil des Plantes*. Three years after he sat to his brother for this portrait, he was busy designing the wedding coat of Louis XVI.

The portrait is one of the typical medallions of Augustin de Saint-Aubin, very much in the manner of Cochin, whose designs he was constantly engraving. He transcribed the likeness of his brother with affectionate artistry, subtly modeling the full-fleshed jaw and the prominent Saint-Aubin chin and aquiline nose. The skeptical, half-amused look that he catches, even in profile view, accords with M. Tardieu's description of Charles Germain, as "gai, spirituel, mais moqueur, satirique et goguenard." The likeness seems to have been regarded as a successful one by his family, for the portrait was copied by the sitter's daughter two years later, in 1769, for presentation to the dramatist Sedaine, who was a friend of all the Saint-Aubin brothers.

Graphite, red and white chalk, faint ochre wash on face

Diameter: 4⅞ inches (124 mm)

Watermark: none

Provenance: Charles Germain de Saint-Aubin; Mme Dounebecq (Marie-Françoise de Saint-Aubin, the sitter's eldest daughter); willed in 1822 to the husband of her niece, Pierre-Antoine Tardieu; Hippolyte Destailleur; his sale, Paris, Damascène Morgand, 26-27 May 1893, lot 124; Champion; Baron Alphonse de Rothschild (according to A. Moreau); E. Grange, London; P. & D. Colnaghi & Co., London.

Bibliography: PML/*FR*, VIII, 1958, pp. 77-79; Michel 1987, p. 147.

Exhibitions: New York PML 1980, no. 97; New York PML 1984, no. 119.

Purchased as the gift of the Fellows

1956.12

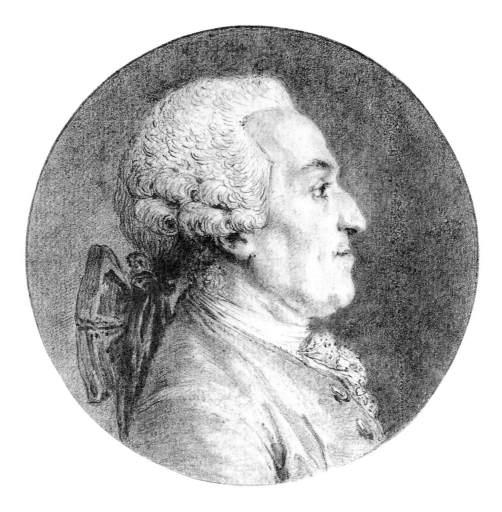

82 Portrait of the Artist's Brother, Charles Germain de Saint-Aubin (1721-1786)

Jean-François Chalgrin

PARIS 1739 – 1811 PARIS

83 La Salle des Machines, Palais des Tuileries

CHALGRIN, trained by Boullée and Moreau, received the *prix de Rome d'architecture* in 1758, enabling him to spend a few years in Rome. Upon his return he was named *inspecteur des travaux de la ville de Paris* and embarked on a busy career, building churches such as Saint-Philippe-du-Roule and finishing St. Sulpice as well as modifying the Palais du Luxembourg. He also became *architecte du roi,* and it must have been in this connection that this large view of the Salle des Machines, in the Palais des Tuileries, was executed. The Salle des Machines was used by both the Opéra and the Comédie-Française for some time before the Revolution. According to his inscription, Chalgrin made his drawing in 1778, the same year that Voltaire received the crown of laurels during a performance of *Irène,* his tragedy in five acts, on 30 March. Chalgrin's rendering of the Salle des Machines is an especially important document in view of the detail it provides of this room, which was destroyed when the Palais des Tuileries, which had existed with considerable modification since the fourteenth century, was destroyed in the fire set by the Commune in 1871.

Chalgrin's last and perhaps most famous commission was the Arc de Triomphe at l'Etoile, which was completed only after his death in 1811.

Pen and black ink, brown and gray wash, watercolor, over faint indications in black chalk

20 x 34¹³⁄₁₆ inches (509 x 888 mm)

Watermark: none visible through lining

Signed and dated at lower left, *Chalgrin 1778*

Provenance: private collection.

Bibliography: PML/*FR*, XXI, 1989, p. 328.

Exhibition: New York PML 1984, no. 81.

Gift of Miss Alice Tully

1986.25

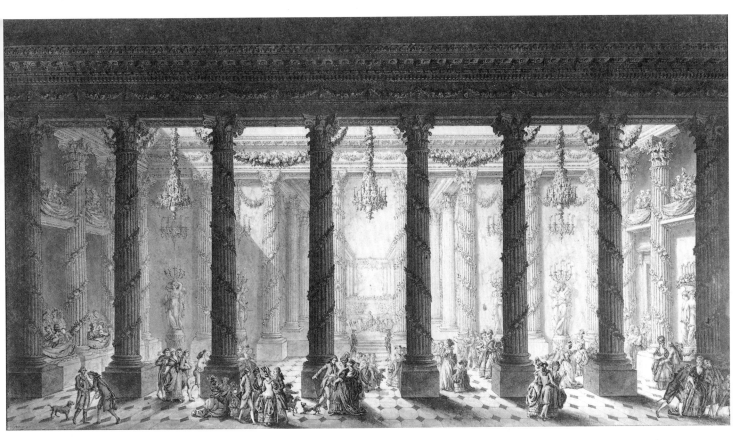

83 Salle des Machines, Palais des Tuileries

Louis Gabriel Moreau, called l'Aîné

PARIS 1740 – 1806 PARIS

84 La Vallée: Pastoral River Landscape

LOUIS GABRIEL MOREAU, called l'Aîné to distinguish him from his brother, the book illustrator Jean-Michel Moreau le Jeune, devoted himself to landscape painting. Since landscape art was not highly regarded in his time, he was never received into the Academy and had to wait to exhibit his work in the salon until the 1790s, when access became unrestricted. Eleven years after his death landscape painting was officially acknowledged, and a *prix de Rome* in historical landscape was inaugurated in 1817. There is not much contemporary information about Moreau, and it was not until the 1920s with the publication of Georges Wildenstein's monograph and an exhibition of his work that he received full recognition as a major artist of the eighteenth century. More than a landscape painter, Moreau was clearly the most gifted exponent of landscape drawing in the difficult medium of gouache, which has the look of paint without its flexibility.

Moreau chose his paper carefully and achieved naturalistic and attractive results, as is evident in this large panoramic river view. Here the artist chose a very thin oriental paper, first preparing it with a layer of blue gouache, and painting in the general outlines of the composition, simultaneously brushing most of the surface with a soft broad brush to achieve atmospheric effects. Later he added accents in color where needed, notably in the little group of peasants with their herd of sheep and goats in the foreground.

Since Moreau apparently never left the Ile-de-France, most of his landscapes must be based on views around Paris. Because of the difficulty of working in gouache, a medium which dries quickly, there is little doubt that the bulk of his work was composed in the studio. The subject of this large airy gouache is decidedly Italianate and may reflect a knowledge of the work of Marco Ricci, the Venetian landscape artist, who also worked in gouache. Moreau's silvery tones and naturalism look ahead to the landscapes of Corot and other Barbizon painters of the nineteenth century.

Gouache over preliminary indications in graphite

22⅞ x 33⁵⁄₁₆ inches (593 x 844 mm)

Watermark: none visible through lining

Signed with initials at lower left, in pen and black ink, *L M*

Provenance: David David-Weill, Neuilly; Mme Jacques Balsan (née Consuelo Vanderbilt, duchess of Marlborough); E. V. Thaw and Co., New York.

Bibliography: Wildenstein 1923, p. 69, no. 180, pl. 180; Henriot 1927, p. 125, repr.; PML/*FR*, XX, 1984, p. 279; Michel 1987, p. 42, fig. 30 (in color).

Exhibitions: Baltimore 1941, no. 64, pl. 62, repr.; New York PML 1984, no. 82.

Purchased on the von Bulow Fund

1981.11

84 La Vallée

Jean-Baptiste Hüet

PARIS 1745 — 1811 PARIS

85 Studies of Corn and Wheat

HÜET IS BEST KNOWN for his pastoral subjects, reminiscent of those of his mentors, Boucher, with whom he may have studied privately, and Leprince. He is also known for his paintings of animals, which resemble those of Oudry, whom Hüet admired. In this atypical work, however, Hüet has taken as his subject some very common plants. A few similar drawings have survived, notably the study of pumpkins now in the Ashmolean Museum, Oxford, signed and dated, 1785 (repr. Rome 1991, no. 85).

It is not known for what purpose Hüet drew these studies or why he very plausibly (as is indicated by the numbering) put them together sequentially in an album or portfolio. Although he often made highly finished botanical studies, these distinctive drawings are quite different in character: in these studies of corn and wheat the artist has treated his subject with a new sensibility, creating a modern still life unique in the art of the period.

Watercolor and some gouache over black chalk

10 x 15½ inches (254 x 401 mm)

Watermark: fragment with a letter *T* on a globe (cf. Heawood 2394)

Signed and dated in pen and brown ink at lower left, *J. B. hüet 1792;* numbered in a different ink at upper left, *14*

Provenance: Kate de Rothschild, London.

Bibliography: Rome 1991, under no. 85, p. 178 n. 2.

Exhibition: London 1990a, no. 38, repr.

Purchased on the Martha Crawford von Bulow Memorial Fund

1992.2

85　Studies of Corn and Wheat

Louis Roland Trinquesse

PARIS CA. 1745 – CA. 1800 PARIS

86 Study of a Lady of Fashion

TRINQUESSE, probably of Burgundian origin, was active in Paris from 1771 to 1797 (according to the dates on his drawings). This "crayonneur à la sanguine," as Edmond de Goncourt called him (Goncourt 1881, p. 164), specialized in studies of women in fashionable costumes posed in domestic surroundings. The Morgan Library's drawing shows a young woman precariously seated on the edge of a narrow rectangular table, her head turned toward the spectator, supporting herself with her left hand in this unstable position. Originating from the Goncourts' own collection, it may be one of a series of twenty-four studies which, according to the artist, were made in 1773 after Madame de Franmery. Several drawings from this group were formerly in the Cailleux Collection (Cailleux 1974, pp. ii-xiv).

Trinquesse seems to have had three different models for these drawings; one of them was Marianne de Franmery, the others, also identified on the basis of inscriptions, were Louise Charlotte Marini and Louise-Elizabeth Bain. Trinquesse, however, was not interested in the facial expression or in the individualization of his sitters; his preoccupation was the rendering of costume in every elegant detail (the flounced skirts and bodices as well as the fancy bonnets and plumed hats). Executed in the red chalk medium and in a fluent drawing style these drawings are small masterpieces in the genre of costume design.

Red chalk

14¹³/₁₆ x 10¹/₁₆ inches (376 x 254 mm)

Watermark: none visible through lining

Provenance: Edmond and Jules de Goncourt (Lugt 1089); their sale, Hôtel Drouot, Paris, 15-17 February 1897, lot 323; G. Menier; sale; Mlle Demarsy, lot 256; her sale; Comte Pierre de Jumilhac et divers, Paris, Galerie Georges Petit, 15 June 1929, no. 5, repr.; Richard Owen, Paris; John Nicholas Brown, Providence;

David Tunick, New York; Thos. Agnew & Sons, London.

Bibliography: Agnew's 1992, p. 136, pl. 126, repr. in color.

Exhibitions: Providence 1931; Paris 1933b, no. 277; Omaha 1941; London 1989, no. 24, repr. in color.

Purchased on the Martha Crawford von Bulow Memorial Fund

1990.16

86 Study of a Lady of Fashion

Dominique Vivant Denon

GIVRY 1747 – 1825 PARIS

87 Satire on an Episode in the French Revolution

VIVANT DENON, friend and protégé of Louis XV, Robespierre, and Napoleon, was active as a diplomat, author, artist, and collector. Before the Revolution he served as a diplomat in such posts as St. Petersburg and Naples. In 1793 he left Italy to return to France at the height of the Terror. Although his property was seized and his name placed on the list of émigrés, his name was removed from the list through his friendship with David, whom he had met in Naples. Eventually, in the salon of Mme de Beauharnais, Vivant Denon met General Bonaparte and embarked on a new career. He accompanied Napoleon on his expedition to Egypt and upon his return published *Voyage dans la basse et la haute Egypte* (1802), which he both wrote and illustrated. In 1804 he became director general of the French museums under Napoleon. Holding this post until 1815 he guided the commandeering of art works that temporarily enriched the Louvre during that period.

This large and unusual composition is one of a series of drawings by Vivant Denon, apparently relating to the French Revolution, that appeared in London in the early 1960s. Unlike many of these works, which include portraits of identifiable people of the period, the Library's drawing has been difficult to interpret.

A very plausible explanation of the subject was offered by the late Professor Arnold Whitridge, Fellow of the Library, who suggested that the naval battle referred to in the banner topped by a Phrygian cap is the defeat of the émigrés at Quiberon in June 1795. The British had landed a small division of émigrés in Brittany with a second division and some British troops to follow, but the republican army, commanded by General Hoche, took nearly 12,000 prisoners. This ill-fated expedition was planned or sponsored by the comte d'Artois, brother of Louis XVI, who may well be represented as Gilles in the drawing as his small crown suggests. While the comte d'Artois did not take part in this expedition he did land on the small island of Yeu, off the coast of Brittany, a few months later, in October 1795. The royalists hoped that he would soon be joining them on the mainland, but on finding the shore strongly fortified by General Hoche, the comte d'Artois lost his nerve and sailed back to England. If Gilles does indeed represent him, his lack of courage would explain the discouragement of the royalists. All of these events took place just a year after the battle of Fleurus, which in view of the balloon must be the battle represented in the

Pen and black ink, gray wash, over indications in black chalk

12⅝ x 18¼ inches (321 x 464 mm)

Watermark: none visible through lining

Provenance: Lady Shelley-Rolls; sale, London, Christie's, 5 December 1961, lot 1389; H. M. Calmann, London.

Bibliography: PML/FR, XIV, 1967, pp. 130-32; Toronto and elsewhere 1972-73, under no. 41.

Exhibition: New York PML 1984, no. 86.

Purchased as the gift of the Fellows 1964.8

87 Satire on an Episode in the French Revolution

background – military balloonists seem first to have been active in the spring of 1794 at the siege of Maubeuge and the battle of Fleurus (26 June 1794), and were discontinued after 1799. Supposing that Vivant Denon made his drawing at the end of 1795, he must have been commemorating the republican successes of the past year.

A large number of Vivant Denon's own drawings were included in the sale of his collection on 1 May 1826, but the catalogue descriptions are not specific enough to permit the identification of individual works.

Jacques Louis David

PARIS 1748 – 1825 BRUSSELS

88 L'Exécution des fils de Brutus

DAVID'S 1789 PAINTING *The Lictors Carrying the Bodies of the Sons of Brutus* (Musée du Louvre) depicts Brutus seated in his house while the bodies of his sons are carried in on a bier. The drawing shows the artist's earlier, and more violent, idea for the painting, the moment when Brutus, having condemned his sons to death for conspiring to restore the Tarquin monarchy, watches as they are executed. A drawing in the Getty Museum, dated 1787, shows the artist's subsequent choice of subject. In a letter to Wicar (14 June 1789), David explains that he has decided to make a painting purely of his own invention:

> Je fais un tableau de ma pure invention. C'est Brutus, homme et père, qui s'est privé de ses enfants et qui, retiré dans ses foyers, on lui raporte ses deux fils pour leur donner la sépulture. Il est distrait de son chagrin, au pied de la statue de Rome, par les cris de sa femme, la peur et l'évanouissement de la plus grande fille.

The layout of the composition and the outdoor setting of the drawing are similar to those of David's *Horatius Defending His Sons* (Louvre). Arlette Sérullaz pointed out (Paris 1989-90, p. 202) that the architecture of each of these drawings recalls David's first trip to Italy. The figure of Brutus was largely taken from studies the artist made of antique sculpture during his sojourn in Rome, when he visited the Vatican and Capitoline Museums (see, for example, drawings in an *album factice,* now in the Département des Arts Graphiques, Louvre).

Pen and black ink with some point of brush and wash over black chalk

16⅜ x 23 inches (416 x 584 mm)

Watermark: cluster of grapes within a circle and illegible letters (cf. Heawood 2395)

Signed at lower left with the initials of both Jules David (Lugt 1437) and Eugène David (Lugt 839)

Provenance: David sale, Paris, 17 April 1826, no. 38; Baronne J. Meunier, Calais.

Bibliography: Inventory of 25 February 1826, no. 17 (cited in Paris 1989-90); David 1880, p. 655; D. and G. Wildenstein 1973, p. 244, no. 38.

Exhibition: Paris 1989-90, p. 197, no. 87, repr.

Collection of Eugene Victor and Clare Thaw

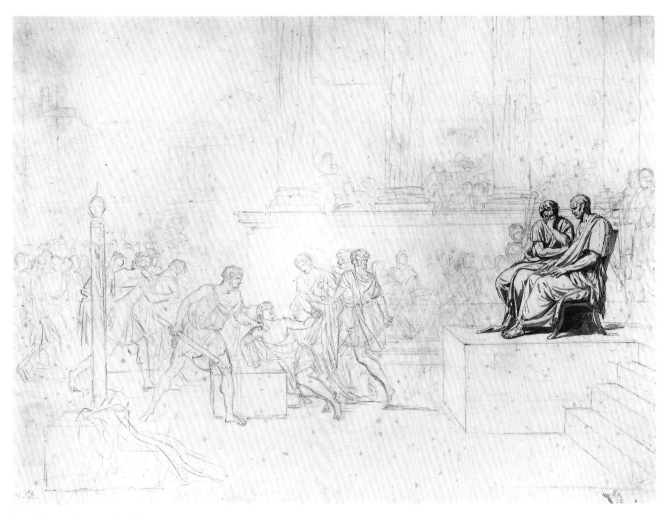

88 L'Exécution des fils de Brutus

Henri-Pierre Danloux

PARIS 1753 – 1809 PARIS

89 Portrait of a Young Woman in a Broad-brimmed Hat

DANLOUX STUDIED PAINTING with both Lépicié and Vien, at whose studio he met Jacques Louis David. When Vien went to Italy, Danloux followed, remaining there until 1780. After his return to Paris in 1785, he painted a series of portraits of Parisian society, such as that of the Sérilly family and the chevalier de Pange. Because of his close connection to the aristocracy, however, Danloux had to flee Paris for London in 1791 to escape the aftermath of the French Revolution. It was in London, where the artist lived for ten years, that he gained considerable reputation as a painter of the kind of elegant portrait illustrated here. The popularity of this smooth style was short-lived, however. Two years after he returned to Paris, the artist exhibited at the salon of 1802 only to realize that his works no longer satisfied contemporary taste.

The identity of the sitter here is thought to be Marie-Antoinette de Saint-Redan, who was to become the artist's wife four years after this charming 1783 likeness was made. This dating is supported by documents from the Danloux family which report that "ce fut à cette époque qu'il se rencontra avec Mlle Marie-Antoinette de Saint-Redan." Two other portraits of her are known: one, signed and dated 1784, is in the Fondation Custodia at the Institut Néerlandais (repr. Paris and Amsterdam 1964, no. 131, pl. 88), while the other, taken in 1785, was formerly in the Tony Dreyfus Collection (Portalis 1910, p. 28).

Black chalk, stumped
Oval: 8⁷/₁₆ x 7¹/₁₆ inches (213 x 180 mm)
Watermark: none visible through lining
Signed and dated at right, in black chalk,
P H. Dx/ 1783
Provenance: unknown collector, ARD (Lugt 172); Galerie Cailleux, Paris.

Bibliography: Portalis 1910, p. 28; PML/ *FR*, XV, 1969, p. 124.
Exhibition: New York PML 1984, no. 87.
Purchased as the gift of the Fellows
1967.17

89 Portrait of a Young Woman in a Broad-brimmed Hat

Elisabeth Louise Vigée-Le Brun

PARIS 1755 – 1842 PARIS

90 Self-portrait

MME VIGÉE-LE BRUN, whose immortality was assured by her role as the favorite painter of Marie-Antoinette, portrayed her own face many times. Her most famous likeness, the portrait where she represented herself with her daughter entwined in her arms, was exhibited in the salon of 1789 just before she fled the terrors of the French Revolution. During the years of her exile (1789-1802) she was often invited to present a self-portrait to the galleries which she visited. She obliged with the portrait of 1790 for the Uffizi at Florence, one in the early 1790s for the Academy of St. Luke at Rome, and one of 1800 for the Royal Academy at St. Petersburg.

The Library's portrait, executed in pencil on blue notepaper, was undoubtedly taken on the spot. As to when and for whom the artist made this souvenir of her friendship, there is no clue. Her circumspect inscription is a basis only for tantalizing speculation.

The simplicity of Mme Le Brun's costume is in accord with a statement in her memoirs, published in 1835 when she was eighty: "I have always lived very modestly. I spent very little on clothes. In this respect, I was even accused of being too careless, for I always wore white dresses of muslin or linen and never had any ornamental dresses made except for my sittings at Versailles. My head-gear never cost me anything. I did my own hairdressing and generally twisted a muslin fichu about my head." This somewhat individual attitude toward fashion makes it difficult to date the drawing by the simple dress with a fichu filling the low, rounded neckline and the high waist, which are of the 1790s. The becoming high bonnet, on the other hand, conforms to the trend of fashion after the turn of the century; yet there is nothing in this self-portrait to suggest the age of forty-five, which she reached in 1800. At most we can say that it was probably during her extended travels in Italy, Austria, and Russia that the painter made this charming likeness. Whatever the occasion, it was one that evoked her best efforts in a crisply penciled self-delineation that foreshadows the great exploiter of the pencil portrait, Ingres.

Pencil on thin blue writing paper
8⁵⁄₁₆ x 6¹⁵⁄₁₆ inches (218 x 175 mm)

Signed at lower left, by the artist, *pour souvenir de / Le Brun fecit*

Watermark: none

Provenance: Galerie Cailleux, Paris.

Bibliography: Jaccottet 1952, pl. 126; PML/*FR*, VII, 1957, pp. 79-81, repr.; PML 1969, p. 175.

Exhibitions: Paris 1935, no. 30; Paris 1937, no. 2, repr.; London 1950, no. 87; Paris 1951, no. 199; Paris 1953-54, no. 190; Fort Worth 1984, no. 52, repr.; New York PML 1984, no. 89.

Purchased as the gift of the Fellows 1955.8

90 Self-portrait

Pierre Paul Prud'hon

CLUNY 1758 – 1823 PARIS

91 Le Cruel rit des pleurs qu'il fait verser

IN 1789 Prud'hon was commissioned by the comte d'Harlai for several works including the painting *La Vengeance des Cérès* and a pair of allegories, *L'Amour réduit à la raison* and *Le Cruel rit des pleurs qu'il fait verser,* produced in Year Two of the French Republic (1793). All three subjects were engraved by Jacques Louis Copia in association with Prud'hon and the latter's good friend Guillaume Constantin, who was later to become curator of the Empress Joséphine's paintings at Malmaison.

The Library's sketch is Prud'hon's first definitive conception for the *The Cruel One Laughs at the Tears He Has Caused to Be Shed,* sometimes referred to as Love Avenged, and its companion as Love Enchained. The subject recalls David's characterization of Prud'hon as "the Boucher of our time." It represents Cupid leaning on his bow and mocking a weeping young woman seated before him, with a wilting rose and its scattered petals lying at her feet. Fortunately, the theme is handled with Prud'hon's poetic feeling and simplicity of emotion.

The final version, a highly finished drawing in black chalk on white paper, which the comte d'Harlai received and on which Copia based the engraving, is in the Fogg Art Museum. At the time the artist delivered the pair of finished drawings to his patron, he apparently made a gift of this sketch and its pendant to his friend Constantin, who had supplied the capital for the engraving project. The inscription on the back of the pendant drawing reads: "Donné par Prud'hon à Constantin 1793 15 mars—Première pensée du dessin gravé par Copia en 1793."

Black and white chalk on blue paper; traced for transfer

9¼ x 12½ inches (236 x 317 mm)

Watermark: none visible through lining

Inscribed on mat, *P.P. Prud'hon invt. fecit l'an deux de La Republique*

Provenance: Constantin; Brun-Neergaard; his sale, 29 August 1814, no. 309; Hauteroche; his sale, 28 January 1828, no. 186; Prud'hon fils; his sale, 17 December 1829, no. 109; Thévenin; his sale, 27 January 1851, no. 88; anonymous sale, 23 December 1853, no. 62; anonymous sale, 16 February 1881, no. 41; Férol; London, anonymous sale, 24 July 1914, no. 3; comte de Lariboisière; Morris (for 24 sh. 2p.); Germain Seligmann.

Bibliography: Goncourt 1876, p. 137; Guiffrey 1924, no. 20; PML/*FR*, VII, 1957, pp. 81-82.

Exhibitions: Paris 1874, no. 253; New York PML 1984, no. 92, repr.

Purchased as the gift of the Fellows 1956.1

91 Le Cruel rit des pleurs qu'il fait verser

Pierre Paul Prud'hon

CLUNY 1758 – 1823 PARIS

92 Study for the Portrait of the Empress Joséphine

THIS IS the definitive compositional sketch for Prud'hon's painting of 1805 now in the Louvre, which depicts the Empress Joséphine seated on some rocks in the gardens at Malmaison. In the painting, however, Prud'hon altered the format from horizontal to vertical, giving greater emphasis to the trees already lightly indicated in the Library's drawing. He also eliminated the lyre from the painting (in the drawing it can be seen at the right) and added an elegant red stole on which Joséphine sits and which is carefully draped around her figure and across her knees. Delacroix commented on the air of beauty and nobility, tinged with melancholy, inherent in the work, which he believed to be one of Prud'hon's masterpieces (Delacroix 1869, p. 21).

Numerous other studies for the portrait survive, notably a sketchier composition study in the Louvre (R. F. 4105) in which Joséphine is depicted seated in a slightly different pose and facing in the opposite direction from the painting. There is also a composition sketch in the Musée Bonnat, Bayonne (Guiffrey 1924, no. 441), and a beautiful pastel study of the empress's head in the David-Weill Collection, Paris (Guiffrey 1924, no. 445).

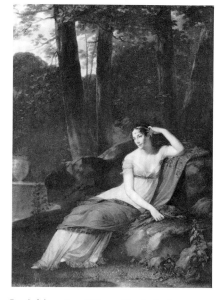

Joséphine. *Inv. RF270, Musée du Louvre*

Black chalk, stumped in some areas, heightened with white, on blue paper; design area ruled in pen and black ink

Design area: 8⅝ x 10¼ inches (208 x 261 mm)

Full sheet: 9¾ x 11⅞ inches (248 x 302 mm)

Watermark: none

Provenance: Charles de Boisfremont (Lugt 353); his son's sale, Paris, Hôtel Drouot, 9 April 1870, lot 1 (cited by Lugt under no. 353 as having brought 700 frs.); Norsay (sale, Paris, 20 May 1873, lot 116); Alfred Sensier; his sale, Paris, Hôtel Drouot, 10-12 December 1877, lot 456; Léon Ferté; Mrs. Herbert N. Straus.

Bibliography: Goncourt 1876, p. 34; *L'Art* 1878, repr. p. 68 (according to Guiffrey 1924, no. 442); *Gazette des Beaux-Arts* 1922, p. 265, repr.; Martine and Marotte 1923, no. 3, repr.; Guiffrey 1924, no. 442; PML/*FR*, XVIII, 1978, p. 285.

Exhibitions: Paris 1874, no. 18; Paris 1922, no. 147; London 1932, no. 843 (Commemorative Catalogue, no. 728, pl. 182); Rotterdam and elsewhere 1958-59, no. 143, repr.

Bequest of Therese Kuhn Straus in memory of her husband, Herbert N. Straus

1977.58

92 Study for the Portrait of the Empress Joséphine

Pierre Paul Prud'hon

CLUNY 1758 – 1823 PARIS

93 The Park at Malmaison

H. J. BOURGUIGNON, curator of Malmaison, where the Empress Joséphine lived from 1798 to 1814, is said to have identified this view as a glade in the park surrounding the château. In this work, Prud'hon achieved an exceptionally beautiful contrast between the light and shaded areas of the glade through his subtle use of black and white chalk. He used the white chalk chiefly to indicate the play of light on the trees beneath the low branches where the sun illuminated them, as well as in the foreground alongside the trunk of one tree, and on a sunlit area of grass. He maintained a careful balance between detail and atmosphere, using finely pointed as well as very broad strokes in the same chalk, which he then stumped. Prud'hon finished the drawing with a detailed delineation of the wispy bush in the foreground, executed in a few fine strokes of black chalk.

The drawing is also known by the titles given it by the Goncourts, *Dessous de bois* and *Lisière d'un bois* (Goncourt 1876, pp. 307, 309). Two other landscape drawings by Prud'hon were included in the exhibition in 1958 (Paris 1958a, nos. 225-26, not repr.).

Black and white chalk on blue paper
13¹/₁₆ x 10⁹/₁₆ inches (332 x 268 mm)
Watermark: none

Provenance: Charles de Boisfremont (Lugt 353); Mme Power (née Boisfremont); her sale, 15-16 April 1864, no. 115; Baron de Clary; Baron de la Tournelle, Montpellier; David David-Weill, Neuilly; Richard S. Davis, Minneapolis; R. M. Light & Co., Inc., Santa Barbara.

Bibliography: Goncourt 1876, pp. 307, 309; Guiffrey 1924, no. 1307, p. 470; Henriot 1928, III, ii, p. 359, repr.

Exhibitions: Paris 1874, no. 318; New York 1938, no. 129; New York 1944c, no. 133; Rotterdam and elsewhere 1958-59, no. 144, repr.

Collection of Eugene Victor and Clare Thaw

93 The Park at Malmaison

Pierre Paul Prud'hon

CLUNY 1758 – 1823 PARIS

94 Portrait of Antoine Cerclet (1796–1849)

PROBABLY COMMISSIONED as a keepsake picture, this small portrait is an excellent example of Prud'hon's extraordinary technical skill. Using almost exclusively black chalk with pen and ink, the artist has achieved a fully sympathetic likeness of the young man, who would have been around twenty-two years old in 1818 when he sat to Prud'hon for this portrait.

Not much is known about Antoine Cerclet. He was sufficiently well known in his own time to merit a brief listing in a nineteenth-century Larousse as *publiciste français*. The entry goes on to say that he was born in Russia and studied for his law degree in Paris, where he was also received at the bar. After the 1830 revolution Cerclet, a collaborator on the political magazine *Le National*, became secretary to the president of the Chamber of Deputies, chief petitioner and managing secretary. Eventually he received the cross of the Légion d'honneur.

Black chalk, stumped, pen and black ink, heightened with white gouache, on light brown paper toned in some areas with black chalk; yellow wash applied to verso corresponds roughly to area of sitter's head

Oval: diameter, 6⅞ inches (146 mm)

Watermark: none

Signed and dated at lower right, in black chalk, *P.P. Prud'hon / 1818*

Inscribed on back of wooden support of old frame, in pen and brown ink, *Portrait de M' / A. Cerclet / Maître des requêtes / Secrétaire-rédacteur / de la chambre des Députés*

Provenance: possibly Eudoxe Marcille (according to Guiffrey 1924; no mark; see Lugt S. 605a); M. Jarre (according to Guiffrey 1924); sale, Paris, Hôtel Drouot, 6 December 1982, lot 172, repr.; Baskett & Day, London.

Bibliography: Goncourt 1876, p. 78 (as "Inconnu"); Guiffrey 1924, no. 478; PML/*FR*, XX, 1984, p. 292.

Exhibitions: Paris 1874, possibly no. 148 (*Portrait d'un homme*); New York PML 1984, no. 93.

Purchased on the Lois and Walter C. Baker Fund and as the gift of Mrs. Carl Stern

1983.7

94 Portrait of Antoine Cerclet (1796-1849)

Pierre Paul Prud'hon

CLUNY 1758 – 1823 PARIS

95 Female Nude

WHILE CONTINUING the French academic tradition, Prud'hon gave a new refinement and finish to the drawing of the nude, working in black and white chalk and—in the case of this sheet—a pale pink, almost flesh-colored chalk. When applied to the intense blue paper Prud'hon liked to use, the highly worked chalk stands out vividly, and the detailed modeling of the figure is very effective.

The drawing is a study for the figure of Innocence in *L'Amour séduit l'Innocence, le Plaisir l'entraîne, le Repentir suit.* In his monograph on Prud'hon, Jean Guiffrey lists four paintings and two oil sketches of this subject and at least eleven preparatory drawings including the present study; the painting in the collection of the duchesse de Bisaccia is reproduced as plate II by Guiffrey 1924. There is also an engraving of the subject by Barthélemy Roger (1767-1841) after Prud'hon's drawings.

It is clear in the present drawing that Prud'hon already knew how the figure of Innocence, if not that of Love, was to be posed and placed in the painted version. There, Love is personified by an Apollonian youth with his left arm draped around the shoulder of Innocence; she, eyes demurely downcast, her right arm slipped about Love's waist, stands to the right, her figure partially hidden by the drapery pulled at by a small cupid. In the drawing, Prud'hon has concentrated his attention on the nude figure of Innocence, and only Love's left hand on her shoulder is visible, although his existence is suggested by the position of her right arm.

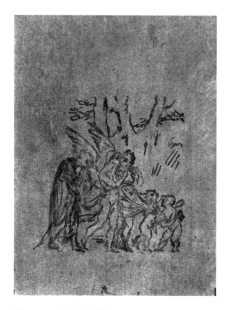

L'Amour Séduit L'Innocence,
le Plaisir l'entraîne, le Repentir suit.
Inv. 306 bis/497. Musée Condé, Chantilly

Black, white, and pale pink chalk, some stumping, on blue paper

23³/₁₆ x 12⁷/₁₆ inches (589 x 316 mm)

Watermark: none

Provenance: Charles de Boisfremont (Lugt 353); Mme Power (née Boisfremont); her sale, 15-16 April 1864; Van Cuyck (for 400 frs.); George Farrow; sale, London, Sotheby's, 27 March 1969, lot 142, repr.; Camille Groult; Mr. and Mrs. Eugene V. Thaw, New York.

Bibliography: Goncourt 1876, p. 144; Guiffrey 1924, p. 8, no. 14; PML/*FR*, XVII, 1976, pp. 148, 178, pl. 19.

Exhibitions: New York PML and elsewhere 1975-76, no. 38, repr.; New York PML 1984, no. 91.

Gift of Eugene Victor and Clare Thaw 1974.71

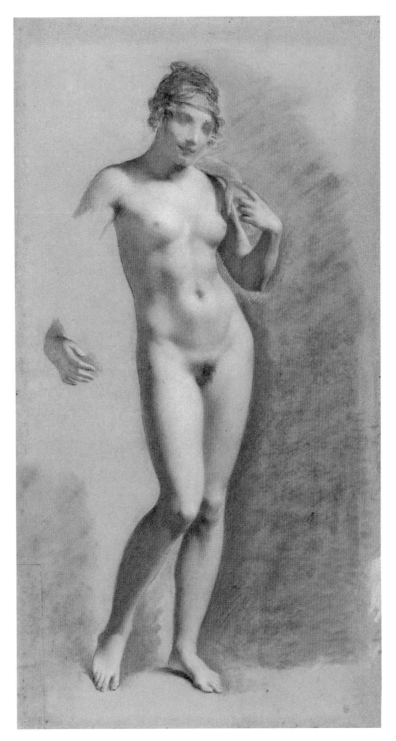

95 Female Nude

Louis Léopold Boilly

LA BASSÉE 1761 – 1845 PARIS

96 Portraits of the Artist's Family and Servants

TO JUDGE FROM THE COSTUMES it would appear that this drawing
dates to around 1800. It is apparent from what we know about Boilly's family
that his second wife, née Adélaïde Françoise Julie Leduc, and two of his sons are
depicted. The man to the right of Boilly's wife is his friend the singer Simon
Chenard, who also acted as tutor for the children of Boilly's first marriage. His
features are well known from Boilly's many depictions of him, notably in the
painting in the Louvre *Réunion d'artistes dans l'atelier d'Isabey,* exhibited in the
Salon de l'An VI (1798; repr. Lille 1988-89, no. 21). Of the four remaining portrait
heads, three are most probably servants, while the woman at the lower left
corner remains unidentified.

The artist must have begun his drawing with the portrait of his wife in the
center, and this portrait is the most carefully finished of any of the eight portraits
on the sheet. Her features accord well with a known portrait of her that Boilly
made in 1796 (repr. Lille 1988-89, no. 28). Boilly must have then sketched in his
friend Chenard's likeness in profile, along with those of two of his sons. The boy
at the upper right could be Marie-Simon, who was born in November 1792,
while the boy at the bottom of the page must be Boilly's eldest son, Félix, born
in 1790. Félix is the boy most probably represented in the oil sketch now in Lille
(repr. Lille 1988-89, no. 16). These sons were the artist's children by his first wife,
née Marie-Madeleine Josèphe Desligne, who died in 1795, the same year in
which he married Adélaïde Françoise. The first child of the second marriage,
Julien-Léopold, born in 1796, would have been too young at this time. His
features, which are very like Boilly's, are known to us from the portrait that the
artist exhibited in the salon of 1808 (repr. Lille 1988-89, no. 38). Next the artist
drew in the young woman with a cap at the upper left, possibly the cook, and
the young woman with the hoop earrings at the lower left. He filled in the sheet
with portraits of an older servant to the left of his wife's portrait and added the
portrait of a young maid at the lower right of the sheet. Since these last two are
drawn over parts of the existing drawing, it may be surmised that they were
added last.

Boilly is not interested in real portraits here. He has indulged his aptitude for
caricature, exaggerating the expressions and grimacing faces of some eighteen
different people.

Black and white chalk on light brown
wove paper

17¾ x 11⅝ inches (451 x 296 mm)

Provenance: Alfred de Rothschild;
Almina, countess of Carnarvon, London;
her sale, Christie's, London, 22 May 1925,
lot 4; Thomas Agnew and Sons, London
and New York; Mrs. John Magee
Wyckoff, New York; George Magee
Wyckoff; private collection, Connecticut.

Collection of Eugene Victor and
Clare Thaw

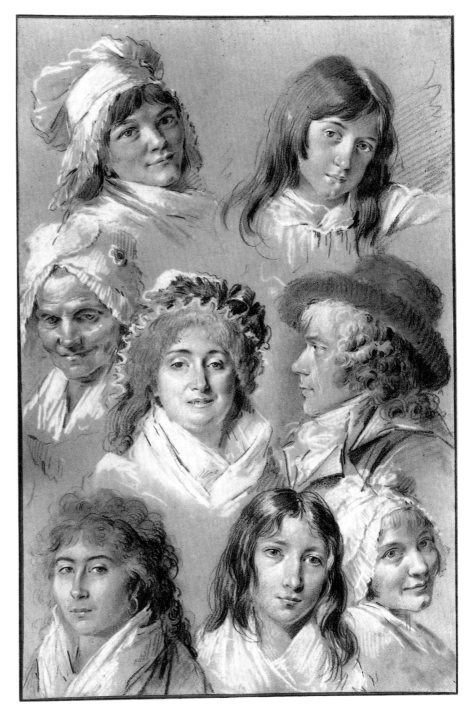

96 Portraits of the Artist's Family and Servants

Louis Léopold Boilly

LA BASSÉE 1761 – 1845 PARIS

97 Study for *Les Déménagements*

THIS STUDY is part of Boilly's elaborate preparations for *Les Déménagements,* the painting now in the Art Institute of Chicago which Boilly exhibited in the salon of 1822. The artist carefully constructed this genre subject to depict the spectacle of ordinary people moving their sundry belongings through the streets to find new lodgings. Although the model in the Morgan drawing appeared to be a middle-aged man, the artist transformed him in the painting into the much older, bald man who is seen loading boxes onto a barrow at the right of the composition. In this study, Boilly examines the effect of the light on the textures of the man's costume, especially his shirt. The subject was successful and a print after the composition was made by Jean-Henri Marlet (repr. Siegfried 1990, pl. 63). A large watercolor sketch of the entire subject is now in the Musée des Beaux-Arts, Lille, and the Musée Cognacq-Jay, Paris, has an oil replica which the artist made in 1840.

Black chalk, heightened with white, on brown wove paper

10½ x 9⅞ inches (268 x 239 mm)

Provenance: unidentified collector's dry stamp FM; sale, London, Christie's, 8 December 1976, lot 113, pl. 43 *(as Study of a Tailor)*.

Bibliography: Russell 1977, p. 153, fig. 116; PML/*FR*, XVIII, 1978, p. 249; Siegfried 1990, p. 520, pl. 61.

Exhibition: New York PML 1984, no. 95.

Purchased as the gift of Mr. and Mrs. Claus von Bulow

1977.38

Moving Day on the Port of Wheat, Paris. *1982.494. The Art Institute of Chicago*

97 Study for Les Déménagements

Jean-Baptiste Isabey

NANCY 1767 – 1855 PARIS

98 Oval Portrait of André Grétry (1741–1813)

THE MINIATURE PAINTER ISABEY, a close friend of both Napoleon and Joséphine, was appointed first painter to the empress in 1805. In this capacity he was charged not only with reproducing the official likenesses of the emperor and empress, but was also the organizer of all the intimate and official fêtes of the Tuileries, Saint-Cloud, and Malmaison. He received the title of *dessinateur du cabinet, et des cérémonies, directeur des décorations de l'Opéra,* and he was also named *peintre des rois*. Unquestionably the most brilliant miniature painter of his time, he continued in this capacity with Louis XVIII, Charles X, Louis-Philippe, and Napoleon III.

One might think this drawing with its dramatic lighting and the presence of the dove was intended as a memorial to the composer André Grétry, who died in 1813, but Grétry must have sat to Isabey, since, presumably, the drawing is preparatory for the print engraved by Jean-Pierre Simon, who died about 1810. Grétry, who was active in the Opéra in Paris, is perhaps best known for his operas *Guillaume Tell* and *Richard Cœur de Lion*.

Black chalk, stumped, heightened with white tempera, on cream-colored wove paper

15 x 10%⁄16 inches (380 x 268 mm)

Watermark: none

Signed and retraced in black chalk, below oval at right, *J. Isabey;* lettered, probably by the artist, below oval at center, *Grétry*

Provenance: Duc de Marnier; Jacques Seligmann, Paris; from whom purchased by Mr. and Mrs. Jesse I. Straus in 1921; their sale, New York, Parke-Bernet Galleries, 21 October 1970, no. 48, repr.

Bibliography: PML/*FR*, XVI, 1971, p. 115.

Exhibitions: New York PML 1984, no. 96.

Purchased for the Mary Flagler Cary Music Collection

1970.15

GRÉTRY

98 Oval Portrait of André Grétry (1741-1813)

Jean-Baptiste Isabey

NANCY 1767 – 1855 PARIS

99 Congrès de Vienne

IN 1814 (in the absence of Louis XVIII, who did not choose to go himself) Talleyrand headed the French delegation to the Congress of Vienna. He invited Isabey to accompany the French contingent and paint the likenesses of the delegates who attended. Isabey probably made quite a few portraits at the time, including this official set containing the portraits of twenty-three representatives, Talleyrand among them, as well as eight circular portraits of the ruling sovereigns of the day. Talleyrand was assisted by the duc de Dalberg, whose likeness is included in the album, and the comte de La Besnardière (who does not appear). Among other delegates at the congress Isabey drew the British representatives, headed by Lord Castelreagh, his half-brother Charles William Stewart, as well as Lords Cathcart and Clancarty. Portraits of Prince Metternich, the head of the Austrian delegation, and Ignaz Heinrich Karl Freiherr von Wessenberg also appear. The portraits are all the same size and executed in very fine point of brush and brown wash. Despite their tiny format, Isabey has endowed each portrait with some suggestion of the subject's character and intellectual ability.

Presumably the drawings were bound into an album in the mid-1820s. Decle was active in the late empire and became a binder to the king, receiving a medal of honor in 1823. Charles X presented the bound album to the duchesse de Berry on New Year's Day 1830. The Susse Frères, also binders, active in the late 1830s and 1840s, must also have worked on or made some repairs to the album, since their paper ticket appears on the flyleaf.

99 Prince Metternich

99 Duke of Wellington

Album of thirty-one miniature portraits of participants in the Congress of Vienna, 1815

Point of brush and brown wash

Approximate measurements of each drawing: 7³/₁₆ x 4½ inches (194 x 116 mm): Leaf: 12¹⁵/₁₆ x 8⅝ inches (329 x 222 mm)

Each portrait is signed, dated, and inscribed by the artist in pen and brown ink

Accompanied by manuscript title page by Isabey in pen and brown ink, *congrès de vienne. / medailles. / des 8 Souverains aliés. / portraits. / des 21 Ministres / et des 2 secré-* *taires. / du protocole. / dessinés d'après nature, par J. Isabey. / à vienne / an. 1815.*

Binding: Purple goat, embossed in blind and gold, *CONGRES DE VIENNE PAR J. ISABEY / AN 1815,* signed by the binder in gold at foot of spine, *Decle,* and with ticket of Susse Frères (fl. 1839-49) on verso of first endleaf; in blue pebble-grained morocco slipcase styled like a diplomatic pouch; measuring 13¼ x 9⅛ inches (337 x 235 mm)

Provenance: Charles X; by whom given to the duchesse de Berry on 1 January 1830; her sale, 20 February 1837, Paris; bought by the marquis of Hertford; by

whom bequeathed to comte Dimitry de Nesselrode; Grand Duke Nicolas; J. Seligmann, Paris; from whom purchased by J. Pierpont Morgan on 24 December 1908 for 27,500 francs (no mark; see Lugt 1509).

Bibliography: Basily-Callimaki 1909, p. 192.

Exhibition: New York PML 1984, no. 123.

Purchased in 1908

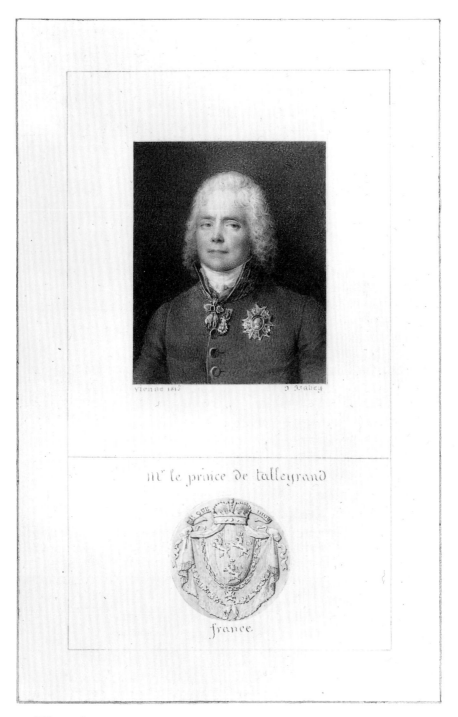

Vienne 1815 J. Isabey

M.ᵉ le prince de talleyrand

france.

99 Talleyrand

217

Baron Antoine-Jean Gros

PARIS 1771 – 1835 MEUDON

100 Portrait of a Woman

ALTHOUGH THE SITTER is turned three-quarters to the left in this half-length portrait, she looks directly at the spectator. Her pleasant, oval face is framed by her dark hair, which is mostly covered by a frilly bonnet tied under her chin.

The portrait may be identical with one formerly in the Alfred Beurdeley Collection which was sold in Paris in 1920 (Galerie Georges Petit, 30 November, 1-2 December 1920 [ninth sale], lot 212, not repr.). The description in the sale catalogue as well as the measurements cited seem to support this assumption.

As tradition has it, the Morgan portrait represents Gros's wife, Augustine Dufresne (1789-1824), a stockbroker's daughter whom Gros married on 31 July 1809. She would have been about thirty-five years old when she sat for this portrait, which dates to around 1824.

By all accounts it was not a happy marriage for the extremely sensitive artist, who did not find the understanding and support he needed. Gros, the painter and chronicler of Napoleon and his military exploits, excelled in catching the specific features of a person he was to portray. This portrait has a knowing and intimate quality that contrasts with the swagger and proud demeanor of his military subjects. Mme Gros's features are well known from Gros's painting of her at the Musée des Augustins in Toulouse. Although she is depicted as a younger woman, the similarity of the features is undeniable.

Portrait de Madame Gros.
RL 6705/LA 93950. Musée des Augustins, Toulouse

Black and white chalk, on brown paper

11¾ x 8¾ inches (298 x 223 mm)

Watermark: MONTGOLFIER

Signed at lower left, *Gros*

Provenance: Germain Seligman, New York; R. M. Light & Co., Inc., Santa Barbara.

Bibliography: Richardson 1979, no. 32, repr.; PML/*FR*, XXI, 1989, p. 346.

Exhibitions: New York and elsewhere 1955-56, p. 34, no. 5, repr.

Purchased as the gift of Mrs. George H. Fitch in honor of Mr. Charles Ryskamp

1986.118

100 Portrait of a Woman

Nineteenth Century

François Marius Granet

AIX-EN-PROVENCE 1775 – 1849 AIX-EN-PROVENCE

101 View of the Church Entrance at Marsat near Riom

A LITHOGRAPH of this portal of a romanesque church by Jean-Baptiste Arnoult (possibly Arnout or Arnould, b. Dijon, 1788) is included in Nodier et al. 1829-33 (I, pl. 14). It was printed by Godefroi Engelmann (1788-1839), who experimented with lithography as early as 1813 (see Laran 1959, p. 315).

Granet, a painter from Aix-en-Provence and a pupil of Jacques-Louis David in Paris, is primarily renowned for his historical and genre paintings as well as for his landscape sketches in brown wash and watercolor. He visited Rome with his friend and fellow painter the comte Auguste de Forbin from 1802 to 1825, a stay interrupted only by journeys to Paris and Assisi. His best-known painting, *Le Chœur de l'église des Capucins,* exhibited at the salon of 1819, was so successful as to require sixteen replicas. Near the time of his death in 1849, he bequeathed his works, including 250 historical and genre paintings and portraits, about 150 landscape paintings, and about 1,200 works on paper, to a museum in his native city that was later renamed the Musée Granet in his honor. The famous portrait of the artist made by Ingres in 1807 is appropriately located in this museum.

The brilliant light and deep shadows that characterize this watercolor sketch enliven the brittle stonework of the ancient church and demonstrate Granet's talent for creating rich tonal compositions. The scene is populated by a handful of bystanders gathered at the left and a worshiper about to enter the church. Granet frequently filled his compositions with such small groups of people, heightening the silent and contemplative mood typical of many of his works. This ability to evoke the atmosphere of a place led Focillon to call Granet a "vrai poète d'une lumière recueillie"—a true poet of meditative light—and has caused many to consider the artist a forerunner of Corot and the impressionists.

For an excellent discussion of Granet and his oeuvre, see *Granet: Paysages de l'Isle de France – Aquarelles et Dessins,* Collections du Musée Granet, Aix-en-Provence, 1984.

Watercolor and point of brush over black chalk

8⁷/₁₆ x 7⁵/₁₆ inches (215 x 185 mm)

Watermark: none

Provenance: Zangrilli, Brady & Co., New York.

Exhibition: New York 1986, no. 28, repr.

Collection of Eugene Victor and Clare Thaw

101 View of the Church Entrance at Marsat near Riom

Jean Auguste Dominique Ingres

MONTAUBAN 1780 – 1867 PARIS

102 Portrait of Guillaume Guillon Lethière (1760–1832)

INGRES'S TALENT for portraiture manifested itself early, and he drew like-nesses of many of his friends and associates while he was at the French Academy in Rome. He portrayed his friend and mentor Guillaume Guillon Lethière, first in the profile portrait of 1811 now in the Fogg Art Museum (repr. Cambridge 1967, no. 19) – virtually repeated in the drawing in the Musée Bonnat, Bayonne – and again in 1815 in this superb frontal portrait made for Lethière's friend Hortense Lescot. Here the artist's pencil captures not only the physiognomical likeness of the man who directed the French Academy during Ingres's term there as a pensioner but also something of his character as well. The sitter is revealed as the genial and intelligent, if somewhat vain, man of whom Alexandre Dumas wrote: "Monsieur Lethière était à la fois un beau talent, un bon coeur et un charmant esprit." Ingres's portrait of Lethière has immense dash and sweep, and every nuance of detail is crisply delineated in a range of tonal effects resulting from the alternation of soft and hard pencils. The tautly stretched paper tablet which the artist used served as a convenient support and also provided a fine resilient surface on which Ingres could draw with absolute control.

Pencil on wove paper

11 x 8¾ inches (280 x 221 mm)

Inscribed at lower right, *M. de Ingres / a Mad*^{lle} *Lescot,* and signed (and erased, but still legible) beneath dedication, *Ingres rome 1815*

Provenance: Mlle Hortense Lescot, later Mme Louis-Pierre Haudebourt; Adrien Fauchier-Magnan; private collection, Paris; sale, Paris, Hôtel Drouot, Salle 7, 13 November 1922, lot 12, repr.; Mr. and Mrs. Herbert N. Straus, New York.

Bibliography: Jouin 1888, p. 119; Lecomte 1913, p. 18, repr.; Zabel 1930, p. 379, repr.; Louchheim 1944, pp. 129, 130, repr.; Mongan 1947, no. 9, repr.; Naef 1963, pp. 65-78, fig. 1; Schlenoff 1967, p. 379; Mongan 1969, p. 141; Feinblatt 1969, p. 262, fig. 4; Naef 1972, p. 660, repr.; Naef 1977-80, pp. 408ff., IV, no. 135, repr.; PML/*FR*, XVIII, 1978, pp. 244, 269f., repr.; Cambridge 1980, under no. 7; Hofstadter 1987, p. 20.

Exhibitions: Paris 1913b, no. 332; Paris 1921a, no. 64; Buffalo 1935, no. 95, repr.; Springfield and New York 1939-40, no. 47; New York 1961a, no. 6, repr.; Cambridge 1967, no. 30, repr.; New York PML 1981, no. 120, repr.; New York PML 1984, no. 100, repr.

Bequest of Therese Kuhn Straus in memory of her husband, Herbert N. Straus

1977.56

102 Portrait of Guillaume Guillon Lethière (1760-1832)

Jean Auguste Dominique Ingres

MONTAUBAN 1780 – 1867 PARIS

103 Portrait of Charles Désiré Norry (1796–1818)

INGRES'S SKILL as a portrait draughtsman is again demonstrated in this deft characterization of Charles Désiré Norry, who died in 1818, aged twenty-two, a year after he sat for this portrait. Not a great deal is known about the sitter; he was studying architecture in Rome with the intention of following the profession of his father, Charles Norry (1757-1832). When the latter came to Rome to visit the younger Norry in 1817, both father and son sat to Ingres for portraits. The portrait of Charles Norry, who survived his son by fourteen years, was in the collection of Mr. William S. Paley, New York, and recently entered the Museum of Modern Art, New York, as part of his bequest (repr. Naef 1977-80, IV, no. 215).

Pencil on wove paper

7¹⁵/₁₆ x 5⅞ inches (202 x 149 mm)

Signed, inscribed, and dated by the artist at lower left, *Ingres à Mʳ Norry / Pere. / rome / 1817*

Provenance: Charles Norry; Henri Rouart; Alexis Rouart; Louis-Henry Rouart; John S. Newberry, Jr.; E. V. Thaw and Co., New York.

Bibliography: Lapauze 1911, pp. 165, 184 repr.; George 1934, p. 197, repr.; *Art Digest* 1950, p. 13, repr.; Naef 1977-80, II, p. 232, IV, no. 216, repr.; PML/*FR*, XVIII, 1978, pp. 244, 269.

Exhibitions: Paris 1924a, no. 179, repr.; Paris 1934a, no. 22; Detroit 1950, no. 23; Detroit 1951, no. 14, repr. as frontispiece; Pittsburgh 1951, no. 156, repr.; Cambridge 1960, no. 20, repr.; New York 1961a, no. 24, repr.; Boston 1962 (no catalogue); New York PML 1981, no. 21, repr.; New York PML 1984, no. 101.

Purchased on the von Bulow Fund

1977.37

103 Portrait of Charles Désiré Norry (1796-1818)

Jean Auguste Dominique Ingres

MONTAUBAN 1780 – 1867 PARIS

104 Studies of Legs, Hands, and the Profile of a Head for the Martyrdom of St. Symphorien

THIS DRAWING is one of Ingres's many existing preparatory studies for the *Martyrdom of St. Symphorien,* the painting commissioned of Ingres in 1824 by the Cathedral of St. Lazare at Autun, where it remains. Ingres had established the general composition of the painting by 1826 but did not finish it until 1834. It was criticized at the salon where it was exhibited in the same year. Some two hundred drawings related to the painting are at Montauban as are several painted studies. Included in this group of studies is a replica of the Morgan drawing executed on tracing paper.

While the large study of legs depicts those of the lictor who stands to the left of St. Symphorien, the legs at the top of the page are for a figure behind the lictor. The small study of legs at the right is for the figure of the lictor who stands at the right side of the saint. The profile is that of the bearded man who stands in back of the saint. The hand grasping the baton is a study for one of the mounted soldiers seen behind the saint, who can be seen in full in the drawing of the *Horsemen* now at the Nelson-Atkins Gallery, Kansas City (Cambridge 1967, no. 61, repr.).

The martyr St. Symphorien was a youth converted to Christianity in the reign of Diocletian. He was beaten and beheaded for showing contempt for the image of the goddess Berecynthia (Cybele) on her festival. One of the most venerated saints in Gaul, a church was built in Symphorien's honor in Autun at the end of the fifth century.

Le Martyre de saint Symphorien.
Cathedrale Saint Lazare, Autun

Black chalk and pencil; partially squared for transfer in black chalk

18 x 12 inches (458 x 305 mm)

Signed at lower right in black chalk, *Ingres;* inscribed by the artist at upper right, *pour le ... / clair demiteinte rouge / chaud fort clair pas / autant les angles / blanc;* near the center, *clair;* numbered one to four corresponding to section of squaring

Provenance: Charles E. Slatkin Galleries, New York; Stephen R. Currier, New York; Michael S. Currier, New York.

Bibliography: Mathey 1945, pl. 10; PML / FR, XXI, 1989, pp. 349f.

Exhibitions: Cambridge 1967, no. 62, repr.; Iowa City 1964, no. 100, repr.

Purchased as the gift of Mrs. Charles Wrightsman

1985.99

104 Studies for the Martyrdom of St. Symphorien

Jean Louis André Théodore Géricault

ROUEN 1792 – 1824 PARIS

105 Mustapha

THIS AND VARIOUS OTHER DRAWINGS by Géricault have been identified as portraits of his servant Mustapha (see Zurich 1953, nos. 210, 215-16). The employment of a Turkish servant was one manifestation of Géricault's predilection for orientalism, and Mustapha is known to have posed for him wearing exotic clothing, some borrowed from the collection of the artist-dilettante Jules-Robert Auguste. M. Auguste was a prominent member of the circle of artists that included Baron Gros and Delacroix, to both of whom he occasionally lent items from his collection of costumes and weapons.

Watercolor over pencil

11^{15}/16 x 8½ inches (302 x 216 mm)

Provenance: baron de Schwiter (Lugt 1768); his sale, Hôtel Drouot, Paris, 20-21 April 1883, no. 43; P.-A. Chéramy, Paris; A. Stroelin, Paris; Pierre Dubaut (Lugt S. 2103b); Walter Goetz, Paris.

Exhibitions: New York PML and elsewhere 1975-76, no. 72, repr.; New York PML 1984, no. 102; New York and elsewhere 1985-86, no. 102, repr.

Collection of Eugene Victor and Clare Thaw

105 Mustapha

Jean Louis André Théodore Géricault

ROUEN 1792 – 1824 PARIS

106 The French Farrier

THIS STURDY FIGURE is a study for *The French Farrier,* a lithograph of the English series, eight prints published in England in 1821 and signed, as was customary there, "J. Géricault" (Delteil 1924, no. 41). The print was revised and executed in reverse by Léon Cogniet in 1822 (Delteil 1924, no. 84). The figure occurs on work sheets as early as 1812-14 as part of a study for the *Blacksmith's Signboard.* In the album now at the Art Institute of Chicago (published by Lorenz Eitner, *Géricault, an Album of Drawings…,* Chicago, 1960) the figure appears on the following pages: 38, 39, 40, and 53 verso, as a subsidiary figure to the blacksmith himself. Folio 38 includes a detail of the hands holding the flexed foreleg of the horse. On folio 40, the man holding the leg is seen from the front and also rotated to be seen from the back. In the finished *Blacksmith's Signboard* the blacksmith himself is only slightly altered in stance and gesture, but the assistant disappears completely. It was this study, with its interesting torsion, that Géricault used for the later lithograph.

Pen and brown ink, some point of brush, and pencil

8½ x 5¹¹⁄₁₆ inches (217 x 144 mm)

Provenance: David Carritt, London.

Exhibition: New York PML and elsewhere 1975-76, no. 75, repr.

Collection of Eugene Victor and Clare Thaw

A French Farrier. *1991.228.7. The Art Institute of Chicago*

106 The French Farrier

Antoine Louis Barye

PARIS 1795 – 1875 PARIS

107 Tigress on Her Back

UNLIKE HIS FRIEND DELACROIX, Barye did not travel at all. Until he went to Barbizon in 1849, he almost never left the city of Paris or got closer to animals in the wild than the Jardin des Plantes. There he was a frequent visitor and acute observer, as his drawings and his masterful clay models and bronzes of animals bear witness. In his drawings and paintings he often placed the animals against colorful landscape backgrounds, which in their contours sometimes echo the animal forms; later he occasionally put the animals in a Barbizon setting. Most often associated with scenes of ferocity–animals stalking prey or battling fiercely–Barye also made various studies of lions and tigers (and even an elephant) rolling playfully on the ground, like the playful young tigress seen here.

Watercolor

8¼ x 10⅞ inches (205 x 275 mm)

Signed in pen and brown ink at lower right, *Barye*

Provenance: P.-A. Chéramy, Paris; his sale, Paris, Galerie Georges Petit, 5-7 May 1908, no. 273 (1,940 Fr.); Alfred Beurdeley, Paris; his sale, Paris, Galerie Georges Petit, 2-4 February 1920, no. 15 (9,100 Fr.); M. Schoeller, Paris; Jacques Zoubaloff, Paris; his sale, Paris, Galerie Georges Petit, 16-17 June 1927, no. 9; Gerson; Galerie Alfred Daber, Paris.

Bibliography: Zieseniss 1955, p. 64, pl. ii, B-14.

Exhibitions: Paris 1889, no. 746; St. Petersburg 1912, no. 17; Paris 1913a, no. 5; Paris 1929, no. 59; Paris 1931b, p. 37; Paris 1936, no. 130; Paris 1956, no. 9; New York 1964b, no. 3, repr.; New York PML and elsewhere 1975-76, no. 76, repr.

Collection of Eugene Victor and Clare Thaw

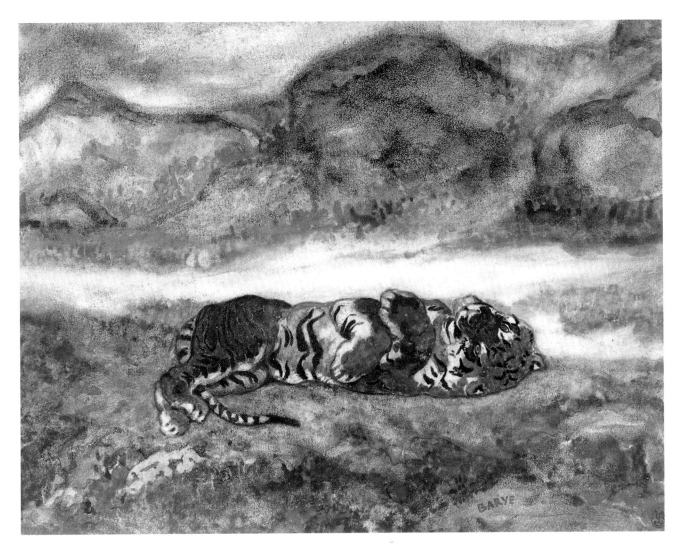

107 Tigress on Her Back

Camille Jean-Baptiste Corot

PARIS 1796 – 1875 PARIS

108 Portrait of a Man

IN THIS WORK Corot, the painter of landscapes and romantic Barbizon pieces, is revealed as a portrait draughtsman of unusual strength and psychological penetration. The drawing was executed in 1844, some twelve years after Ingres's portrait of M. Bertin, the celebrated picture that had such an impact on contemporary and later portraiture. There is something of the visual power of Ingres's portrait in Corot's work here, the crisp execution and close observation, somehow suggestive of his sitter's character and inner life. According to a label on the back of the old mount, this is a portrait of Théodore Rousseau's grandfather. This suggestion, however interesting, does not seem tenable inasmuch as the sitter appears to be too young to be the grandfather of Rousseau, the great Barbizon painter born in 1812. Although Rousseau's maternal grandfather, Guillaume-Etienne Colombet, a marble worker, was still alive in 1844, he would have been ninety-four when this portrait was made. The subject here appears to be in his sixties or seventies, much closer to the age of Rousseau's father, who was born in 1787.

The viewer would like to know more about this man, whose quizzical countenance immediately engages the spectator's interest and sympathy.

Pencil, partly stumped, on wove paper

10½ x 8½ inches (265 x 216 mm)

Signed and dated at lower right, *C. Corot./octobre. 1844*

Provenance: Abbé Constantin; sale, Paris, Hôtel Drouot, 6 April 1914, lot 16; André Desrouges (all according to back of old mount); M. R. Schweitzer, New York.

Bibliography: *Art Journal,* Winter 1964-65, p. 187, repr. in advertisement of M. R. Schweitzer, New York (as M. Rousseau).

Exhibition: New York PML and elsewhere 1975-76, no. 78, repr.

Collection of Eugene Victor and Clare Thaw

C. COROT.
octobre . 1844

108 Portrait of a Man

Ferdinand Victor Eugène Delacroix

CHARENTON-SAINT-MAURICE 1798 – 1863 PARIS

109 A Persian Horseman with a Lance

AMONG DELACROIX'S STUDIES after works of art of one kind or another is a series of sketches from Persian miniatures, oriental coins, and architectural decoration. These he sometimes worked up in watercolor, and such a procedure may lie behind the spirited horse and rider of this Thaw drawing. The Louvre album of 1825 (Inv. no. R.F. 23.355, ff. 28-29) contains figures copied from miniatures, including a turbaned man riding a camel, his right arm raised, his left bent across his body, in a pose similar to that of this horseman. Most of the oriental studies date from the time Delacroix was working on the *Massacre at Scio* and the *Death of Sardanapalus*. His extraordinary color sense is shown to advantage in the brilliant blues and reds and the silvery whites and grays of the drawing.

Watercolor and some gouache over a few traces of pencil

6⁵/₁₆ x 8 inches (161 x 203 mm)

Signed in pen and brown ink at lower right: *Eug Delacroix*

Provenance: Hugo Perls, New York; César de Hauke and Co., Paris; Edith Wetmore.

Exhibitions: New York 1970, no. 24, p. 5; New York PML and elsewhere 1975-76, no. 80, repr.; New York PML 1984, no. 104.

Collection of Eugene Victor and Clare Thaw

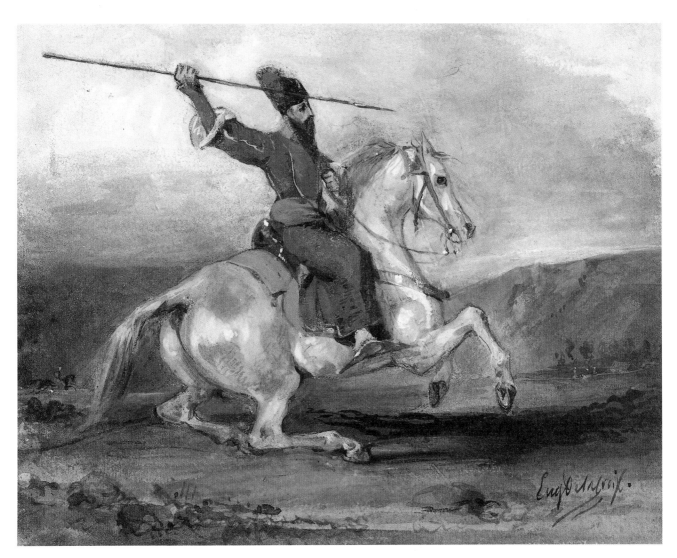

109 A Persian Horseman with a Lance

Ferdinand Victor Eugène Delacroix

CHARENTON-SAINT-MAURICE 1798 – 1863 PARIS

110 Royal Tiger

A KEEN STUDENT of animal anatomy, Delacroix was a frequent visitor to the Paris Museum of Natural History, often in the company of his friend the sculptor Barye (Cat. no. 107). Tigers especially fascinated him. Alfred Robaut, who compiled the earliest catalogue raisonné of Delacroix's work, listed more than fifty renderings of tigers in various poses. This sleek watercolor of the powerful animal depicted in an open landscape is close to the artist's lithograph *Royal Tiger,* 1829, but closer still to *Crouching Royal Tiger,* the painting at Princeton (Acc. no. 61-140. See Mras 1962, pp. 16-24).

A sheet of studies of a flayed tiger includes one small figure in a pose almost identical to that in the Thaw watercolor (repr. Moreau-Nélaton 1919, fig. 78). Although Delacroix was occupied with similar subjects over a period of many years, the restrained style of this *Tiger* is compatible with that of drawings of the late 1820s. "Royal tiger" is a popular term and not a scientific designation, but it may in this case refer to the animal's obviously large size. There is a similar watercolor of a tiger in the Rosenwald Collection, National Gallery of Art, Washington.

Pen and brown ink, and watercolor over pencil

7 x 10⁹⁄₁₆ inches (178 x 268 mm)

Signed in pen and brown ink at lower right: *Eug Delacroix*

Bibliography: Frankfurt 1987-88, under no. I 12, p. 200.

Exhibitions: New York PML and elsewhere 1975-76, no. 79, repr.; New York PML 1984, no. 103, repr.

Collection of Eugene Victor and Clare Thaw

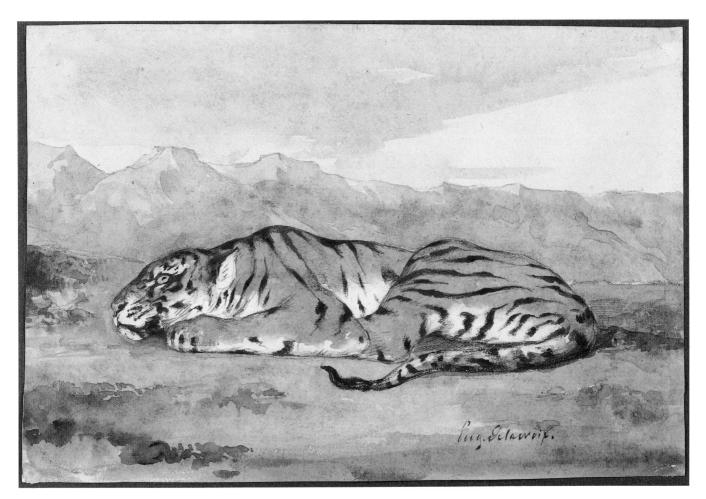

110 Royal Tiger

Ferdinand Victor Eugène Delacroix

CHARENTON-SAINT-MAURICE 1798 – 1863 PARIS

111 Christ on the Cross

DELACROIX'S TRAVELS took him to Belgium in 1838 and again in 1850, when he and his domestic, Jenny, left for Brussels on 6 July returning to Paris only on 14 August 1850. They traveled first to Brussels, went back and forth to Antwerp a few times, and visited other places of interest in Belgium and in the neighboring areas of Germany. Delacroix was much taken with Rubens's paintings in the Musée Royal des Beaux-Arts, Antwerp, and devoted a number of pages in his journals for this trip to the great Flemish master. He was to paint several free copies of Rubens's famous *Coup de Lance* of 1620, in that museum, including the copy now in the Baltimore Museum of Art. On 10 and 11 August he spent a good deal of time revisiting the Rubens paintings and later drew from memory those that had particularly impressed him. This drawing might well be one of the works referred to in his diary, "Dessiné de mémoire tout ce qui m'avait frappé pendant mon excursion d'Anvers" (Journal, 1822-63, p. 264) since it has all the strength and freedom of execution of a work recalled from memory rather than copied.

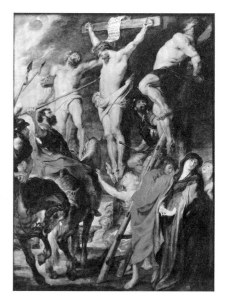

Peter Paul Rubens. Le Coup de lance. *Musée Royal des Beaux-Arts, Antwerp*

Pen and brown ink, brown wash

14¼ x 9¼ inches (362 x 235 mm)

Watermark: illegible letters

Provenance: the artist's atelier (Lugt S. 838a); his sale, Paris, 21 February 1864, probably one of lots 635-37; M. Riesener (?); Pierre Geismar (Lugt S. 2078b); his sale, Paris, Hôtel Drouot, 15 November 1928, lot 10, repr.; Stonborough sale, New York, Parke-Bernet, 17 October 1940, lot 40, repr.; John S. Thacher.

Bibliography: Badt 1946, no. 16; Paris 1963, no. 44, repr.; Ehrlich-White 1967, p. 39 n. 23; Robaut 1969, no. 1680, p. 428, possibly part of no. 1956 (eight sheets); PML/*FR*, XXI, 1989, pp. 313, 334f.

Exhibitions: Paris 1924a, no. 97, repr.; Paris 1925a, no. 57; New York 1944a, no. 890; Frankfurt 1987-88, no. K4, repr.

Bequest of John S. Thacher

1985.33

III Christ on the Cross

Ferdinand Victor Eugène Delacroix

CHARENTON-SAINT-MAURICE 1798 — 1863 PARIS

112 Harbor at Dieppe

THIS WATERCOLOR is one of a group of four drawings by Delacroix that were included in the bequest of John S. Thacher. Three of these drawings, including the present example, are of seascapes. *Harbor at Dieppe* can be precisely dated to Thursday, 7 September 1854, because the artist refers to it in his journal for that date. Delacroix was especially moved by some singers from the Pyrenees whom he heard on that day in the church of Saint-Jacques, Dieppe (first noted in New York 1991, no. 71). He observed that after mass in the church, when he was on his way back to his rooms at 6, quai Duquesne, he stopped and made this very drawing: "une petite aquarelle inachevée du port, rempli d'une eau verte. Contraste, sur cette eau, des navires très noirs, des drapeaux rouges, etc." (Journal, 1822-63, p. 464).

Delacroix visited Dieppe on several occasions between 1851 and 1860, and he made other seascapes of the port, including the drawings in the Albertina and in two private collections (Frankfurt 1987-88, p. 251, J6). There are, moreover, numerous sketches and notes in a sketchbook dated August-September 1854, now in the Rijksprentenkabinet in Amsterdam.

Watercolor and touches of gouache, over pencil, on light brown paper

9⁵⁄₁₆ x 12³⁄₁₆ inches (237 x 313 mm)

Inscribed at lower right in brush and brown watercolor, *77.bv. jeudi/Chanteurs*

Provenance: the artist's atelier (Lugt S. 838a); his sale, Paris, 17-20 February 1864, possibly part of lot 600; sale, Paris, Palais Galliera, 29 June 1962, lot 5, repr.; John S. Thacher.

Bibliography: PML/*FR*, XXI, 1987, p. 335; Frankfurt 1987-88, no. J6.

Exhibition: New York 1991, no. 71, repr.

Bequest of John S. Thacher

1985.44

112 Harbor at Dieppe

Louis Gabriel Eugène Isabey

PARIS 1803 – 1886 PARIS

113 View of Etretat

LOUIS GABRIEL EUGÈNE ISABEY, son of the important miniature paint-er Jean-Baptiste Isabey (Cat. nos. 98, 99), is particularly well known for his descriptive and sensitive coastal scenes–the artist's equivalent to the landscapes of the Barbizon movement.

He is known to have been part of Delacroix's circle of friends during the 1820s and may even have accompanied Bonington and Delacroix to England in 1825. Isabey also prepared drawings for Charles Nodier and Alphonse de Cailleux, and for Baron Taylor's *Voyages pittoresques et romantiques de l'ancienne France,* published from about 1829 on. After the July revolution, Louis-Philippe appoint-ed Isabey official painter to the French expedition in Africa. In the late 1830s, Isabey traveled to Belgium and Holland and returned to France with Jongkind; then the two artists traveled together throughout Normandy and Brittany. This watercolor probably does not date to this time, for, according to Isabey's journal, he is known to have visited Etretat only in 1822, 1823, 1847, and 1858. Isabey made many studies at Etretat–usually concentrating on the interesting rock formations–but in this sheet he was interested in the view of the coastal town itself, which is seen at some distance, although the natural bridge formed by the rocks can still be discerned in the background.

For a recent discussion of Isabey see Pierre Miquel, *Eugène Isabey: La Marine au XIXe siècle,* Maurs-La-Joie, 1980.

Black chalk, brush and watercolors

7½ x 13¼ inches (190 x 336 mm)

Signed, in monogram, lower left, in pen and brown ink *EI*

Provenance: the artist's family; Jacques Fischer and Chantal Kiener, Paris.

Purchased on the Lois and Walter C. Baker Fund

1991.40

113 View of Etretat

Honoré Daumier

MARSEILLES 1808 – 1879 VALMONDOIS

114 La Lecture

DAUMIER MADE at least half a dozen drawings (Maison 1968, II, nos. 353-58) and several paintings of a man reading to one or two others (Maison 1968, I, nos. 1-99 and 101), all straightforward, serious studies concentrating on the differences in pose and expression of reader and listeners. The Thaw sheet is the only finished composition among the drawings and is analogous in the general configuration, and especially in the lighting, to the painting in the Stedelijk Museum, Amsterdam (Maison 1968, I, no. 1-100), which Daumier recorded selling on 18 March 1877 to M. Tabourier for 1,200 francs. Both the absorbed middle-aged reader and his older, probably somewhat deaf listener, leaning slightly forward to catch every word, are intent on the tale that is being unfolded—with some suspense, one would judge. Like the painting, such a finished drawing was no doubt made for sale.

Black chalk, pen and black ink, gray wash

9½ x 11⅞ inches (241 x 303 mm)

Signed in pen and black ink at lower right, *h. Daumier*

Provenance: Mme Hecht, Paris; Pontremoli; Trenel; Wildenstein and Co., New York; Norton Simon, Los Angeles.

Bibliography: Klossowski 1923, no. 341;

Maison 1956, p. 203, fig. 25; Maison 1968, I, p. 105, under no. 1-100, II, no. 358, pl. III.

Exhibitions: Paris 1901, no. 213; Paris 1934b, no. 77; Los Angeles 1958, no. 200; New York PML and elsewhere 1975-76, no. 86, repr.

Collection of Eugene Victor and Clare Thaw

114 La Lecture

Honoré Daumier

MARSEILLES 1808 – 1879 VALMONDOIS

115 L'Enfant et le Maître d'école

IN 1855, at one of the regular Saturday evenings at Théodore Rousseau's house in Barbizon, the artists and writers present decided to produce a volume of compositions from some of La Fontaine's fables. Each of the painters, including Diaz, Dupré, Daumier, Millet, Barye, Ziem, and presumably Rousseau, would have to contribute a certain number of subjects fixed on that occasion. Daumier, who was "en verve rabelaisienne," was to illustrate the following fables: *Le Villageois et son Seigneur, Le Cygne et le Cuisinier, L'Ecolier et le Pédant, L'Astrologue, Le Savetier et le Financier, L'Huître et les Plaideurs, L'Ivrogne et sa Femme* (Sensier 1872, p. 231).

The project never really went anywhere, but according to Maison (1968, II, p. 137) Daumier executed six drawings for three different subjects, of which only two are finished watercolors, the present drawing and *Les Deux médecins et la Mort* in the Reinhart Collection, Winterthur. Of the remaining four drawings, two are preparatory for *L'Enfant et le Maître d'école*.

Pen and brush, black ink, watercolor, and brown wash heightened with white over black chalk

11⅜ x 9⁵⁄₁₆ inches (289 x 237 mm)

Signed in pen and black ink at lower right, *h. Daumier*

Provenance: Mme Paul Meyer; Andrew Lawrence; Schweitzer Galleries, New York; Lord Rayne; Hazlitt, Gooden & Fox, London.

Bibliography: Klossowski 1923, no. 318b.; Maison 1968, II, no. 398, pl. 133; Albrey 1985, p. 555, fig. 62; Provost 1989, p. 23 (mentioned).

Exhibitions: Paris 1901, no. 234; London 1985, no. 12, frontispiece (in color), pl. 15.

Collection of Eugene Victor and Clare Thaw

115 L'Enfant et le Maître d'école

Hilaire Germain Edgar Degas

PARIS 1834 – 1917 PARIS

116 Self-portrait in a Brown Vest

INCLUDED in the John S. Thacher bequest that entered the Library in 1985 is a group of eight drawings by Degas, an artist not previously represented in the collection. Despite its small format, Degas consciously chose to make his self-portrait at age twenty-two resemble a painting. His choice of technique, oil on paper afterwards mounted to canvas, suggests this, and he has successfully achieved a memorable likeness of himself. He was fascinated by his own features and by his own resemblance to his family, whom he often drew and painted. The years between 1855 and 1860 saw the rapid development of Degas's style, which can be seen in a study of some of his self-portraits.

In 1855 he painted a large, somewhat conventional half-length portrait of himself, now in the Musée d'Orsay (repr. Paris and elsewhere 1988-89, no. 1). About a year later he painted this portrait in the Renaissance manner. Here, although he wears his familiar brown vest, his green shirt resembles a sixteenth-century tunic, and he portrays himself before an easel with green draperies behind. The three straight thick lines in the middle distance suggest that he blocked out a three-line inscription. In 1856, he painted another small self-portrait on paper, now in the Sterling and Francine Clark Art Institute in Williamstown (repr. Paris and elsewhere 1988-89, no. 12). While these last two portraits have much in common—they are almost the same size and both are executed in oil on paper, and mounted to canvas—there is a vast difference in the effect. In the Williamstown portrait, Degas has portrayed himself as a modern painter; he wears a soft-brimmed hat that shades his features, giving him a somewhat dreamy appearance. The brushwork is much bolder and more brilliant; it is also much closer to that of other self-portraits he made at about the same time, notably the etching he made in 1857 (which perhaps refers to his interest in Rembrandt's etched self-portraits). We know that during the 1850s Degas made a study of the Renaissance masters in the Louvre, where he also copied prints in the Cabinet des Estampes of the Bibliothèque Nationale.

Oil on paper mounted to canvas

9½ x 7½ inches (240 x 190 mm)

Inscribed on a piece of paper attached to the back of frame in pen and brown ink, *Portrait de Degas par lui-même / Appartenant à Melle Fevre / 9bis Avenue des Fleurs / Nice Alpes lles France*

Provenance: the artist's atelier (Lugt 657-58); Mlle J. Fèvre, Nice; Paul Cassirer, Amsterdam; Paulette Goddard Remarque; her sale, New York, Sotheby's, 7 November 1979, lot 512, repr.; E. V. Thaw & Co., Inc., New York; John S. Thacher

Bibliography: Lemoisne 1946, II, no. 13, repr.; Boggs 1962, p. 87 n. 36; Minervino and Russoli 1970, no. 116, repr.; PML/FR, XXI, pp. 311-12, 333-34.

Exhibitions: Paris 1931a, no. XX, repr.; Paris 1931d, no. 9; Venice 1936, no. 202; Amsterdam 1938, no. 95; New York 1941, no. 33; New York 1943a, no. 8; Schaffhausen 1963, no. 38.

Bequest of John S. Thacher

1985.46

116 Self-portrait in a Brown Vest

Hilaire Germain Edgar Degas

PARIS 1834 – 1917 PARIS

117 Portrait of M. and Mme Paul Valpinçon, 1861

DEGAS drew this double portrait of his friends the Valpinçons in 1861 as a sort of double homage, to the then newly married pair and to Ingres, whose work he greatly admired. The drawing, in this case a fine linear pencil drawing, much resembles the pencil portraits Ingres executed during the years he was at the French academy in Rome (Cat. nos. 102, 103). Since the Valpinçons were the owners of a number of important works by Ingres, including the *Bathers,* which Degas admired, it must have seemed especially appropriate for Degas to adopt Ingres's style for this portrait. Degas and Paul Valpinçon were boyhood friends, and the artist apparently sought quiet and relaxation at their house in Ménil-Hubert in Normandy whenever he was tired or out of sorts. Degas remained friendly with the family throughout his life and painted numerous portraits of the Valpinçons and their children, Henri and Hortense.

Pencil

13⁹⁄₁₆ x 10¹⁄₁₆ inches (344 x 256 mm)

Signed, dated, and inscribed at lower left in pencil, *Edgar DeGas/Paris 1861.* Originally signed at lower right, now erased. Inscribed by the artist on the verso in pencil, *un passe partout Epais filets 06 (?) / papier gris – et un petit filets* [sic] */ noir apres les filets 06 (?) / et ouverture Caret (?) / l'exterieur (?) à 40-/sur (?) 50-*

Provenance: Mme Jacques Fourchy (née Hortense Valpinçon).

Bibliography: Boggs 1962, pp. 36, 92 n. 63; Conisbee 1986, p. 924, repr.; Paris and elsewhere 1988-89, p. 157, fig. 84; PML/FR, XXI, 1989, pp. 331-32.

Exhibition: Paris 1924b, no. 80.

Bequest of John S. Thacher

1985.37

117 Portrait of M. and Mme Paul Valpinçon, 1861

Hilaire Germain Edgar Degas

PARIS 1834 – 1917 PARIS

118 Standing Man in a Bowler Hat; Slight Sketch of a Woman at Left

THIS STUDY OF A MAN is probably preparatory for the figure of a man standing in a doorway in *Interior (The Rape),* a painting dated to 1868-69, now in the Philadelphia Museum of Art. The connection is suggested not only by the placement of the figure on the sheet but also by the inscription on the back of the drawing's frame, "première idée pour le Viol…" The style and technique also compare well with another drawing unquestionably for the painting, *Study of a Seated Woman* (Cat. no. 119). While the somewhat menacing attitude of the man in the Morgan drawing fits the mood of the painting, his pose and costume differ in several respects from that of the man in the painting, who is neither wearing a hat nor carrying an umbrella and who leans against the doorway, hands in his pockets. Several *pentimenti* in the Morgan sheet, however, do show that Degas first thought of drawing the man leaning back with his ankles crossed, in a pose closer to that of the man in the painting.

Essence on brown oiled paper; several *pentimenti* for the pose of the man

12¾ x 7⅞ inches (323 x 201 mm)

Inscribed on back of frame in pen and black ink, *première idée pour le Viol (l'homme* [cut off] */ adosse à le* [cut off] */ vers 1825/ par Degas (Edgar) / peinture à l'essence sur papier huilé/ nº 49 de la 2º vente de l'atelier Degas* and on a label attached to the backing, *M. Guerin/ 22 Bd. Sᵗ Michel/ 14.* Numbered on verso beneath lining in pencil(?), *237.(?)*

Provenance: the artist's atelier (Lugt 657-58); his sale, Paris, Galerie Georges Petit, 11-13 December 1918, lot 49, repr.; Marcel Bing, Paris; Marcel Guérin, Paris.

Bibliography: Rivière 1922-23, no. 77, repr.; Lemoisne 1946, II, no. 344, repr.; Minervino and Russoli 1970, no. 382, repr.; PML/*FR*, XXI, 1989, pp. 313, 332, fig. 6 in color.

Exhibition: Paris 1931d, no. 72.

Bequest of John S. Thacher
1985.39

118 Standing Man in a Bowler Hat; Slight Sketch of a Woman at Left

Hilaire Germain Edgar Degas

PARIS 1834 – 1917 PARIS

119 Study of a Seated Woman

WHILE THE CONNECTION of *Standing Man in a Bowler Hat* (Cat. no. 118) with the McIlhenny painting, now in the Philadelphia Museum of Art, remains uncertain, there is little doubt that this drawing is Degas's preparation for the woman in his enigmatic painting *Interior* of about 1868-69. Theodore Reff has plausibly connected the subject with Zola's *Thérèse Raquin,* although Degas probably used Zola's subject as the starting point rather than his text for this highly charged psychological study with its ambivalent emotional content.

Here as in the *Standing Man,* Degas employed an innovative technique, painting in essence–oil paint thinned with turpentine–on paper prepared with an oil wash to achieve a darkly intense, somewhat chalky effect.

Essence over pencil, on paper mounted on canvas

13¾ x 8³⁄₁₆ inches (350 x 209 mm)

Extraneous numbers in pencil (possibly *2 x 2-*) visible through the essence

Provenance: the artist's atelier (Lugt 657-58); his sale, Paris, Galerie Georges Petit, 2-4 July 1919, lot 5, repr.; Marcel Guérin, Paris.

Bibliography: Rivière 1922-23, no. 24, repr.; Lemoisne 1946, II, no. 350, repr.; Minervino and Russoli 1970, no. 376, repr.; Reff 1976, no. 145, repr.; Thaw 1985, p. 60; PML/*FR*, XXI, pp. 312, 332.

Exhibitions: Paris 1924b, no. 57; Paris and elsewhere 1988-89 (Metropolitan Museum of Art, New York, only; not in catalogue).

Bequest of John S. Thacher

1985.38

Interior: Le Viol. *Acc. 1986-26-10, Philadelphia Museum of Art*

119 Study of a Seated Woman.

Hilaire Germain Edgar Degas

PARIS 1834 – 1917 PARIS

120 Group of Four Jockeys

DEGAS DREW MANY STUDIES of loosely grouped horses and jockeys from which he might lift single figures or groups for use in later compositions. The studies are fascinating for the strong characterization of both men and animals and for the sense they give of the tension and frequent conflicts in the paddock before a race. The present drawing, with its play of intersecting lines of movement, has strong similarities to the painting *Jockeys before the Race* (Lemoisne 1946, II, no. 649, repr.).

Degas was a frequent spectator at the races, as he was at the ballet, and it might be said that his treatment of horses was generally more sympathetic than his treatment of dancers. Paul Valéry says of Degas's remarkable perception of horses: "Le cheval marche sur les pointes. Quatre ongles le portent. Nul animal ne tient de la première danseuse, de l'étoile du corps de ballet, comme un pur-sang en parfait équilibre, que la main de celui qui le monte semble tenir suspendu, et qui s'avance au petit pas en plein soleil. Degas l'a peint d'un vers: il dit de lui: 'Tout nerveusement nu dans sa robe de soie' dans un sonnet fort bien fait où il s'est diverti et évertué à concentrer tous les aspects et fonctions du cheval de course: entraînement, vitesse, paris et fraudes, beauté, élégance suprême" (Valéry 1938, pp. 69-70).

Pencil with some stumping, on tracing paper faded and mounted

17¹¹⁄₁₆ x 16⅜ inches (449 x 416 mm)

Artist's atelier stamp (Lugt 658) at lower left and on back of mount (Lugt 657)

Provenance: Fourth Degas atelier sale (Lugt 657-58), Galerie Georges Petit, Paris, 2-4 July 1919, III, p. 154, lot 178a, repr.; Lord Howard de Walden, London; sale, London, Sotheby's, 22 April 1971, lot 26.

Bibliography: Thomson 1979, p. 677, fig. 92.

Exhibitions: New York PML and elsewhere 1975-76, no. 96, repr.; Edinburgh 1979, no. 9 and under nos. 2, 8, 10, repr.; Tübingen and Berlin 1984, p. 47, no. 63, fig. 63.

Collection of Eugene Victor and Clare Thaw

120 Group of Four Jockeys

Paul Cézanne

AIX-EN-PROVENCE 1839 – 1906 AIX-EN-PROVENCE

121 The Card Player

THIS POWERFUL DRAWING is one of Cézanne's figure studies for *Card Players,* of which five versions are known, dating from 1890 and after. While it is closest to the figures at the right of the Musée d'Orsay and Courtauld paintings, it is not specifically a study for either. In fact, it greatly resembles a painting of a single card player in the collection of Sydney R. Barlow, Beverly Hills (repr. Tübingen 1978, p. 325). A drawing of the same model's head, wearing the familiar soft crushed hat and smoking a cigarette, is in the Boymans-van Beuningen Museum, Rotterdam (Inv. F II 225; see Chappuis 1973, no. 1094). In Chappuis's opinion the Library's drawing could be one of the earliest in the series of figure studies. The sheet, one of the largest of Cézanne's drawings, gives an impression of great solidity, which Cézanne built up with a series of light strokes, repeatedly going over the contours. The figure verges to the right of the sheet, but this effect is counterbalanced by the lightly indicated table and the power of the player's concentrated gaze. Cézanne's model is said to have been a workman who posed for him in 1891 at his country house.

Pencil

21¾ x 17⅛ inches (552 x 430 mm)

Provenance: Ambroise Vollard, Paris; F. Matthiesen, London; Paul Rosenberg and Co., New York; Knoedler and Co., New York; Dr. and Mrs. T. Edward Hanley, Bradford, Pennsylvania; Norton Simon Foundation, Los Angeles; Eugene V. Thaw.

Bibliography: Vollard 1924, p. 72, repr.; Badt 1956, p. 61, fig. 15; Moskowitz and Sérullaz 1962, p. 101, repr.; Andersen 1970, no. 250, repr.; Chappuis 1973, I, no. 1093, II, repr.; Sutton 1974, p. 99; PML/*FR*, XVIII, 1978, p. 257; Badt 1985, p. 120, fig. 15.

Exhibitions: Philadelphia 1957 (unnumbered checklist); Buffalo 1960, no. 55; New York 1961b, no. 43; Ann Arbor 1962, no. 31, pl. XIVc; New York and Philadelphia 1967, p. 61, repr.; Midland and Columbus 1967-68, no. 51; Newcastle and London 1973, p. 164, no. 67, repr.; Tokyo and elsewhere 1974, no. 125; New York PML 1974, p. 56; New York PML and elsewhere 1975-76, no. 98, repr.; Tübingen 1978, no. 62, repr.

Gift of Eugene Victor and Clare Thaw

1975.39

121 The Card Player

Paul Cézanne

AIX-EN-PROVENCE 1839 — 1906 AIX-EN-PROVENCE

122 Trees

CÉZANNE'S ELABORATE PATTERN of brushstrokes breaks this stand of trees into a prismatic color block. Each stroke retains its chromatic autonomy — blue, green, yellow, and orange are seen individually even as they interact with each other in the dominant blue tonality. It is this breaking down of form, the elements to be reworked into a pattern, that to some critics suggests parallels with cubism in Cézanne's work after about 1900. But his depiction here of the scheme of volume and voids is perhaps not so much an intellectual translation of nature as a recording of the natural optical effect of light in moving foliage, rendered with a brilliantly authoritative watercolor technique. Prof. Theodore Reff notes that this compact arrangement, with the wedge of foliage hanging above the small ravine, is unique among Cézanne's hundreds of tree and foliage studies (Reff 1960, p. 118).

Watercolor over pencil

18¾ x 12⁵⁄₁₆ inches (476 x 313 mm)

Provenance: Paul Vallotton, Lausanne; private collection, Switzerland; Wildenstein and Co., New York; Lazarus Phillips, Montreal; Georges Bernier, New York.

Bibliography: Reff 1960, p. 118, fig. 27.

Exhibitions: Neufchâtel 1956; New York 1959b, no. 76, repr.; New York 1965, no. 62, repr.; Washington and elsewhere 1971, no. 55, repr.; Tokyo and elsewhere 1974, no. 80; New York PML and elsewhere 1975-76, no. 99, repr.; New York 1977a, pl. 101.

Collection of Eugene Victor and Clare Thaw

122 Trees

Odilon Redon

BORDEAUX 1840 – 1916 PARIS

123 Cavalier

REDON PREPARED at least nine etchings of cavaliers or riders between 1865 and 1866. These demonstrate both his admiration of Delacroix and his debt to his master, Rodolphe Bresdin. Although they are conventional works, they reflect the strong influence of the romantic movement. An exact contemporary of Monet, Redon did not aspire to the naturalistic goals of the impressionists. He was more interested in the mysterious than the actual. He read extensively and his imagination was stirred by many literary sources, including classical myths and medieval legends. Horses recur in his art, whether the winged Pegasus of Greek mythology or those of the chivalric legends. He also executed a number of oriental subjects, inspired by Delacroix's numerous studies of Arabian horsemen. About twenty years later, Redon returned to the thematic material of the earlier etchings and produced a series of drawings and lithographs suggestive of the Middle Ages. As noted by Agnes Mongan, the subject of the Thaw drawing resembles one of the earlier etchings, *Porte-étendard franchissant un gué* (see Rotterdam and elsewhere 1958-59, no. 177).

The *Cavalier* is one of Redon's best-known charcoal pictures and was exhibited in the retrospective exhibition of his works in 1926, ten years after his death. As in all of the artist's works, its content is enigmatic. Even though the drawing is related to the medieval etchings, it is not really clear from the unspecified nature of his costume whether the rider is medieval at all. Redon delighted in this sort of unconventional dream-like imagery, which challenges the viewer's imagination.

Introduced to a wider public in J. K. Huysmans's controversial and widely read novel of decadence, *A rebours,* published in 1884, Redon aroused much interest among those who wished to identify with the literary avant-garde. Before this he was appreciated only by the very small circle of symbolist artists and writers, including Stéphane Mallarmé and Huysmans himself. The symbolists saw in Redon's art a visualization of their ideas. Mallarmé wrote in appreciation of Redon: "In our silences you ruffle the plumage of reverie and night…What is personal in you is apparent in your *Songes* [Redon's suite of lithographs]…your imagination has a depth equal to certain of your blacks."

Charcoal pencil on light brown wove paper

21⅛ x 14¾ inches (535 x 375 mm)

Signed at lower left, *ODILON REDON*

Provenance: Gustave Fayet, Béziers; Alexander M. Bing, New York; sale, New York, Christie's, 17 May 1984, lot 110, repr.

Bibliography: Berger 1966, p. 228, no. 623 (called *Rider*).

Exhibitions: Paris 1926, no. 208; New York 1928, no. 60; New York 1952, no. 8; Rotterdam and elsewhere 1958-59, no. 177, repr.; New York PML and Richmond 1985-86, no. 52, repr.

Collection of Eugene Victor and Clare Thaw

123 Cavalier

Odilon Redon

BORDEAUX 1840 – 1916 PARIS

124 The Fool *or* Intuition

REDON WORKED almost exclusively in black from the late 1860s through the 1890s. It was probably through Corot that he discovered charcoal, "that powder which is volatile, impalpable, and fugitive. It expressed me best and I kept to it." Redon loved his black pictures, "mes noirs," as he called them. "One must respect black....It does not please the eye and it conveys no sensuality. It is the agent of the mind far more than the most beautiful colors of the palette or the prism" (A. S. M., p. 125). He produced between four and five hundred charcoal pictures and worked in lithography as well. In the 1870s Redon began what was to be the most intensively creative period of his life. From rather conventional beginnings he gradually evolved an idiosyncratic canon of symbolic motifs, and he achieved the most intense blacks. He developed a series of imaginary portraits often characterized by a weird, secret imagery known only to himself.

The key to the interpretation of the imaginary portraits may be found in this passage from one of Redon's letters: "The sense of mystery consists in existing always under some aspect of ambiguity. This may be a double or triple aspect or even suspicions of such aspects; for example: images within images, forms which are becoming or will become in accord with the viewer's state of mind" (A. S. M., p. 97). *The Fool* or *Intuition* illustrates the sort of ambiguity Redon sought. It is interesting to contrast it with another imaginary portrait of the same date (Musée du Louvre, Département des Arts Graphiques), which was also meant to be interpreted on various levels of meaning and to evoke a "sense of mystery" in the mind of the viewer. It is entitled *Mephistopheles*. Both heads are similar in type: emaciated and mask-like. Mephistopheles is dressed in cap and bells, while the Fool wears a cap trimmed with a feather, the angle of which complements the Fool's knowingly crooked finger. The expression of the eyes of the two subjects differs: those of Mephistopheles are huge, vacuous, melancholic, and unfocused, while those of the Fool are knowing and perceptive, as if to reflect that alter-aspect of the title, *Intuition*.

Redon admired the works of Poe and Baudelaire, as witness his lithographic suites inspired by their works: *A Edgar Poe,* 1882, and *Les Fleurs du Mal,* 1890. Both writers found aesthetic meaning in distortion and the unnatural and in the concept that there is beauty in evil. Redon invested these portraits with seemingly contradictory aspects. From his inscriptions we know that he had Mephistopheles in mind, the elegant, smiling devil introduced in Goethe's *Faust*.

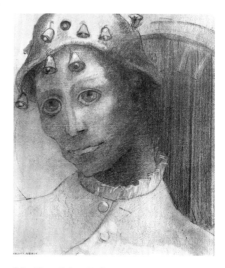

Mephistopheles (Folie). Inv. RF 35822, Musée du Louvre

Charcoal on light brown wove paper

15½ x 13½ inches (394 x 343 mm)

Signed at lower right, *Odilon Redon;* inscribed on verso at upper left, *Mephistophéles;* at lower left center, *91*

Provenance: Jacques Dubourg, Paris; René Malamoud, Zurich; Hazlitt, Gooden & Fox, London.

Bibliography: Berger 1950, no. 51, repr.; Roger-Marx 1950, no. 2, repr.; Berger 1964, no. 578, pl. 43; Selz 1971, p. 33, repr.

Exhibition: New York PML and Richmond 1985-86, no. 50, repr.

Collection of Eugene Victor and Clare Thaw

124 The Fool *or* Intuition

Paul Gauguin

PARIS 1848 – 1903 ATUANA, HIVAOA, MARQUESAS ISLANDS

125 Queen of Beauty

WHEN GAUGUIN RETURNED TO TAHITI in January of 1896 from his visit to France, he found that Tehamana, the Tahitian woman with whom he had lived before, had married during his absence. Obliged to find another *vahine,* he soon took up with a young girl, Pahura, who was only thirteen and a half. Gauguin had convinced himself that only in Tahiti would he be able to create something really new – in Tahiti, which he saw as a new paradise, he would take inspiration from the experience of recapturing man's childhood from a primitive race of people. Shortly after his return in 1896 Gauguin painted *Te Arii Vahine* (Wildenstein 1964, no. 542) and this watercolor. Much has been written about the painting and its antecedents, notably its link with Manet's *Olympia,* which Gauguin had seen on his last visit to Paris. Unquestionably the most arresting commentary on the subject, however, is that provided by Gauguin himself in the illustrated letter of April 1896 that he sent to his friend Daniel de Monfreid in Paris:

> I have just finished a canvas…that I believe to be much better than anything I have ever done previously: a naked queen, reclining on a green tapestry, a servant girl gathering fruit, two old men, near the big tree, discussing the tree of knowledge; a shore in the background: this light trembling sketch only gives you a vague idea. I think that I have never done anything with such deep, sonorous colors. The trees are in blossom, the dog is on guard, the two doves at the right are cooing.

Gauguin's choice of color for the watercolor is different and brighter than that of the oil. It is unexpected, provocative, and poetically charged. The woman, for instance, reclines on a blue ground, rather than the dark jewel-like green of the oil. Some insight into Gauguin's rather symbolist notions about color is provided by an interview published in *L'Echo de Paris* in 1895: "I borrow some subject or other from life or from nature, and, using it as a pretext, I arrange lines and colors so as to obtain symphonies, harmonies that do not represent a thing that is real, in the vulgar sense of the word, and do not directly express any idea, but are supposed to make you think the way music is supposed to make you think unaided by ideas or images, simply through the mysterious affinities that exist between our brains and such arrangements of colors and lines."

Watercolor with pen and black ink over charcoal. Verso: studies of a girl's head and legs in charcoal

6¹⁵⁄₁₆ x 9½ inches (176 x 235 mm)

Signed at lower left, *PG;* inscribed, lower center, *TE ARII VAHINE*

Provenance: Ambroise Vollard, Paris; Baron von Bodenhausen; Mr. and Mrs. Ward Cheney, New York; private collection; Acquavella Galleries, Inc., New York.

Bibliography: Goldwater 1957, repr. (in color); Rewald 1958, no. 100, repr.; Leymarie 1962, pl. 23 (in color); Wildenstein 1964, under no. 542, p. 224; Pickvance 1970, p. 40, pl. 98; Goldwater 1972, repr. (in color); Washington and elsewhere 1988-89, no. 215a, repr.; Leymarie 1989, p. 75, repr. (in color).

Exhibitions: Paris 1906, no. 82; Berlin 1928, no. 124; New York 1956, no. 69; Chicago and New York 1959, no. 112, repr.; New Haven 1960, no. 190, repr.

Collection of Eugene Victor and Clare Thaw

125 Queen of Beauty

Although most recent scholars are inclined to think that Gauguin painted the watercolor after the painting, there is room for speculation that the watercolor preceded the oil since the position of certain compositional elements such as the old men and the doves differs in the two works. Above all, the sonorous color that so pleased Gauguin when he described the canvas to his friend Monfreid is very different in the watercolor: the ground on which Pahura reclines is blue rather than green. There are also what appear to be two related sketches on the verso of the sheet, one possibly preliminary for the position of Pahura's head and the other, a much slighter sketch, studying the position of her feet.

In 1898 Gauguin reworked the composition again as a woodcut, printing at least thirty impressions on Japanese paper, mostly monogrammed by the artist in ink or pencil at the lower right corner. One of these impressions is in the Metropolitan Museum of Art, New York; the original woodblock is today preserved in the National Gallery, Prague.

125 Verso: Studies of a Woman's Head and Legs

Short Title References

BOOKS AND ARTICLES

Adhémar and Huyghe 1950 Hélène Adhémar and René Huyghe, *Watteau: Sa vie – son oeuvre*, Paris, 1950.

Agnew's 1992 *Agnew's, 1982-1992*, London, 1992.

Alfrey 1985 Nicholas Alfrey, "London, Nineteenth-Century Drawings," exhibition review in *Burlington Magazine*, CXVIII, no. 989, August 1985, pp. 554-57.

Ananoff 1957 Alexandre Ananoff, "Comment dessinait Fragonard," *Jardin des Arts*, no. 33, July 1957, pp. 515-52.

Ananoff 1961 Alexandre Ananoff, *L'Oeuvre dessiné de Jean-Honoré Fragonard (1732-1806). Catalogue raisonné*, I, Paris, 1961.

Ananoff 1963 Alexandre Ananoff, *L'Oeuvre dessiné de Jean-Honoré Fragonard (1732-1806). Catalogue raisonné*, II, Paris, 1963.

Ananoff 1966 Alexandre Ananoff, *L'Oeuvre dessiné de François Boucher (1703-1770). Catalogue raisonné*, I, Paris, 1966.

Ananoff 1968 Alexandre Ananoff, *L'Oeuvre dessiné de Jean-Honoré Fragonard*, III, Paris, 1968.

Ananoff and Wildenstein 1976 Alexandre Ananoff, with the collaboration of Daniel Wildenstein, *François Boucher*, 2 vols., Lausanne and Paris, 1976.

Andersen 1970 Wayne V. Andersen, *Cézanne's Portrait Drawings*, Cambridge, Massachusetts, 1970.

Apgar 1985 Garry Apgar, "The Age of Diderot?" *Art in America*, LXXIII, February 1985, pp. 108-15.

Art Digest 1950 "Detroit Sees France from David to Courbet," *Art Digest*, XXIV, no. 1, February 1950, p. 13.

Artemis 1933 *Artemis S. A., 1991-2*, Luxembourg, 1993.

Ashton 1988 Dore Ashton, *Fragonard in the Universe of Painting*, Washington, 1988.

A.S.M. 1922 Odilon Redon, *A Soi-Même. Journal (1867-1915)*, Paris, 1922.

Badt 1946 Kurt Badt, *Eugène Delacroix Drawings*, Oxford, 1946.

Badt 1956 Kurt Badt, *Die Kunst Cézannes*, Munich, 1956.

Badt 1985 Kurt Badt, *The Art of Cézanne*, trans. by Sheila Ann Ogilvie, New York, 1985.

Bartsch 1920-22 Adam Bartsch, *Le Peintre-graveur*, 21 vols., Würzburg, 1920-22.

Basily-Callimaki 1909 Mme de Basily-Callimaki, *J.-B. Isabey: sa vie – son temps*, Paris, 1909.

Bean 1986 Jacob Bean with the assistance of Lawrence Turčić, *15th to 18th Century French Drawings in the Metropolitan Museum of Art*, New York, 1986.

Beau 1968 Marguerite Beau, *La Collection des dessins d'Hubert Robert au Musée de Valence*, Lyon, 1968.

Béguin 1959 Sylvie Béguin, "A Drawing by Ambroise Dubois," *Art Quarterly*, XXII, No. 2, Summer 1959, pp. 164-68.

Béguin 1960 Sylvie Béguin, *L'Ecole de Fontainebleau*, Paris, 1960.

Béguin 1961 Sylvie Béguin, "Le Maître de Flore de l'Ecole de Fontainebleau," *Arts de France*, I, 1961.

Béguin 1966 Sylvie Béguin, "Dessins d'Ambroise Dubois," *L'Oeil*, CXXXV, March 1966, pp. 6-15.

Béguin and Bessard 1968 Sylvie Béguin and Bella Bessard, "L'Hôtel du Faur dit Torpanne," *Revue de l'Art*, I-II, 1968, pp. 39-56.

Béguin 1970 Sylvie Béguin, *Il cinquecento francese*, Milan, 1970.

Béguin and Vitzthum 1970 Sylvie Béguin and Walter Vitzthum, *I disegni dei maestri: Il cinquecento francese*, Milan, 1970.

Béguin 1972a Sylvie Béguin, "La Charité," *L'Oeil*, CCX-CCXI, June-July 1972, pp. 12-19.

Béguin 1972b Sylvie Béguin, "L'Ecole de Fontainebleau," *La Revue du Louvre*, XXII, nos. 4-5, 1972, pp. 401-7.

Bénard 1810 Robert Bénard, *Cabinet de M. Paignon-Dijonval*, Paris, 1810.

Berenson 1968 Bernard Berenson, *Seeing and Knowing*, Greenwich, Connecticut, 1968.

Berger 1950 Klaus Berger, *French Master Drawings of the Nineteenth Century*, New York, 1950.

Berger 1964 Klaus Berger, *Odilon Redon*, London, 1964.

Berger 1966 Klaus Berger, *Odilon Redon: Fantasy and Colour*, New York, 1966.

Bergot 1972 François Bergot, *Dessins de la Collection du marquis de Robien conservés au Musée de Rennes*, Paris, 1972.

Bergsträsser 1970 Gisela Bergsträsser, "Zeichnungen von J.J. de Boissieu im Hessischen Landesmuseum zu Darmstadt," *Kunst in Hessen und am Mittelrein*, X, 1970.

Besnard and Wildenstein 1928 Albert Besnard and Georges Wildenstein, *Latour*, Paris, 1928.

Bjurström 1976 Per Bjurström, *Drawings in Swedish Public Collections*, Stockholm, 1976.

Blunt 1966 Anthony Blunt, *The Paintings of Nicolas Poussin, A Critical Catalogue*, London, 1966.

Blunt 1967 Anthony Blunt, Nicolas Poussin, *The A. W. Mellon Lectures in the Fine Arts*, National Gallery, Washington (1958), 2 vols., New York, 1967.

Blunt 1973 Anthony Blunt, "A Drawing Illustrating Tasso by Ambroise Dubois," *Burlington Magazine*, CXV, January 1973, pp. 38-41.

Blunt 1974 Anthony Blunt, "Jacques Stella, the de Masso Family and Falsifications of Poussin," *Burlington Magazine*, CXXVI, December 1974, pp. 774-79.

Blunt 1979 Anthony Blunt, *The Drawings of Nicolas Poussin*, New Haven and London, 1979.

Boggs 1962 Jean Sutherland Boggs, *Portraits by Degas*, Berkeley, 1962.

Boon 1950 K.G. Boon, "Over Grisaille en Zilverstift," *Maandblad voor beeldende Kunsten*, XXVI, 1950, pp. 263-73.

Bruand and Hébert 1970 Yves Bruand and Michèle Hébert, *Bibliothèque Nationale, Départment des Estampes. Inventaires du fonds français: graveurs du XVIIIe siècle*, XI, Paris, 1970.

Brion 1948 Marcel Brion, *Lumière de la Renaissance*, Paris, 1948.

Briquet 1907 C. M. Briquet, *Les Filigranes: Dictionnaire historique des marques du papier*, 4 vols., Geneva, 1907.

Brunet 1862 Jacques-Charles Brunet, *Manuel de libraire*, 6 vols., Paris, 1862.

Bukdahl 1980 E.-M. Bukdahl, *Diderot critique d'art – I – Théorie et pratique dans les Salons de Diderot*, Copenhagen, 1980.

Bulletin 1877 *Bulletin de la libraire Morgand et Fatout*, no. 6, January 1877.

Cafritz et al. 1988 Robert C. Cafritz, Lawrence Gowing and David Rosand, *Places of Delight: The Pastoral Landscape*, Washington, 1988.

Cailleux 1961 Jean Cailleux, "L'Art du Dix-Huitième Siècle – Decorations by Antoine Watteau for the Hôtel Nointel," *Burlington Magazine*, CIII, no. 696, March 1961, supplement, no. 7, pp. i-v.

Cailleux 1974 Jean Cailleux, "The Drawings of Louis Roland Trinquesse," *Burlington Magazine*, CXVI, February 1974, pp. ii-xiv.

Camesasca and Rosenberg 1970 Ettore Camesasca and Pierre Rosenberg, *Tout l'oeuvre peint de Watteau*, Paris, 1970.

Chappuis 1973 Adrien Chappuis, *The Drawings of Paul Cézanne, a Catalogue Raisonné*, Greenwich, Connecticut, 1973.

Châtelet 1972 Albert Châtelet, "Un artiste à la cour de Charles VI: a propos d'un carnet d'esquisses du XIVe siècle conservé à la Pierpont Morgan Library," *L'Oeil*, CCXVI, 1972, pp. 16-21.

Chiarini 1968 Marco Chiarini, *Claudio Lorenese Disegni*, Florence, 1968.

Chiarini 1990 Marco Chiarini, *Gaspard Dughet 1615-1675*, Paris, 1990.

Clark 1987 Alvin L. Clark, Jr., *From Mannerism to Classicism: Printmaking in France*, New Haven, 1987.

Cleveland Bulletin 1978 Sherman E. Lee, "The Year in Review for 1977," *The Bulletin of the Cleveland Museum of Art*, LXV, January 1978.

Coffin 1969 David Coffin, *The Villa d'Este at Tivoli*, Princeton, 1969.

Cohen 1880 Henry Cohen, ed., *Guide de l'amateur de livres à vignettes (et à figures) du XVIII^e siècle*, Paris, 1880.

Cohen 1912 Henry Cohen, *Guide de l'amateur de livres à gravures du XVIII^e siècle*, Paris, 1912.

Colombier 1945 Pierre du Colombier, *L'art Renaissance en France*, Paris, 1945.

Comstock 1953 Helen Comstock, "The Connoisseur in America," *Connoisseur* CXXII, no. 533, November 1953, pp. 134-39.

Conisbee 1986 Philip Conisbee, "London and Paris, French artists at home and abroad," exhibition review in *Burlington Magazine*, CXXVIII, no. 1000, July 1986, pp. 532-34.

Coope 1972 Rosalys Coope, *Salomon de Brosse*, London, 1972.

Cordellier 1985 Dominique Cordellier, "Toussaint Dubreuil, singulier en son art," *Bulletin de la Société de l'Histoire de l'Art français*, 1985.

Cormack 1970 Malcolm Cormack, *The Drawings of Watteau*, New York, 1970.

Cornillot 1957 Marie Lucie Cornillot, *Collection Pierre-Adrien Pâris, Besançon. Inventaire général des dessins des musées de Provence*, Paris, 1957.

Cuzin 1988 Jean-Pierre Cuzin, *Jean-Honoré Fragonard: Life and Work*, New York, 1988.

Dacier 1911 Emile Dacier, (notice) *Société de Reproduction des Dessins de Maîtres*, 3e année, Paris, 1911.

Dacier 1913 Emile Dacier, *Les Préparations de M.-Q. de La Tour, conservées dans les musées et les collections particulières*, Paris, 1913.

Dacier 1929-31 Edouard Emile Gabriel Dacier, *Gabriel de Saint-Aubin, peintre, dessinateur et graveur (1720-80)*, 2 vols., Paris and Brussels, 1929-31.

Dacier and Vuaflart 1921-29 Emile Dacier and Albert Vuaflart, *Jean de Julliene et les graveurs de Watteau au XVIII^e siècle*, 4 vols., Paris, 1921-29.

David 1880 Jules David, *Le peintre Louis David 1748-1825*, I, Paris, 1880.

Delacroix 1869 Eugène Delacroix, "Prud'hon," *L'Artiste*, XXXIX, 1869.

Delteil 1924 L. Delteil, *Théodore Géricault. Le peintre-graveur illustré*, XVIII, Paris, 1924.

Desguine 1950 A. Desguine, *L'Oeuvre de J.-B. Oudry sur le Parc et les Jardins d'Arcueil*, Paris, 1950.

Deshairs 1913 Léon Deshairs, "Les Arabesques de Watteau," *Archives de l'art français*, VII, 1913.

Diderot 1875-77 D. Diderot, *Oeuvres complètes*, XX, ed. M. Tourneux and J. Assézat, Paris, 1875-77.

Dilke 1902 Lady Dilke, *French Engravers and Draughtsmen of the 18th Century*, London, 1902.

Dimier 1930 Louis Dimier, *Les Peintures française du XVIII^e siècle*, Paris, 1930.

Dimier 1932 Louis Dimier, "D'un album de dessins supposé du XIV^e siècle," *Mémoires de la société nationale des antiquaires de France*, LXXVIII, 1932.

Duclaux 1971 Lise Duclaux, "La Décoration de la Chapelle et l'Hospice des Enfants trouvés à Paris," *Revue de l'Art*, XIV, 1971, pp. 45-50.

Duclaux 1975 Lise Duclaux, *Musée du Louvre. Inventaire général des dessins: Ecole française*, XII, Paris, 1975.

Duclaux 1991 Lise Duclaux, *Les Cahiers du dessin français: Charles Natoire*, Paris, 1991.

Eckhardt 1975 D. Eckhardt, *Antoine Watteau*, Berlin, 1975.

Ehrlich-White 1967 Barbara Ehrlich-White, "Delacroix's Painted Copies after Rubens," *Art Bulletin*, XLIX, no. 1, March 1967, pp. 37-44.

Ehrmann 1956a Jean Ehrmann, "Caron et les tapisseries des Valois," *Revue des arts*, VI, March 1956, pp. 9-14.

Ehrmann 1956b Jean Ehrmann, "Dessins d'Antoine Caron pour les tapisseries des Valois du Musée des Offices à Florence," *Bulletin de la Société de l'Histoire de l'Art français*, Nov. 1956, pp. 115-25.

Ehrmann 1956c Jean Ehrmann, "Les Tapisseries des Valois du Musée des Offices à Florence," *Les Fêtes de la Renaissance*, ed. J. Jacquot, I, Paris, 1956, pp. 93-100.

Ehrmann 1958 Jean Ehrmann, "Drawings by Antoine Caron for the Valois Tapestries in the Uffizi, Florence," *Art Quarterly*, XXI, no. 1, Spring 1958, pp. 47-65.

Ehrmann 1986 Jean Ehrmann, *Antoine Caron: peintre des fêtes et des massacres*, Paris, 1986.

Eidelberg 1970 Martin Eidelberg, "P. A. Quillard, An Assistant to Antoine Watteau," *Art Quarterly*, XXXIII, no. 1, Spring 1970, pp. 39-70.

Eidelberg 1984 Martin Eidelberg, "Gabriel Huquier – Friend or Foe of Watteau," *The Print Collector's Newsletter*, XV, no. 5 (November-December), 1984.

Einem 1966 Herbert von Einem, "Poussin's 'Madonna an der Treppe,'" *Wallraf-Richartz-Jahrbuch*, XXVIII, 1966.

Eisler 1963 Colin Eisler, "A New Drawing by Jacques Bellange at Yale," *Master Drawings*, I, no. 4, Winter 1963, pp. 32-38.

Emiliani 1982 *Le arti a Bologna e in Emilia dal XVII secolo*. Acts of the XXIVth Congresso Internazionale di Storia

dell'Arte, vol. 4, 1979. Ed. A. Emiliani, Bologna, 1982.

Fairfax Murray 1905-12 C. Fairfax Murray, *Collection J. Pierpont Morgan: Drawings by the Old Masters Formed by C. Fairfax Murray*, 4 vols., London, 1905-12.

Feinblatt 1969 Ebria Feinblatt, "An Ingres Portrait for Los Angeles," *Connoisseur*, CLXX, April 1969, pp. 262-65.

Fleury and Brière 1954 Elie Fleury and Gaston Brière, *Collection Maurice Quentin de La Tour à Saint-Quentin*, Saint-Quentin, 1954.

Fourcaud 1908-09 L. de Fourcaud, "Antoine Watteau, peintre d'arabesques," *Revue de l'Art ancien et moderne*, XXIII, no. 141 (December 1908), pp. 431-40; XIV, no. 142 (January 1909), pp. 49-59; XV, no. 143 (February 1909), pp. 129-40.

Freedberg 1957 Anne Blake Freedberg, "A 4th Century Miracle by a 17th Century Artist," *Bulletin of Boston Museum of Fine Arts*, LV, no. 300, Summer 1957, pp. 38-43.

Friedlaender and Blunt 1939-74 Walter Friedlaender and Anthony Blunt, *The Drawings of Nicolas Poussin: Catalogue Raisonné*, 5 vols., London. I, 1939; II, 1949; III, 1952; IV 1969; V, 1974.

Fröhlich-Bum 1921 Lili Fröhlich-Bum, *Parmigianino und der Manierismus*, Vienna, 1921.

Fröhlich-Bum 1923 Lili Fröhlich-Bum, "Ein unbekanntes Bild von Primaticcio," *Belvedere*, III, 1923.

Fry 1906 Roger E. Fry, "On a Fourteenth Century Sketchbook," *Burlington Magazine*, X, no. 43, 1906, pp. 31-38.

Fry 1910 Roger E. Fry, "A Drawing by André Beauneveu," *Burlington Magazine*, XVII, no. 85, 1910, p. 51.

Gazette des Beaux-Arts **1922** *Gazette des Beaux-Arts*, 5e période, 1922.

Gazette des Beaux-Arts **1965** *Gazette des Beaux-Arts*, "Les Oeuvres de Charles Le Brun," LXVI, 1965, pp. 1-58.

Gazette des Beaux-Arts **1977** *Gazette des Beaux-Arts*, "Gazette la Chronique des Arts: Principales Acquisitions des Musées en 1975," VIe période, LXXXIX (March) 1977.

George 1934 Waldemar George, "Portraits par Ingres et ses élèves," *La Renaissance de l'art français*, XVII, October-November 1934, pp. 193-210.

Goldwater 1957 Robert Goldwater, *Paul Gauguin*, New York, 1957.

Goldwater 1972 Robert Goldwater, *Paul Gauguin*, New York, 1972.

Goncourt 1865 Edmond de Goncourt, *Fragonard étude contenant quatre dessins gravés à l'eau-forte*, Paris, 1865.

Goncourt 1875 Edmond de Goncourt, *Catalogue raisonné de l'oeuvre peint, dessiné et gravé d'Antoine Watteau*, Paris, 1875.

Goncourt 1876 Edmond de Goncourt, *Catalogue raisonné de l'oeuvre peint, dessiné et gravé de P.-P. Prud'hon*, Paris, 1876.

Goncourt 1881 Edmond de Goncourt, *La Maison d'un artiste*, Paris, 1881, I.

Graham and Johnson 1979 Victor E. Graham and W. McAllister Johnson, *The Royal Tour of France by Charles IX and Catherine de' Medici: Festivals and Entries, 1564-66*, Toronto, 1979.

Grasselli 1986 Margaret Morgan Grasselli, "Eleven New Drawings by Nicolas Lancret," *Master Drawings*, 23-24, no. 3, Autumn 1986, pp. 377-88.

Grasselli 1987 Margaret Morgan Grasselli, "New Observations on Some Watteau Drawings," from *Antoine Watteau (1684-1721) le peintre, son temps et sa légende*, eds. François Moureau and Margaret Morgan Grasselli, Paris and Geneva, 1987.

Grimm 1879 Baron F. Melchior Grimm, *Correspondance littéraire, philosophique et critique*, 16 vols., ed. M. Tourneux, Paris, 1879.

Guiffrey 1924 Jean Guiffrey, *L'Oeuvre de Pierre Paul Prud'hon*, Paris, 1924.

Guiffrey and Marcel 1907-28 Jean Guiffrey and Pierre Marcel, *Inventaire général des dessins du Musée du Louvre et du Musée de Versailles. Ecole française*, 10 vols., Paris, 1907-28. (The tenth volume brings the alphabetical inventory to *Meissonier-Millet*.)

Habelberg 1936 Maria Th. Habelberg, *Liber pictus A 74 der Preuss. Staatsbibliothek zu Berlin. Ein Beitrag zur Erforschung mittelalterlicher Skizzen- und Musterbücher*, Zeulenroda, 1936.

Heawood 1950 Edward Heawood, *Watermarks, Mainly of the Seventeenth and Eighteenth Centuries*, Hilversum, 1950.

Henriot 1925 Gabriel Henriot, "La Collection David Weill, "*L'Amour de l'art*, VI, January 1925, pp. 1-23.

Henriot 1927 Gabriel Henriot, *Collection David Weill, II: pastels, aquarelles, gouaches, tableaux modernes*, Paris, 1927.

Henriot 1928 Gabriel Henriot, *Collection David Weill*, 5 vols., Paris, 1928.

Hibbard 1974 Howard Hibbard, *Poussin: The Holy Family on the Steps*, London, 1974.

Hind 1925 A. M. Hind, *Drawings of Claude Lorrain*, London, 1925.

Hofstadter 1987 Dan Hofstadter, "Sacred Monster," *New Criterion*, January 1987, pp. 17-25.

Ingamells 1989 John Ingamells, *The Wallace Collection Catalogue of Pictures, III*, London, 1989.

Jaccottet 1952 P. Jaccottet, *Le Dessin français au XVIIIe siècle*, Lausanne, 1952.

Jean-Richard 1978 Pierrette Jean-Richard, *L'Oeuvre gravé de François Boucher dans la Collection Edmond de Rothschild*, Paris, 1978.

Jenni 1976 Ulrike Jenni, *Das Skizzenbuch der internationalen Gotik in den Uffizien*, Vienna, 1976.

Jenni 1978 Ulrike Jenni, "Vom mittelalterlichen Musterbuch zum Skizzenbuch der Neuzeit," *Die Parler und der Schöne Stil: 1350-1400*, III, Cologne, 1978.

Jenni 1987 Ulrike Jenni, *Das Skizzenbuch des Jacques Daliwe*, Leipzig, 1987.

Jouin 1888 Henry Jouin, *Musée de portraits d'artistes*, Paris, 1888.

Journal 1822-63 Eugène Delacroix, *Journal, 1822-63*, intro. and notes by André Joubin, Paris, 1981.

Kauffmann 1960a Georg Kauffmann, "La 'Sainte Famille à l'escalier' et le problème des proportions dans l'oeuvre de Poussin," *Nicolas Poussin. Actes du Colloque International*, ed. André Chastel, Paris, 1960.

Kauffmann 1960b Georg Kauffmann, *Poussin-Studien*, Berlin, 1960.

Klossowski 1923 Erich Klossowski, *Honoré Daumier*, Munich, 1923.

Knab 1953 Eckhart Knab, "Die Zeichnungnen Claude Lorrains in der Albertina," *Alte und Neue Kunst*, II, no. 4, 1953, pp. 121-60.

Knab 1956 Eckhart Knab, "Der heutige Bestand an Zeichnungen Claude Lorrains im Boymans Museum," *Bulletin Museum Boymans*, VII, no. 4, 1956, pp. 103-40.

Knab 1963 Eckhart Knab, "Appreciation of Michael Kitson's Paper: Stylistic Problems of Claude's Draftsmanship," *Studies in Western Art*, III, Princeton, 1963, pp. 113-17.

Knab 1964 Eckhart Knab, *Claude Lorrain und die Meister der Römischen Landschaft im XVII. Jahrhundert*, Vienna, 1964.

Kreuter-Eggermann 1964 Helga Kreuter-Eggermann, *Das Skizzenbuch des "Jacques Daliwe*," Munich, 1964.

Lapauze 1911 Henry Lapauze, *Ingres: sa vie et son oeuvre*, Paris, 1911.

Laran 1959 Jean Laran, *L'Estampe*, Paris, 1959.

Lavallée 1930 Pierre Lavallée, *Le Dessin français du XIIIᵉ au XVIᵉ siècle*, Paris, 1930.

Lavergnée 1986 Barbara Brejon de Lavergnée, "New Attributions around Simon Vouet," *Master Drawings*, XXIII-XXIV, no. 3, Autumn 1986, pp. 347-51.

Le Blanc 1854-56 Charles Le Blanc, *Manuel de l'amateur d'estampes*, 4 vols., Paris, 1854-56.

Lecomte 1913 Georges Lecomte, "David et ses élèves," *Arts*, XII, no. 142, October 1913, pp. 2-18.

Lemoisne 1946 Paul André Lemoisne, *Degas et son oeuvre*, 4 vols., Paris, 1946.

Leymarie 1962 Jean Leymarie, *Paul Gauguin, Watercolors, Pastels*, New York, 1962.

Leymarie 1989 Jean Leymarie, *Gauguin: Watercolors, Pastels, Drawings*, New York, 1989.

Lieure 1921 Jules Lieure, *Jacques Callot. Catalogue de l'oeuvre gravé*, Paris, 1921.

L'Oeil 1977 "Marché de l'art: les maîtres du dessin français au XVIIIᵉ siècle," *L'Oeil*, no. 261, April 1977, pp. 42-45.

Locquin 1912 Jean Locquin, *Catalogue raisonné de l'oeuvre de Jean-Baptiste Oudry (1686-1755)*, 1912.

Lossky 1969 Boris Lossky, "Nouvelles acquisitions. Musée de Fontainebleau, acquisitions depuis 1965," *La Revue du Louvre*, XIX, 1969, pp. 311-16.

Louchheim 1944 Aline B. Louchheim, "The Great Tradition of French Drawing from Ingres to Picasso in American Collections," *Art News Annual*, XLIII, no. 16, part II, 1944-45, pp. 127-58.

Lugt 1921 Frits Lugt, *Les Marques de collections de dessins et d'estampes*, Amsterdam, 1921.

Lugt S. 1956 Frits Lugt, *Les Marques de collections de dessins et d'estampes; supplément*, The Hague, 1956.

Lugt 1968 Frits Lugt, *Musée du Louvre. Inventaire général des dessins des écoles du nord: maîtres des anciens Pays-Bas nés avant 1550*, Paris, 1968.

Lurie 1982 Ann Tzeutschler Lurie, "Poussin's 'Holy Family on the Steps' in The Cleveland Museum of Art: New Evidence from Radiography," *Burlington Magazine*, CXXIV, no. 956, 1982, pp. 664-71.

MacMillan 1982 "Du Cerceau Family," *MacMillan Encyclopedia of Architects*, I, ed. Adolf K. Placzek, New York and London, 1982.

Maison 1956 K. E. Maison, "Further Daumier Studies, II: Preparatory Drawings for Paintings," *Burlington Magazine*, XCVIII, 1956, pp. 199-202.

Maison 1968 K. E. Maison, *Honoré Daumier. Catalogue raisonné…*, London, 1968.

Mantz 1892 Paul Mantz, *Cent Dessins de Watteau gravés par Boucher*, Paris, 1892.

Mariette 1851-60 P. J. Mariette, *Abecedario de P. J. Mariette…* Compiled 1740-70. Edited and published by Philippe de Chennevières and Anatole de Montaiglon, 6 vols., Paris, 1851-60.

Martin and Masson 1908 J. Martin and C. Masson, *Catalogue raisonné de l'oeuvre peint et dessiné de J.-B. Greuze*, Paris, 1908.

Martine and Marotte 1923 Ch. Martine and L. Marotte, *70 Dessins de P.-P. Prud'hon*, Paris, 1923.

Massengale 1979 Jean Montague Massengale, review of Fragonard exhibition, *Burlington Magazine*, CXXI, 1979, p. 271.

Mathey 1938 Jacques Mathey, "A propos d'un catalogue des dessins de Watteau; Nouvelles acquisitions," *Bulletin de la Société de l'Histoire de l'Art français*, 1938, no. 2, pp. 158-65.

Mathey 1945 Jacques Mathey, *Ingres*, Paris, 1945.

Mathey 1960 Jacques Mathey, "Drawings by Watteau and Gillot," *Burlington Magazine*, CII, August 1960, pp. 354-59.

Meaume 1860 Edouard Meaume, *Recherches sur la vie et les oeuvrages de Jacques Callot*, 2 vols., 3rd ed., Paris, 1860.

Meiss 1967 Millard Meiss, *French Painting in the Time of Jean de Berry: The Late XIV Century and the Patronage of the Duke*, London, 1967.

Michel 1889 A. Michel, *François Boucher suivi d'un catalogue raisonné de l'oeuvre peint et dessiné* (1889), est. by Soullié with M. Ch. Masson, Paris, 1955.

Michel 1984 Marianne Roland Michel, *Watteau: An Artist of the Eighteenth Century*, Secaucus, New Jersey, 1984.

Michel 1987 Marianne Roland Michel, *Le Dessin français au XVIIIᵉ Siècle*, Fribourg, 1987.

Miller 1962-64 Naomi Miller, "Architectural Drawings Ascribed to Jacques Androuet Du Cerceau the Elder in the Morgan Library, New York," *Marsyas*, XI, 1962-64, pp. 31-41.

Minervino and Russoli 1970 Fiorella Minervino and Franco Russoli, *L'opera completa di Degas*, Milan, 1970.

Mongan 1947 Agnes Mongan, *Ingres: 24 Drawings*, New York, 1947.

Mongan 1959 Agnes Mongan, "De Clouet à Matisse: Les Américains, collectionneurs de dessins français," *Le Jardin des arts*, LI, 1959, pp. 185-90.

Mongan 1969 Agnes Mongan, *Ingres as a Great Portrait Draughtsman*, Colloque Ingres 1967, Montauban, 1969.

Montaiglon and Guiffrey 1901 A. de Montaiglon and J. Guiffrey, *Correspondance des directeurs de l'Académie de France à Rome*, Paris, VI, 1901.

Moreau 1903 A. Moreau, "Titre du recueil de plantes de Germain de Saint-Aubin," *L'Art*, LXII, pp. 73-78, 129-34, 1903.

Moreau-Nelaton 1919 E. Moreau-Nelaton, *Delacroix raconté par lui-même*, Paris, I, 1919.

Morel 1973 Jacques Morel, *La Renaissance III 1570-1624*, Paris, 1973.

Moskowitz 1962 Ira Moskowitz, ed., *Great Drawings of All Time*, 4 vols., New York, 1962.

Moskowitz and Sérullaz 1962 Ira Moskowitz and Maurice Sérullaz, *Drawings of the Masters: French Impressionists*, New York, 1962.

Moureau and Grasselli 1987 *Antoine Watteau (1684-1721) le peintre, son temps et sa légende*, eds. François Moureau and Margaret Morgan Grasselli, Paris and Geneva, 1987.

Mras 1962 George P. Mras, "Crouching Royal Tiger by Delacroix," *Record of the Art Museum, Princeton University*, XXI, no. 1, 1962, pp. 16-24.

Naef 1963 Hans Naef, "Ingres und die Familie Guillon Léthière," *du*, December 1963, pp. 65-78.

Naef 1972 Hans Naef, "Ingres und die Villa Medici," *du*, September 1972, p. 660.

Naef 1977-80 Hans Naef, *Die Bildniszeichnungen von J.-A.-D. Ingres*, 5 vols., Bern, 1977-80.

Nodier et al. Charles Nodier, J. Taylor and Alphonse de Cailleux, *Voyages pittoresques et romantiques dans l'ancienne france*, Paris, 1829-33.

Nolhac 1906 P. de Nolhac, *J.-H. Fragonard, 1732-1806*, Paris, 1906.

Opperman 1977 Hal N. Opperman, *Jean-Baptiste Oudry*, 2 vols., New York, 1977.

Ottley 1823 William Young Ottley, *The Italian School of Design*, London, 1823.

Pächt 1956 Otto Pächt, "Un tableau de Jacquemart de Hesdin?," *Revue des arts*, VI, 1956, pp. 149-60.

Pariset 1950 François-Georges Pariset, "Dessins de Jacques Bellange," *Critica d'arte*, VIII, 1950, p. 351.

Pariset 1965 François-Georges Pariset, "De Bellange à Deruet," *Bulletin de la Société de l'Histoire de l'art Français*, 1965, pp. 61-73.

Pariset 1967 François-Georges Pariset, "Claude Deruet," *L'Oeil*, no. 155, 1967.

Parker 1931 K. T. Parker, *The Drawings of Antoine Watteau*, London, 1931.

Parker 1938 K. T. Parker, *Catalogue of the Drawings in the Ashmolean Museum*, I, Oxford, 1938.

Parker and Mathey 1957 K. T. Parker and J. Mathey, *Antoine Watteau: catalogue complet de son oeuvre dessiné*, Paris, 1957.

Parkhurst 1941 C. P. Parkhurst, "The Madonna of the Writing Christ Child," *Art Bulletin*, XXIII, 1941, pp. 292-306.

Pickvance 1970 Ronald Pickvance, *The Drawings of Gauguin*, New York, 1970.

PML 1930 The Pierpont Morgan Library, *Report 1924-29*, New York, 1930.

PML 1949 The Pierpont Morgan Library, *Review of the Activities and Major Acquisitions of the Library, 1941-1948*, New York, 1949.

PML/FR I-XXI, 1950-89 The Pierpont Morgan Library, *Report to the Fellows of the Pierpont Morgan Library*, New York, 1950-89. Reports edited by Frederick B. Adams, Jr., through 1968; by Charles Ryskamp 1969 through 1986. Essays by Felice Stampfle, Cara D. Denison, and other members of the staff of the Department of Drawings and Prints.

PML 1969 The Pierpont Morgan Library, *Review of Acquisitions, 1949-1968*, New York, 1969.

Populus 1930 Bernard Populus, *L'Oeuvre gravé de Claude Gillot*, Paris, 1930.

Porcher 1953 Jean Porcher, "Les Très Belles Heures de Jean de Berry et les ateliers parisiens," *Scriptorium*, VII, 1953, pp. 121-23.

Portalis 1877 Baron Roger Portalis, *Les Dessinateurs d'illustrations au dix-huitième siècle*, 2 vols., Paris, 1877.

Portalis 1889 Baron Roger Portalis, *Fragonard: sa vie et son oeuvre*, Paris, 1889.

Portalis 1910 Baron Roger Portalis, *Henri-Pierre Danloux, peintre de portraits, et son journal durant l'émigration*, Paris, 1910.

Portalis and Béraldi 1880-82 R. Portalis and H. Béraldi, *Les Graveurs du dix-huitième siècle*, 2 vols., Paris, 1880-82.

Posner 1984 Donald Posner, *Antoine Watteau*, Ithaca, New York, 1984.

Preston 1977 S. Preston, "The Revaluation of Greuze," *Apollo*, CV, February 1977, pp. 136-39.

Provost 1989 Louis Provost, *Honoré Daumier: A Thematic Guide to the Oeuvre*, New York, 1989.

Ragghianti 1972 Carlo Ragghianti, "Pertinenze francesi nel Cinquecento," *Critica d'Arte*, XXXVII, n.s., no. 122, 1972, pp. 3-92.

Réau 1928 Louis Réau, *Les Dessins de Boucher*, Paris, 1928.

Réau 1938 Louis Réau, "Catalogue de l'oeuvre de Carle van Loo," *Archives de l'art français*, XIX (1935-37), 1938, pp. 9-96.

Réau 1956 Louis Réau, *Fragonard, sa vie et son oeuvre*, Brussels, 1956.

Reff 1960 Theodore Reff, "A New Exhibition of Cézanne," *Burlington Magazine*, CII, 1960, p. 118.

Reff 1976 Theodore Reff, *Degas: The Artist's Mind*, New York, 1976.

Rewald 1958 John Rewald, *Gauguin Drawings*, New York, 1958.

Ricci 1937 Seymour de Ricci, *Census of Medieval and Renaissance Manuscripts in the United States and Canada*, New York, 1937.

Richardson 1979 John Richardson, ed., *The Collection of Germain Seligman, Paintings, Drawings and Works of Art*, New York, Luxembourg, and London, 1979.

Ring 1949 Grete Ring, *A Century of French Painting, 1400-1500*, London, 1949.

Rivière 1922-23 Henri Rivière, *Les Dessins de Degas*, Paris, 1922-23.

Robaut 1969 Alfred Robaut, *L'Oeuvre complet de Eugène Delacroix*, New York, 1969.

Roberts-Dumesnil 1835-71 A. P. F. Roberts-Dusmenil, *Le Peintre graveur*, 11 vols., Paris, 1835-71.

Roethlisberger 1961 Marcel Roethlisberger, *Claude Lorrain: The Paintings*, 2 vols., New Haven, Connecticut, 1961.

Roethlisberger 1962a Marcel Roethlisberger, *Claude Lorrain: L'album Wildenstein*, Paris, 1962.

Roethlisberger 1962b Marcel Roethlisberger, "Claude Lorrain: ses plus beaux dessins retrouvés," *Connaissance des Arts*, 1962, pp. 144ff.

Roethlisberger 1965 Marcel Roethlisberger, "Gelleé-Deruet-Tassi-Onofri," *Walter Friedlaender zum 90. Geburtstag*, Berlin, 1965, pp. 143-45.

Roethlisberger 1968 Marcel Roethlisberger, *Claude Lorrain: The Drawings*, 2 vols., Berkeley and Los Angeles, 1968.

Roethlisberger 1971 Marcel Roethlisberger, *The Claude Lorrain Album in the Norton Simon Museum of Art*, Los Angeles, 1971.

Roethlisberger 1975 Marcel Roethlisberger, *L'Opera completa di Claude Lorrain*, Milan, 1975.

Roger-Marx 1950 Claude Roger-Marx, *Redon: Fusains*, Paris, 1950.

Roger-Marx 1956 Claude Roger-Marx, "Odilon Redon, peintre et mystique," *L'Oeil*, no. 17, May 1956, pp. 21-27.

Rosenberg 1959 Jakob Rosenberg, *Great Draughtsmen from Pisanello to Picasso*, Cambridge, Massachusetts, 1959.

Rosenberg 1966 Pierre Rosenberg, *Inventaire des collections publiques françaises. 14. Rouen-Musée des Beaux-Arts. Tableaux français du XVIIème siècle*, Paris, 1966.

Rosenberg 1971 Pierre Rosenberg, *I disegni dei maestri: Il Seicento francese*, Milan, 1971.

Rosenberg and Compin 1974 Pierre Rosenberg and Isabelle Compin, "Quatre Nouveaux Fragonard au Louvre," *Revue du Louvre*, XIV, 1974, pp. 183-92.

279

Rosini 1840 Giovanni Rosini, *La Storia della pittura italiana…*, II, Pisa, 1840.

Russell 1977 Francis Russell, "Salesroom Discoveries," *Burlington Magazine,* CXIX, 1977, p. 153.

Russell 1989 H. Diane Russell, "Claude Lorrain's Drawings from Nature," *Drawing,* XI, Sept.-Oct. 1989, pp. 50-51.

Scheller 1963 R. W. Scheller, *A Survey of Medieval Model Books*, Haarlem, 1963.

Schleier 1981 Reinhard Schleier, *Neue Zeichnungen alter Meister*, Muenster, 1981.

Schlenoff 1967 Norman Schlenoff, "Ingres Centennial at the Fogg Museum," *Burlington Magazine,* CIX, 1967, pp. 376-79.

Schnapper 1977 Antoine Schnapper, "Greuze, un précurseur?," *Connaissance des Arts,* June 1977, pp. 86-91.

Schneider 1967 Pierre Schneider, *The World of Watteau 1684-1721*, New York, 1967.

Selz 1971 Jean Selz, *Odilon Redon*, Lugano, 1971.

Sensier 1872 Alfred Sensier, *Souvenirs sur Théodore Rousseau*, Paris, 1872.

Seznec and J. Adhémar 1967 Denis Diderot, *Salons*, 4 vols. (1769, 1771, 1775, 1781), eds. J. Seznec and J. Adhémar, Oxford, 1967.

Seznec 1972 Jean Seznec, "Diderot and Neo-Classicism," *The Listener,* 26 October 1972.

Shoolman and Slatkin 1942 Regina Shoolman and Charles E. Slatkin, *The Enjoyment of Art in America*, New York, 1942.

Shoolman and Slatkin 1950 Regina Shoolman and Charles E. Slatkin, *Six Centuries of French Master Drawings in America*, New York, 1950.

Siegfried 1990 Susan L. Siegfried, "The Artist as Nomadic Capitalist; The Case of Louis-Léopold Boilly," *Art History,* XIII, no. 4, December 1990, pp. 516-41.

Slatkin 1975 Regina Shoolman Slatkin, "Francois Boucher: St. John the Baptist, A Study in Religious Imagery," *Bulletin of the Minneapolis Institute of Arts,* LXII, 1975, pp. 4-27.

Smith 1837 J. Smith, *Catalogue Raisonné of the Works of the Most Eminent Dutch, Flemish and French Painters*, 9 vols., London, 1837; *Supplement,* 1842.

Squilbeck 1950 J. Squilbeck, "La Vierge à l'encrier ou l'Enfant écrivant," *Revue belge,* XIX, 1950, pp. 127-40.

Stampfle 1991 Felice Stampfle, *Netherlandish Drawings of the Fifteenth and Sixteenth Centuries and Flemish Drawings of the Seventeeth and Eighteenth Centuries in The Pierpont Morgan Library,* New York, 1991.

Steiner 1932 Eva Steiner, "Zu Jacques Bellange," *Mitteilungen der Gesellschaft für vervielfältigende Kunst,* LV, 2-3, 1932, pp. 47-49.

Steneberg 1955 Karl Erik Steneberg, *Kristindatidens Malerei*, Malmö, 1955.

Strong 1973 Roy Strong, *Splendor at Court*, Boston, 1973.

Strong 1984 Roy C. Strong, *Art and Power: Renaissance Festivals, 1450-1650*, Woodbridge and Suffolk, England, 1984.

Sutton 1949 Denys Sutton, *French Drawings of the Eighteenth Century*, London, 1949.

Sutton 1974 Denys Sutton, "The Paradoxes of Cézanne," *Apollo,* C, 1974, pp. 98-107.

Sutton 1987 Denys Sutton, "Jean-Honoré Fragonard: The World as Illusion," *Apollo,* CXXV, 1987, pp. 102-13.

Ternois 1962a Daniel Ternois, *Jacques Callot: catalogue complet de son oeuvre dessiné,* Paris, 1962.

Ternois 1962b Daniel Ternois, *L'Art de Jacques Callot*, Paris, 1962.

Thaw 1985 Eugene Victor Thaw, "Forum: Degas's 'Femme debout,'" *Drawing,* VII, no. 3, September-October 1985, p. 60.

Thieme-Becker Ulrich Thieme and Felix Becker, eds., *Allgemeines Lexikon der Bildenden Künstler von der Antike bis zur Gegenwart,* 14 vols., Leipzig, 1921.

Thomson 1979 Richard Thomson, "Degas in Edinburgh," *Burlington Magazine,* CXXI, no. 919, 1979, pp. 674-77.

Thomson 1988 David Thomson, *Androuet du Cerceau's Les Plus Excellents Bastiments de France*, Paris, 1988.

Thoré 1846 T. Thoré, *Le Salon de 1846*, Paris, 1846.

Tourneux 1878 Maurice Tourneux, "Les Portraits de Diderot," *L'Art,* XII, 1878, pp. 124-25.

Tourneux 1904 Maurice Tourneux, "Collection de M. Jacques Doucet: pastels et dessins," *Les Arts,* XXXVI, December, 1904, pp. 1-5.

Tourneux 1908 Maurice Tourneux, "Exposition de cent pastels," review of exhibition in *Gazette des Beaux-Arts,* II, 1908, pp. 5-16.

Troescher 1966 Georg Troescher, *Burgundische Malerei, Maler und Malwerke um 1400 in Burgund…*, Berlin, 1966.

Turčić 1984 Lawrence Turčić, review of "New York: French Drawings," *Burlington Magazine,* CXXVI, no. 977, 1984, pp. 523-27.

Vaissière 1981 Pascal de La Vaissière, "Promenade dans l'oeuvre de jeunesse de Gabriel de Saint-Aubin," *L'Estampille,* CXXXIII, May, 1981.

Valéry 1938 Paul Valéry, *Degas, danse, dessin*, Paris, 1938.

Vallery-Radot 1953 Jean Vallery-Radot, *Les Dessins français au XVIIe siècle*, Lausanne, 1953.

Valori 1813 C. de Valori, "Notice sur Greuze et sur ses ouvrages," *Greuze, ou l'Accordée de Village*, Paris, 1813.

Vermeule 1964 Cornelius Vermeule, *European Art and the Classical Past*, Cambridge, Massachusetts, 1964.

Viatte 1964 Germain Viatte, "Quatre Tableaux de Claude Deruet," *La Revue du Louvre,* XIV, 4-5, 1964.

Voelkle 1981 William Voelkle, "Two New Drawings for the Boxwood Sketchbook in The Pierpont Morgan Library," *Gesta,* XX, no. 1, 1981, pp. 243-45.

Vollard 1924 Ambroise Vollard, *Paul Cézanne, His Life and Work*, London, 1924.

Walch 1971 Nicole Walch, *Die Radierungen des Jacques Bellange*, Munich, 1971.

Watrous 1957 James Watrous, *The Craft of Old Master Drawing*, Madison, Wisconsin, 1957.

Wescher and Rosenberg 1933 Paul Wescher and Jacob Rosenberg, "Bellange-Zeichnungen im Berliner Kupferstichkabinet," *Berliner Museen,* LIV, no. 2, 1933, pp. 36-38.

Wild 1980 Doris Wild, *Nicolas Poussin*, 2 vols., Zurich, 1980.

Wildenstein 1923 Georges Wildenstein, *Un peintre de paysage au XVIIIe siècle*, Paris, 1923.

Wildenstein 1924 Georges Wildenstein, *Lancret*, Paris, 1924.

Wildenstein 1926 Georges Wildenstein, "Fragonard et les expositions de son temps," *Mélanges,* Paris, 1926, pp. 5-23.

Wildenstein 1964 Georges Wildenstein, *Gauguin*, Paris, 1964.

D. and G. Wildenstein 1973 Daniel and Georges Wildenstein, *Documents complémentaires au catalogue de l'oeuvre de Louis David*, Paris, 1973.

Wilhelm 1948 Jacques Wilhelm, ed., Bergeret de Grancourt, *Voyage d'Italie, 1773-1774*, Paris, 1948.

Wilson 1972 Arthur M. Wilson, *Diderot*, New York, 1972.

Yates 1959 Frances Yates, *The Valois Tapestries*, London, 1959.

Yates 1975 Frances Yates, *The Valois Tapestries*, 2nd ed., London, 1975.

Young 1990 Mahonri Sharp Young, "Letter from the USA: The End Is Delectation," *Apollo*, CXXI, April 1990, pp. 272-73.

Zabel 1930 Morton D. Zabel, "Ingres in America," *The Arts*, XVI, 1930, pp. 369-82.

Zieseniss 1955 Charles O. Zieseniss, *Les Aquarelles de Barye*, Paris, 1955.

Zolotov and Nemilova 1973 Y. K. Zolotov and I. S. Nemilova, *Antoine Watteau*, Leningrad, 1973.

EXHIBITION CATALOGUES

Amsterdam 1938 Amsterdam, Stedelijk Museum, *Honderd Jaar Fransche Kunst*, 1938.

Ann Arbor 1962 Ann Arbor, University of Michigan, Museum of Art, *A Generation of Draughtsmen*, 1962.

Ann Arbor 1969 Ann Arbor, University of Michigan, Museum of Art, *The World of Voltaire*, 1969.

Atlanta 1983 Atlanta, High Museum of Art, *The Rococo Age*, exhibition catalogue by Eric M. Zafran, 1983.

Baltimore 1940 Baltimore, Baltimore Museum of Art, *Divertissements*, 1940 (no catalogue).

Baltimore 1941 Baltimore, Johns Hopkins University, *Landscape Painting from Patinir to Hubert Robert*, 1941.

Baltimore 1959 Baltimore, Baltimore Museum of Art, *The Age of Elegance: The Rococo and Its Effect*, 1959.

Berlin 1928 Berlin, Galerie Thannhauser, *Paul Gauguin*, 1928.

Berlin 1985 Berlin, Orangerie '85, *Deutscher Kunsthandel im Schloss Charlottenburg*, 1985.

Bern 1949 Bern, Kunstmuseum, *Sammlung Reitlinger, London*, 1949.

Bologna 1962 Bologna, Palazzo dell'Archiginnaso, *L'ideale classico del seicento in Italia e la pittura di paesaggio*, 1962.

Bologna and elsewhere 1986-87 Bologna, Pinacoteca Nazionale, Washington, National Gallery of Art, and New York, Metropolitan Museum of Art, *The Age of Correggio and the Carracci*, 1986-87.

Boston 1962 Boston, Museum of Fine Arts, *Fifty-one Watercolors and Drawings, John S. Newberry Collection*, 1962 (no catalogue).

Brussels 1985 Brussels, Bibliothèque Royale Albert I^er, *Diderot et son temps*, 1985.

Buffalo 1935 Buffalo, Albright-Knox Art Gallery, *Master Drawings Selected from the Museums and Private Collections of America*, 1935.

Buffalo 1960 Buffalo, Albright-Knox Art Gallery, *The T. Edward Hanley Collection*, 1960.

Cambridge 1960 Cambridge, Massachusetts, Fogg Art Museum, Harvard University, *Thirty-Three French Drawings from the Collection of John S. Newberry*, 1960.

Cambridge 1967 Cambridge, Massachusetts, Fogg Art Museum, Harvard University, *Ingres Centennial Exhibition 1867-1967*, catalogue by Agnes Mongan and Hans Naef, 1967.

Cambridge 1980 Cambridge, Massachusetts, Fogg Art Museum, Harvard University, *Works by J-.A.-D. Ingres in the Collection of the Fogg Art Museum*, catalogue by Marjorie B. Cohn and Susan L. Siegfried, 1980.

Chicago and New York 1959 Chicago, Art Institute of Chicago, and New York, Metropolitan Museum of Art, *Gauguin, Paintings, Drawings, Prints, Sculpture*, 1959.

Cincinnati 1948 Cincinnati, Cincinnati Art Museum, *Nicolas Poussin and Peter Paul Rubens*, 1948.

Clermont-Ferrand 1984 Clermont-Ferrand, Conservation des Musées d'Art de la Ville de Clermont-Ferrand, *Greuze & Diderot*, 1984.

Cleveland and elsewhere 1989 Cleveland, Cleveland Museum of Art, Cambridge, Massachusetts, Fogg Art Museum, and Ottawa, National Gallery of Canada, *From Fontainebleau to the Louvre: French Drawings from the Seventeenth Century*, catalogue by Hilliard T. Goldfarb, 1989.

Copenhagen 1935 Copenhagen, Charlottenberg Palace, *Art français au XVIIIième siècle*, 1935.

Des Moines and elsewhere 1975-76 Des Moines, Des Moines Art Center, Boston, Museum of Fine Arts, and New York, Metropolitan Museum of Art, *The Etchings of Jacques Bellange*, catalogue by Amy N. Worthen and Sue Welsh Reed, 1975-76.

Detroit 1950 Detroit, Detroit Institute of Arts, *French Painting from David to Courbet*, 1950.

Detroit 1951 Detroit, Detroit Institute of Arts, *Recent Additions to the Collection of John S. Newberry*, 1951.

Edinburgh 1979 Edinburgh, National Gallery of Scotland, *Degas 1879*, catalogue by Ronald Pickvance, 1979.

Fort Worth and Austin 1965 Fort Worth, Fort Worth Art Center, Austin, Art Museum, University of Texas at Austin, *School of Fontainebleau*, 1965.

Fort Worth, 1984 Fort Worth, Kimbell Art Museum, *Elisabeth Louise Vigée Le Brun, 1755-1842*, catalogue by Joseph Baillio, 1984.

Frankfurt 1986-87 Frankfurt am Main, Städelsches Galerie im Städelschen Kunstinstitut, *Französische Zeichnungen im Städelschen Kunstinstitut 1550 bis 1800*, catalogue by Hildegard Bauereisen and Margret Stuffmann, 1986-87.

Frankfurt 1987-88 Frankfurt am Main, Städelschen Kunstinstitut, *Eugène Delacroix, Themen und Variationen, Arbeiten auf Papier*, catalogue by Margret Stuffmann et al., 1987-88.

Hartford 1931 Hartford, Wadsworth Atheneum, *Retrospective Exhibition of Landscape Painting*, 1931.

Hartford 1960 Hartford, Wadsworth Atheneum, *The Pierpont Morgan Treasures*, 1960.

Hartford and elsewhere 1976-77 Hartford, Wadsworth Atheneum, San Francisco, Palace of the Legion of Honor, and Dijon, Musée des Beaux-Arts, *Jean-*

Baptiste Greuze, 1725-1805, catalogue by Edgar Munhall, 1976-77.

Iowa City 1964 Iowa City, State University of Iowa, *Drawing and the Human Figure*, 1964.

Kansas City 1956 Kansas City, Nelson Gallery-Atkins Museum, *The Century of Mozart*, 1956.

Lille 1988-89 Lille, Musée des Beaux-Arts, *Boilly: 1761-1845: Un grand peintre français de la Révolution à la Restauration*, catalogue by Annie Scottez-De Wambrechies and Sylvain Laveissière, 1988.

London 1835 London, Royal Academy of Arts, *The Lawrence Gallery: Third Exhibition*, 1835.

London 1909 London, Burlington Fine Arts Club, *Illustrated Catalogue of Early English Portraiture*, 1909.

London 1932 London, Royal Academy of Arts, *Exhibition of French Art, 1200-1900: Commemorative Catalogue*, 1932.

London 1935a London, P. & D. Colnaghi and Co., *Drawings of Rome and Italy in the Seventeenth Century*, catalogue by I. Silvestre, 1935.

London 1935b London, Royal Academy of Arts, *The Lawrence Gallery: Third Exhibition*, 1935.

London 1949 London, Royal Academy of Arts, *Landscape in French Art*, 1949.

London 1950 London, Matthiesen Gallery, *Drawings of Master Painters of the XVIII Century*, 1950.

London 1953 London, Royal Academy of Arts, *Drawings by the Old Masters*, 1953.

London 1956 London, P. & D. Colnaghi and Co., *Exhibition of Old Master Drawings*, 1956.

London 1962 London, Arts Council Gallery, *Old Master Drawings from the Collection of Mr. C. R. Rudolf*, 1962.

London 1964 London, Courtauld Institute of Art, *The Sir Anthony Blunt Collection*, 1964.

London 1965 London, P. & D. Colnaghi and Co., *Exhibition of Old Master Drawings*, 1965.

London 1968 London, Royal Academy of Arts, *France in the Eighteenth Century*, catalogue by Denys Sutton, 1968.

London 1974 London, P. & D. Colnaghi and Co., *Exhibition of Old Master Drawings*, 1974.

London 1980 London, Kate de Rothschild and Morton Morris and Co., *Exhibition of Old Master and English Drawings*, 1980.

London 1982 London, Baskett & Day, *Exhibition of Fifty Old Master Drawings*, 1982.

London 1985 London, Hazlitt, Gooden & Fox, *Nineteenth-Century French Drawings*, 1985.

London 1989 London, Thos. Agnew & Sons, Ltd., *Master Drawings & Sculpture*, 1989.

London 1990a London, Duke Street Gallery, Yvonne Tan Bunzl and Kate de Rothschild, *Master Drawings*, 1990.

London 1990b London, Harari & Johns, Katrin Bellinger, *Meisterzeichnungen / Master Drawings 1500-1900*, 1990.

Los Angeles 1958 Los Angeles, Los Angeles County Museum of Art, *Honoré Daumier*, 1958.

Los Angeles 1961 Los Angeles, UCLA Gallery, *French Masters, Rococo to Romanticism*, 1961.

Los Angeles 1976 Los Angeles, Los Angeles County Museum of Art, *Old Master Drawings from American Collections*, catalogue by Ebria Feinblatt, 1976.

Middletown and Baltimore 1975 Middletown, Connecticut, Davison Art Center, Wesleyan University, Baltimore, Baltimore Museum of Art, *Prints and Drawings by Gabriel de Saint-Aubin: 1724-1780*, catalogue by Victor Carlson, Ellen D'Oench, and Richard S. Field, 1975.

Midland and Columbus 1967-68 Midland, Texas, Museum of the Southwest, and Columbus, Ohio, Columbus Gallery of Fine Arts, *The Hanley Collection*, 1967-68.

Minneapolis 1961 Minneapolis, University of Minnesota, *The Eighteenth Century, One Hundred Drawings by One Hundred Artists*, 1961.

Montreal 1950 Montreal, Montreal Museum of Fine Arts, *The Eighteenth Century Art of France and England*, 1950.

Montreal 1993 Montreal, Centre Canadien d'Architecture, *Exploring Rome: Piranesi and His Contemporaries*, catalogue by Cara D. Denison, Myra Nan Rosenfeld, and Stephanie Wiles, 1993.

Nancy 1992 Nancy, Musée Historique Lorrain, *Jacques Callot, 1592-1635*, 1992.

Neufchâtel 1956 Neufchâtel, Musée des Beaux-Arts, *Cézanne*, 1956.

Newcastle and London 1973 Newcastle, Laing Art Gallery and London, Hayward Gallery, *Watercolor and Pencil Drawings by Cézanne*, 1973.

New Haven 1956 New Haven, Yale University Art Gallery, *Pictures Collected by Yale Alumni*, 1956.

New Haven 1960 New Haven, Yale University Art Gallery, *Paintings, Drawings, and Sculpture Collected by Yale Alumni*, 1960.

New Haven 1987 New Haven, Yale University Art Gallery, *From Mannerism to Classicism: Printmaking in France, 1600-1660*, catalogue by Alvin J. Clark, 1987.

New London 1936 New London, Connecticut, Lyman Allyn Museum, *Fourth Anniversary Exhibition: Drawings*, 1936.

New York 1919 New York, New York Public Library, *Drawings from the J. Pierpont Morgan Collection*, 1919.

New York 1928 New York, C. M. de Hauke & Co., *Exhibition of Odilon Redon*, 1928.

New York 1938 New York, Wildenstein and Co., *French Eighteenth-Century Pastels, Water-Colors and Drawings from the David-Weill Collection*, 1938.

New York 1939 New York, Barnard College, 1939 (no catalogue).

New York 1941 New York, Metropolitan Museum of Art, *French Painting from David to Toulouse-Lautrec*, 1941.

New York 1943a New York, Knoedler and Co., Inc., *Loan Exhibition of the Collection of Pictures of Erich Maria Remarque*, 1943

New York 1943b New York, Wildenstein and Co., *The French Revolution*, 1943.

New York 1944a New York, Wildenstein and Co., *Eugène Delacroix, 1798-1863*, 1944.

New York 1944b New York, Wildenstein and Co., *Five Centuries of Ballet*, 1944.

New York 1944c New York, Wildenstein and Co., *French Pastels and Drawings from Clouet to Degas*, 1944.

New York 1952 New York, Museum of Modern Art, *Picasso, His Graphic Art: Redon, Drawings and Lithographs*, 1952.

New York 1956 New York, Wildenstein and Co., *Gauguin*, 1956.

New York 1959a New York, Knoedler and Co., *Great Master Drawings of Seven Centuries*, 1959.

New York 1959b New York, Wildenstein and Co., *Cézanne*, 1959.

New York 1961a New York, Galerie Paul Rosenberg, *Ingres in American Collections*, 1961.

New York 1961b New York, Wildenstein and Co., *Paintings and Drawings from The Hanley Collection*, 1961.

New York 1964a New York, Charles E. Slatkin Galleries, *Fair Ladies*, 1964.

New York 1964b New York, E.V. Thaw & Co., *19th and 20th Century Master Drawings*, 1964.

New York 1965 New York, M. Knoedler and Co., Inc., *Cézanne Watercolors*, 1965.

New York 1965-66 New York, Metropolitan Museum of Art, *Drawings from New York Collections: I, The Italian Renaissance*, catalogue by Jacob Bean and Felice Stampfle, 1965-66.

New York 1968-69 New York, Wildenstein and Co., *Gods and Heroes: Baroque Images of Antiquity*, 1968-69.

New York 1970 New York, Metropolitan Museum of Art, *Classicism and Romanticism*, 1970.

New York 1971 New York, Jacques Seligmann and Co., *Master Drawings*, 1971.

New York 1972 New York, Metropolitan Museum of Art, *French Drawings and Prints of the Eighteenth Century*, 1972.

New York 1977a New York, Museum of Modern Art, *Cézanne: The Late Work*, ed. William Rubin, 1977.

New York 1977b New York, Wildenstein and Co., *Paris–New York; A Continuing Romance*, 1977.

New York 1978 New York, Wildenstein and Co., *Romance and Reality*, 1978.

New York 1980 New York, Wildenstein and Co., *François Boucher*, catalogue by Denys Sutton, 1980.

New York 1986 New York, Zangrilli, Brady & Co., *French and English Drawings, 1700-1875*, 1986.

New York 1990a New York, Didier Aaron, *French Paintings and Drawings, 1700-1865*, 1990.

New York 1990b New York, P. & D. Colnaghi, Ltd., *Claude to Corot: The Development of Landscape Painting in France*, ed. Alan Wintermute, 1990.

New York 1991 New York, Metropolitan Museum of Art, *Eugène Delacroix (1798-1863): Paintings, Drawings, and Prints from*

North American Collections, catalogue by Lee Johnson, 1991.

New York and Edinburgh 1987 New York, Drawing Center, Edinburgh, National Gallery of Scotland, *The Art of Drawing in France, 1400-1900: Drawings from the Nationalmuseum, Stockholm*, catalogue by Per Bjurström, 1987.

New York and Philadelphia 1967 New York, Gallery of Modern Art, and Philadelphia, Philadelphia Museum of Art, *Selections from the Collection of Dr. and Mrs. T. Edward Hanley*, 1967.

New York and Fort Worth 1991 New York, Frick Collection, and Fort Worth, Texas, Kimbell Art Museum, *Nicolas Lancret, 1690-1743*, catalogue by Mary Tavener Holmes, 1991.

New York and elsewhere 1955-56 New York, Jacques Seligmann & Co., Minneapolis, Minneapolis Institute of Arts, and Cleveland, Cleveland Museum of Art, *Baron Antoine-Jean Gros*, 1955-56.

New York and elsewhere 1985-86 New York, The Pierpont Morgan Library, San Diego, San Diego Museum of Art, and Houston, Museum of Fine Arts, *Master Drawings by Gericault*, catalogue by Philippe Grunchec, 1985.

New York and elsewhere 1986-87 New York, Metropolitan Museum of Art, Detroit, Detroit Institute of Arts, and Paris, Réunion des Musées Nationaux, Grand Palais, *François Boucher 1703-1770*, 1986-87.

New York PML 1939 New York, The Pierpont Morgan Library, *Exhibition Held on the Occasion of the New York World's Fair*, 1939.

New York PML 1953 New York, The Pierpont Morgan Library, *Landscape Drawings and Water-Colors: Bruegel to Cézanne*, catalogue by Felice Stampfle, 1953.

New York PML 1969 New York, The Pierpont Morgan Library, *Drawings from Stockholm: A Loan Exhibition from the Nationalmuseum*, catalogue by Per Bjurström, 1969.

New York PML 1974 New York, The Pierpont Morgan Library, *Major Acquisitions 1924-1974: Drawings*, catalogue by Felice Stampfle, 1974.

New York PML 1980 New York, The Pierpont Morgan Library, *Flowers in Books and Drawings, ca. 940-1840*, catalogue by Helen B. Mules, 1980.

New York PML 1981 New York, The Pierpont Morgan Library, *European*

Drawings, 1375-1825, catalogue by Cara D. Denison and Helen B. Mules with the assistance of Jane V. Shoaf, 1981.

New York PML 1984 New York, The Pierpont Morgan Library, *French Drawings, 1550-1825*, catalogue by Cara D. Denison, 1984.

New York PML and Richmond 1985-86 New York, The Pierpont Morgan Library, and Richmond, Virginia Museum of Fine Arts, *Drawings from the Collection of Mr. & Mrs. Eugene Victor Thaw*, catalogue by Cara D. Denison, William Robinson, Julia Herd, and Stephanie Wiles, 1985-86.

New York PML and elsewhere 1957 New York, The Pierpont Morgan Library, Cleveland, Cleveland Museum of Art, Chicago, Art Institute of Chicago, San Francisco, California Palace of the Legion of Honor, San Marino, Henry E. Huntington Library and Art Gallery, Kansas City, Nelson Gallery and Atkins Museum, Houston, Museum of Fine Arts of Houston, Cambridge, Massachusetts, Fogg Art Museum, Harvard University, *Treasures from The Pierpont Morgan Library: Fiftieth Anniversary Exhibition*, 1957.

New York PML and elsewhere 1975-76 New York, The Pierpont Morgan Library, Cleveland, Cleveland Museum of Art, Chicago, Art Institute of Chicago, Ottawa, National Gallery of Canada, *Drawings from the Collection of Mr. & Mrs. Eugene V. Thaw*, catalogue by Felice Stampfle and Cara D. Denison, 1975.

Nice and elsewhere 1977 Nice, Musée Chéret, Clermont-Ferrand, Musée Bargoin, Nancy, Musée des Beaux-Arts, *Carle van Loo, 1705-1765*, catalogue by Marie C. Sahut, 1977.

Omaha 1941 Omaha, Nebraska, Joslyn Art Museum, *Tenth Anniversary Exhibition*, 1941 (no catalogue).

Paris 1846 Paris, *La Peinture française depuis la fin du dix-huitième siècle*, Salon of 1846.

Paris 1874 Paris, Ecole des Beaux-Arts, *Exposition de l'oeuvre de Prud'hon*, catalogue by Camille and Eudoxe Marcille, 1874.

Paris 1889 Paris, Ecole des Beaux-Arts, *Barye*, 1889.

Paris 1900 **Paris, Petit Palais,** *Exposition universelle de 1900. Exposition rétrospective*, 1900.

Paris 1901 Paris, Palais de l'Ecole des Beaux-Arts, *Exposition Daumier,* 1901.

Paris 1904 Paris, Pavillon de Marsan et Bibliothèque Nationale, "Exposition des primitifs français," 1904.

Paris 1906 Paris, Salon d'Automne, *Rétrospective Gauguin,* 1906.

Paris 1908 Paris, Galerie Georges Petit, *Cent Pastels,* 1908.

Paris 1913a Paris, Galerie La Boétie, *Deuxième Salon des artistes animaliers,* 1913.

Paris 1913b Paris, Palais des Beaux-Arts de la Ville de Paris, *David et ses élèves,* 1913.

Paris 1921a Paris, Chambre syndicale de la curiosité et des Beaux-Arts, *Ingres,* 1921.

Paris 1921b Paris, Musée des Arts Décoratifs, *Exposition d'oeuvres de J.-H. Fragonard,* catalogue by Georges Wildenstein, 1921.

Paris 1922 Paris, Palais des Beaux-Arts de la Ville de Paris, *Prud'hon,* 1922.

Paris 1924a Paris, Galerie Balzac, *De David à Manet,* 1924.

Paris 1924b Paris, Galerie Georges Petit, *Exposition Degas,* 1924.

Paris 1925a Paris, Galerie Dru, *Aquarelles et dessins de Eugène Delacroix,* 1925.

Paris 1925b Paris, Hôtel Charpentier, *Exposition des Saint-Aubin,* 1925

Paris 1926 Paris, Musée des arts décoratifs, Odilon Redon, *Exposition rétrospective de son oeuvre,* 1926.

Paris 1927 Paris, Hôtel Charpentier, *Exposition de pastels français du XVIIe et du XVIIIe siècle,* catalogue by Emile Dacier, 1927.

Paris 1929 Paris, Galerie Dru, *Barye,* 1929.

Paris 1931a Paris, chez Marcel Guérin, *Dix-neuf Portraits de Degas par lui-même,* catalogue by Marcel Guérin, 1931.

Paris 1931b Paris, Exposition coloniale internationale de Paris, *Beaux-Arts,* 1931.

Paris 1931c Paris, Jacques Seligmann and Co., *Dessins de Fragonard,* 1931.

Paris 1931d Paris, Musée de l'Orangerie, *Degas: portraitiste, sculpteur,* 1931.

Paris 1933a Paris, *Exposition Goncourt* (organized by the *Gazette des Beaux-Arts*), 1933.

Paris 1933b Paris, Wildenstein, *De Goncourt Exhibition,* 1933.

Paris 1934a Paris, Galerie Jacques Seligmann, *Portraits par Ingres et ses élèves,* 1934.

Paris 1934b Paris, Musée de l'Orangerie, *Daumier: peintures, aquarelles, dessins,* 1934.

Paris 1935 Paris, Musée Galliera, *Auteuil et Passy d'autrefois,* 1935.

Paris 1936 Paris, Petit Palais, *Gros, ses amis, ses élèves,* 1936.

Paris 1937 Paris, Galerie Marcel Guiot, *Portraits dessinés,* 1937.

Paris 1951 Paris, Gallerie Cailleux, *Le Dessin français de Watteau à Prud'hon,* 1951.

Paris 1953-54 Paris, Galerie Charpentier, *Célébrités françaises,* 1953-54.

Paris 1956 Paris, Galerie Alfred Daber, *Univers de Barye,* 1956.

Paris 1958a Paris, Musée Jacquemart-André, *Pierre-Paul Prud'hon, 1758-1823,* 1958.

Paris 1958b Paris, Petit Palais, *Le XVIIᵉ siècle français: chef-d'oeuvres des musées de Provence,* 1958.

Paris 1960 Paris, Musée du Louvre, *Nicolas Poussin,* 1960.

Paris 1963 Paris, Musées Nationaux, *Le Rôle du dessin dans l'oeuvre de Delacroix,* 1963.

Paris 1967 Paris, Musée du Louvre, *Mariette,* 1967.

Paris 1977-78 Paris, Musée de l'Orangerie, *Collections of Louis XIV,* 1977-78.

Paris 1984 Paris, Musée du Louvre, *Dessins et sciences: XVIIᵉ–XVIIIᵉ siècles,* 1984.

Paris 1984-85 Paris, Hôtel de la Monnaie, *Diderot et l'art de Boucher à David: Les Salons: 1759-1781,* 1984-85.

Paris 1987 Paris, Musée du Louvre, *Dessins de Simon Vouet 1590-1649,* catalogue by Barbara Brejon de Lavergnée, 1987.

Paris 1988 Paris, David Jones, *Old Master Drawings,* 1988.

Paris 1990 Paris, Musée du Louvre, *Hoüel: voyage en Sicile 1776-1779,* catalogue by Madeleine Pinault, 1990.

Paris 1991 Paris, Galerie Cailleux, *Le Rouge et Le Noir: cent dessins français de 1700 à 1850,* intro. by Marianne Roland Michel, 1991.

Paris and Amsterdam 1964 Paris, Institut Néerlandais, and Amsterdam, Rijksmuseum Prentenkabinet, *Le Dessin français de Claude à Cézanne dans les collections hollandaises,* 1964.

Paris and Ottawa 1972-73 Paris, Grand Palais, and Ottawa, National Gallery of Canada, *L'Ecole de Fontainebleau,* 1972-73.

Paris and New York 1987-88 Paris, Galeries nationales du Grand Palais, and New York, Metropolitan Museum of Art, *Fragonard,* exhibition catalogue by Pierre Rosenberg, 1987-88.

Paris and Versailles 1989-90 Paris, Musée du Louvre, and Versailles, Musée national du château, *Jacques Louis David, 1748-1825,* catalogue by Antoine Schnapper and Arlette Sérullaz, 1989-90.

Paris and elsewhere 1981-82 Paris, Ecole Nationale Supérieure des Beaux-Arts, Malibu, J. Paul Getty Museum, and Hamburg, Hamburger Kunsthalle, *De Michel-Ange à Géricault, Dessins de la donation Armand-Valton,* catalogue by Emmanuelle Brugerolles, 1981-82.

Paris and elsewhere 1988-89 Paris, Galeries nationales du Grand Palais, Ottawa, National Gallery of Canada, New York, Metropolitan Museum of Art, *Degas,* catalogue by Jean Sutherland Boggs, 1988-89.

Philadelphia 1950-51 Philadelphia, Philadelphia Museum of Art, *Masterpieces of Drawing,* 1950-51.

Philadelphia 1957 Philadelphia, Philadelphia Museum of Art, *The T. Edward Hanley Collection,* 1957.

Pittsburgh 1951 Pittsburgh, Carnegie Institute, *French Painting, 1100-1900,* 1951.

Poughkeepsie 1962 Poughkeepsie, Vassar College Art Gallery, *Hubert Robert, 1733-1808: Paintings and Drawings,* 1962.

Providence 1931 Providence, Museum of Art, Rhode Island School of Design, *French Painting,* 1931.

Providence 1970 Providence, Department of Art, Brown University, and Museum of Art, Rhode Island School of Design, *Jacques Callot, 1592-1635,* 1970.

Providence 1975 Providence, Department of Art, Brown University, and Museum of Art, Rhode Island School of Design, *Rubenism,* 1975.

Providence 1979 Providence, Bell Gallery, Brown University, *Festivities: Ceremonies and Celebrations in Western Europe, 1500-1790,* 1979.

Richmond 1956 Richmond, Virginia Museum of Fine Arts, *Les Fêtes galantes,* 1956.

Richmond 1981 Richmond, Virginia Museum of Fine Arts, *Three Masters of Landscape: Fragonard, Robert and Boucher,* 1981.

Rome 1990-91 Rome, Villa Medici, *J. H. Fragonard e H. Robert a Roma,* catalogue by

Jean-Pierre Cuzin, Pierre Rosenberg, and Catherine Boulot, 1990-91.

Rome 1991 Rome, Palazzo Ruspoli, *Il Segno del Genio*, catalogue of drawings from the Ashmolean Museum, Oxford, by Christopher White, Catherine Whistler, and Colin Harrison, 1991.

Rome and Nancy 1982 Rome, Accademia de Francia a Roma, Villa Medici, and Nancy, Musée des Beaux-Arts, *Claude Lorrain e i pittori lorenesi in Italia nel XVII secolo*, catalogue by Jacques Thuillier, 1982.

Rotterdam and elsewhere 1958-59 Rotterdam, Museum Boymans, Paris, Musée de L'Orangerie, and New York, Metropolitan Museum of Art, *French Drawings from American Collections: Clouet to Matisse*, 1958-59.

San Francisco 1940 San Francisco, Golden Gate International Exposition, *Master Drawings*, 1940.

Schaffhausen 1963 Schaffhausen, Museum zu Allerheiligen, *Die Welt des Impressionismus*, 1963.

Springfield and New York 1939-40 Springfield, Massachusetts, Springfield Museum of Fine Arts, and New York, M. Knoedler and Co., *David and Ingres*, 1939-40.

Stockholm 1966 Stockholm, Nationalmuseum, *Christina, Queen of Sweden*, 1966.

Stockholm 1970 Stockholm, Nationalmuseum, *Morgan Library gästar Nationalmuseum*, catalogue by Felice Stampfle, 1970.

St. Petersburg 1912 St. Petersburg, Hermitage, *Centenniale de l'art français*, 1912.

Tokyo and elsewhere 1974 Tokyo, Musée National d'Art Occidental and elsewhere, *Exposition Cézanne*, 1974.

Toronto and elsewhere 1972-73 Toronto, Art Gallery of Ontario, Ottawa, National Gallery of Canada, San Francisco, California Palace of the Legion of Honor, and New York, New York Cultural Center, *French Master Drawings of the 17th and 18th Centuries in North American Collections*, catalogue by Pierre Rosenberg, 1972-73.

Tübingen 1978 Tübingen, Kunsthalle Tübingen, *Paul Cézanne: Zeichnungen*, catalogue by Götz Adriani, 1978.

Tübingen and Berlin 1984 Tübingen, Kunsthalle Tübingen, and Berlin, Nationalgalerie, *Edgar Degas: Pastelle, Olskizzen, Zeichnungen*, catalogue by Götz Adriani, 1984.

Utica 1963 Utica, Munson Williams Proctor Institute, *Masters of Landscape East and West*, 1963.

Venice 1936 Venice, *Exposition Biennale Internationale des Beaux-Arts*, 1936.

Vienna 1967-68 Vienna, Graphische Sammlung Albertina, *Die Kunst der Graphik IV: Zwischen Renaissance und Barock*, catalogue by Konrad Oberhuber, 1967-68.

Washington 1978 Washington, National Gallery of Art, *Hubert Robert: Drawings and Watercolors*, catalogue by Victor Carlson, 1978

Washington and Chicago 1973-74 Washington, National Gallery of Art, and Chicago, Art Institute of Chicago, *François Boucher in North American Collections: 100 Drawings*, catalogue by Regina Shoolman Slatkin, 1973-74.

Washington and Paris 1982-83 Washington, National Gallery of Art, and Paris, Grand Palais, *Claude Lorrain, 1600-1682*, catalogue by H. Diane Russell, 1982-83.

Washington and elsewhere 1971 Washington, Phillips Collection, Chicago, Art Institute of Chicago, Boston, Museum of Fine Arts, *Paul Cézanne*, catalogue by John Rewald, 1971.

Washington and elsewhere 1978-79 Washington, National Gallery of Art, Cambridge, Massachusetts, Fogg Art Museum, and New York, Frick Collection, *Drawings by Fragonard in North American Collections*, catalogue by Eunice Williams, 1978-79.

Washington and elsewhere 1984-85 Washington, National Gallery of Art, Paris, Grand Palais, and Berlin, Schloss Charlottenburg, *Watteau, 1684-1721*, catalogue by Margaret Morgan Grasselli and Pierre Rosenberg, 1984-85.

Washington and elsewhere 1988-89 Washington, National Gallery of Art, Chicago, Art Institute of Chicago, and Paris, Grand Palais, *The Art of Paul Gauguin*, catalogue by Richard Brettell, Françoise Cachin, Claire Frèches-Thory, and Charles F. Stuckey, 1988-89.

Zurich 1946 Zurich, Graphische Sammlung der Eidg. Techn. Hochschule, *Architektur- und Dekorations-Zeichnungen der Barockzeit aus der Sammlung Edmond Fatio*, 1946.

Zurich 1953 Zurich, Winterthur, Kunstmuseum, *Théodore Géricault*, 1953.

Index of Artists

FRENCH MASTER DRAWINGS
FROM THE PIERPONT MORGAN LIBRARY

was designed by Klaus Gemming, New Haven, Connecticut.
The text was set by Finn Typographic Service, Stamford, Connecticut,
in Galliard, which was drawn by Matthew Carter based on typefaces
by the sixteenth-century French type designer Robert Granjon.

The book was printed by Stamperia Valdonega, Verona, Italy,
under the supervision of Martino Mardersteig, on a paper
containing 30% cotton, specially developed for Stamperia Valdonega
by the Cordenons paper mill in Pordenone.

The book was bound by Legatoria Torriani, Milan, in Brillianta
cloth by Scholko and Ingres endpapers by Fabriano. Part of the
edition was bound in paper. The slipcase for a special edition
with a detail of Chalgrin's *La Salle des Machines* (cat. no. 83)
was also made by Legatoria Torriani, Milan.

The decorations stamped on the cloth binding were taken from
Blondel's *Fête Publique,* bound by Antoine-Michel Padeloup (PML 1957).